A Complete Guide to
PRINTMAKING

A Complete Guide to
PRINTMAKING

Edited by
Stephen Russ

A Studio Book
The Viking Press
New York

Published in 1975 by The Viking Press, Inc.
625 Madison Avenue, New York, NY 10022

SBN: 670-23422-2

Library of Congress catalog card number: 74-7692

This book was designed and produced
by George Rainbird Limited
Marble Arch House, 44 Edgware Road, London W2

House Editor: Erica Hunningher
Designer: Pauline Harrison
Index by: Irene Clephane

Printed and bound by A. Wheaton & Co., Exeter, Devon
Color plates printed by Cox & Wyman Ltd, Fakenham, Norfolk

Printed and bound in Great Britain

Acknowledgments

The editor is grateful to Ewen Wannop for the black-and-white
photographs on pages 10 to 61 and 100 to 132; to John Hunnex for those
on pages 68 to 96; and to Derrick Witty for those on pages 8 and 36.

The Swiss Bolting Cloth Manufacturing Co. Limited, Thal, St Gallen,
Switzerland, kindly supplied the microphotographs of bolting silk, nylon
monofilament and polyester multifilament on page 14.

Thanks are due to the Principals of Bath Academy of Art and Goldsmiths
College, London University, for providing facilities in their studios.

Contents

Introduction

This is a workshop handbook for the artist printer. It consists of four chapters, each devoted to one of the main hand-printing processes – relief printing, etching, lithography and screen printing. Each chapter has been written and illustrated by an artist writing on his own craft.

There are two good reasons for taking up printing: the first is that it offers a convenient way to manufacture a set of identical copies from a given original, the second is that printing contains within itself a quality which is unique and valuable for its own sake.

In his working life, the commercial printer is limited to reproducing his customers' originals. The artist printer has no such limitation; his time is his own, he can change his mind half way through the job, and add or take away as much as he likes. In other words, although he may use an original drawing, his real work is done with his hands on the printing process itself.

This book has been written in the hope that it may embolden more artists to take up printing. They are almost certain to enjoy the experience. And in turn it is equally probable that they, because they are artists, will put new life into printing.

Stephen Russ

Screen Printing
by Stephen Russ

Equipment

The essential tools of the screen printer's trade are a printing table, a screen, and a squeegee. Although it is not strictly necessary to have more than one screen, it is very much more convenient, particularly when embarking on ambitious prints, to have a screen for each colour. Before starting to make the screens it is worth spending some time considering what will be the most useful size. A frame with internal dimensions 12×18 in. ($30 \cdot 5 \times 46$ cm.) will give a printing area $9 \times 11\frac{3}{4}$ in. (23×30 cm.); a frame with internal dimensions 25×38 in. ($63 \cdot 5 \times 96 \cdot 5$ cm.) will give a printing area 20×30 in. (51×76 cm.). These two sizes have been found in practice to cover all the ordinary work flowing through a busy studio. But whatever is decided, it is important to restrict the frames to one or two standard sizes.

The best wood for screen frames is Western red cedar, and after that hemlock spruce and Douglas fir. The best grade is sold as 'clear' or 'best joinery', and this means straight grain, no knots and no tendency to warp. A screen frame must not warp. The pieces to make the small frame should have a cross section about $1\frac{1}{2}$ in. (4 cm.) square; the pieces for the large frame should be about $2\frac{1}{2} \times 1\frac{1}{2}$ in. ($6 \cdot 5 \times 4$ cm.) with the $2\frac{1}{2}$ in. ($6 \cdot 5$ cm.) face on the flat. The corner joints must be accurately cut, glued with a urea/formaldehyde glue, and screwed. An ordinary half-lap joint is all that is needed. When the glue has set, the frame must be tested for flatness, and any error corrected by planing. All the outside edges and corners should then be well rounded with sandpaper, the inside edges left square. Finally, the frame should be given at least two coats of polyurethane varnish to seal the pores in the wood and keep it clean and dry.

The frame is normally attached to the table by hinges, so that it can be raised and lowered like the lid of a desk. In fact the arrangement is more complicated than this, because when he is getting ready for a run the printer will almost certainly need to make small adjustments to the setting of his screen, a fraction to the left or right, a fraction forward or back. He may also need to raise or lower the pivot of the hinge. All these movements can be accommodated very simply by attaching the hinges not to the table itself but to an adjustable hinge bar.

An adjustable hinge bar consists of two identical strips of wood lying one on top of the other. The lower strip is screwed to the table, the top strip is free to move. The strips are about 4 in. (10 cm.) longer than the over-all width of the screen frame, and their combined thickness is equal to the thickness of the screen frame. The two members of the

Hand-drawn photographic stencil—a student's first attempt.

The adjustable hinge bar, consisting of
two strips of wood lying one on top of
the other (see detail below). A magnet has
been screwed to the screen frame and an
iron plate to the squeegee so that it
cannot fall into the ink.

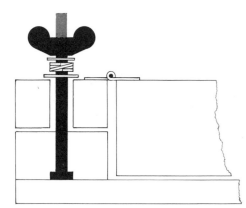

hinge bar are connected by a pair of coach bolts passing through holes drilled about $1\frac{1}{4}$ in. (3 cm.) in from each end. The hole in the lower member is drilled to the exact diameter of the coach bolt, the hole in the upper member is about $\frac{1}{4}$ in. (6 mm.) larger than this. The head of the coach bolt is countersunk in the underside of the lower member, and its threaded end should project about $1\frac{1}{4}$ in. (3 cm.) above the upper surface of the top member. Each bolt will need two large washers with a spring washer between, and finally a wing nut. By slacking off both wing nuts, the upper member of the hinge bar can be moved up to $\frac{1}{4}$ in. (6 mm.) to left or right, forward or back. By inserting strips of plywood or card between the upper and lower members, the over-all height can be raised or lowered through about $\frac{5}{8}$ in. (16 mm.). When the adjustments have been made, the wing nuts are tightened down hard.

A screen is attached to the hinge bar only for the duration of the printing run: at the end of the run it is taken off for cleaning and storage. Time can be saved, and the labour of screwing and unscrewing hinges avoided, by using a special type of hinge known as a push-pin or loose-pin butt. Changing screens is done by withdrawing the pin. If the first hinge is taken apart and screwed to the hinge bar in the manner shown, with the male part at one end and the female part at the other, all the screens will slot into it automatically.

Every time a print is made, the screen has to be raised, and there must be some device to hold it in a raised position, leaving the printer with both hands free. The simplest idea, perfectly satisfactory for a small screen, is a little wooden strut pivoted to the side of the screen frame somewhere near the printer's left hand. A large screen can be held up by a length of sash cord running from a screw eye set in the front edge of the frame and running up over a couple of pulleys in the ceiling and down to a counterbalance weight.

The surface or bed of the printing table must be rigid, perfectly flat, hard, smooth and easy to clean. Suitable materials are ordinary hardboard, laminated plastic of the 'Formica' type, and aluminium sheet. A very useful portable bed for a small screen can be made by simply

Take-apart hinges enable the printer to change screens quickly and easily.

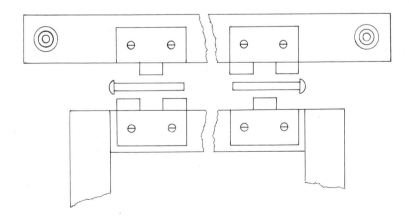

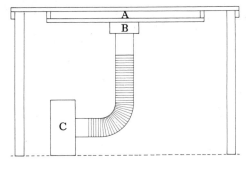

(*top*) The vacuum table, showing:
 A airtight chest
 B vacuum control
 C extractor fan

(*below*) The vacuum table top.

screwing an adjustable hinge bar to one end of a sheet of hardboard. This little bed can be clamped to the top of any convenient table, and removed at the end of the printing run. A comfortable height for the table top would be about 32 in. (81 cm.), more or less according to the height of the printer. Professional printers usually work on a table built with a top that slopes down from a height of about 35 in. (89 cm.) at the back to about 31 in. (79 cm.) at the front.

A professional printing table also incorporates one highly specialized refinement – a vacuum or suction bed. This consists of a powerful extractor fan connected by a flexible hose to a shallow airtight chest built on the underside of the bed. The surface of the bed is perforated with innumerable fine holes drilled down into the airtight chest. When the fan is switched on, any sheet of paper laid on the bed is immediately gripped by the suction.

Make the table top of $\frac{1}{2}$ in. (13 mm.) plywood; chipboard is not good enough. Cut a sheet of laminated plastic to the same size and clamp it temporarily to the surface of the plywood, but at this stage do not glue it. Mark out a $\frac{1}{2}$ in. (13 mm.) square grid all over the centre of the plastic sheet, and drill through every intersection with a $\frac{1}{16}$ in. (1·5 mm.) bit. Allow the bit to enter the top surface of the plywood, but make no attempt to drill right through it. Now release the clamps, take off the plastic sheet, and change to an $\frac{1}{8}$ in. (3 mm.) bit. Insert this bit in the $\frac{1}{16}$ in. (1·5 mm.) holes already started in the surface of the plywood, and drill right through. Apply adhesive to the plastic sheet and to the surface of the plywood and bring the two together, taking care that the holes coincide.

The airtight chest should be as small as possible, that is to say no deeper than 1 in. (2·5 cm.) inside, and no larger than the area covered by the perforations. The flexible hose is usually connected to the centre of the underside of the airtight chest, but the exact position of this connection is of no importance.

During a printing run the vacuum has to be cut off temporarily every time the screen is raised, and formed again as the screen is lowered. This means that, somewhere along the connection between the airtight chest and the extractor fan, there must be a vacuum control. On a trade printer's table this control is triggered automatically by raising and lowering the screen. The drawing shows how to build an effective control operated by a simple push–pull lever.

A squeegee consists of a long straight flexible blade set in a groove cut in the underside of a wooden handle. The over-all length of blade and handle should be about $1\frac{1}{4}$ in. (3 cm.) less than the inside width of the screen frame. The section of the handle should be about $1\frac{1}{4} \times 3\frac{1}{2}$ in. (3×9 cm.), and the edges should be well rounded so as to give a comfortable hand-hold. Polyurethane is by far the best material for squeegee blades: cheaper blades are made from neoprene or rubber. All these materials are sold by length cut from running strip with a section $\frac{3}{8} \times 2$ in. (1×5 cm.).

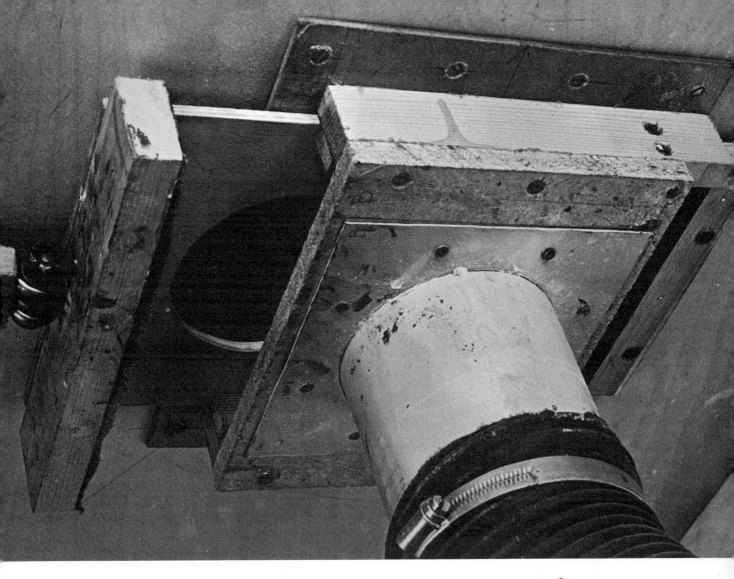

The vacuum control seen from below,
showing (*right*):
A sliding shutter
B flanged connector

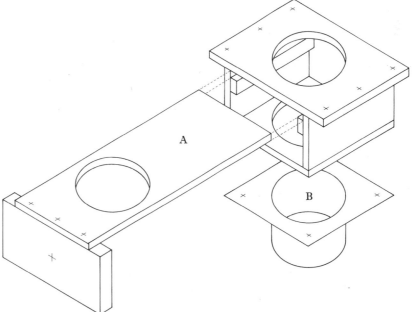

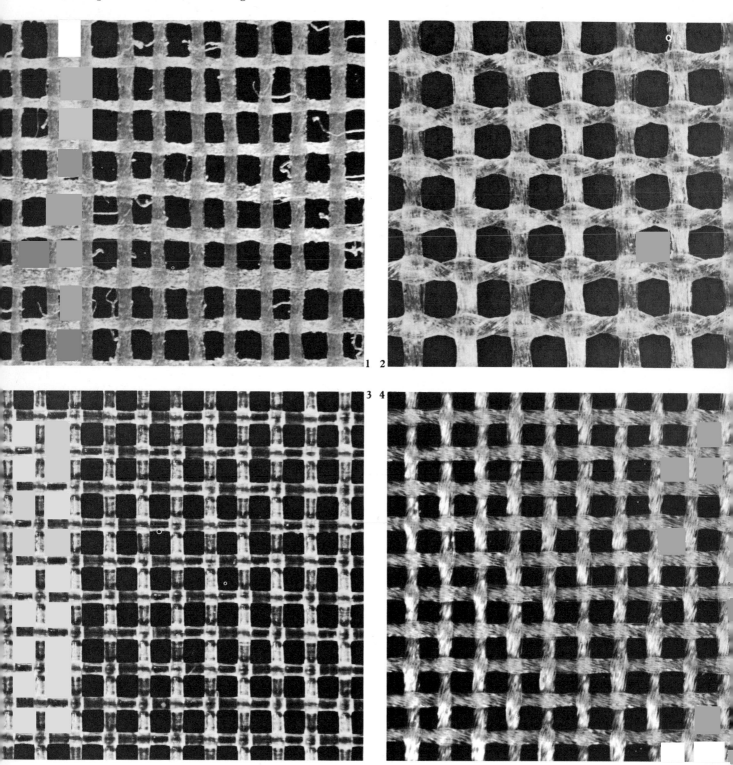

1 2
3 4

The mesh:
1 cotton organdie
2 silk bolting cloth
3 nylon monofilament
4 polyester multifilament

The mesh

Screen mesh material is available in cotton, natural silk, nylon and polyester fibre. Each of these fibres has its own characteristic properties, and an understanding of the different types of mesh begins with an understanding of the fibres from which they are made.

Cotton is the least expensive and the least strong of all the mesh materials. A cotton mesh will give a straight printing run of several hundreds of prints, but it will not stand up to repeated washings. The reason for this is that cotton has very poor dimensional stability and almost no elasticity. It tightens up when wet and goes slack as it dries out, and with a slack screen it is almost impossible to make a decent print. By nature soft and absorbent, cotton will take all types of stencil, and will hold them well.

Natural silk is a strong, elastic, hard-wearing fibre; it is very good-natured, and will take and hold all types of stencil. Unlike cotton, it will keep its tension reasonably well even after many washings.

Silk mesh comes in two distinct types of weave. The simplest, known as plain weave or taffeta, has the same ordinary square structure as cotton organdie. The other weave is known as bolting cloth. In this, the warp threads are heavier than the weft. The weft threads run as a pair, and as they pass between each warp thread and the next they are given a twist like a rope. This interlocked structure prevents the threads from being dragged back and forth by the squeegee.

Nylon is spun as a continuous monofilament thread. It has the tensile strength of steel, a surface as smooth as a glass rod, it is elastic, resistant to abrasion, non-absorbent and easy to clean. It is spun and woven with a degree of precision unattainable in a natural fibre.

Nylon mesh has the same square woven structure as organdie or taffeta, but as it comes off the loom the material is subjected to a heat treatment which fuses the warp and weft threads together at every intersection. In this way the shape and size of the aperture is permanently set.

Although nylon is undamaged by the chemicals and solvents generally found in a printing studio, it is sensitive to heat. It softens at 455°F (235°C), and melts at 482°F (250°C). This means that great care must be taken when using iron-on stencils.

The polished surface of the nylon thread gives a very poor anchorage to most kinds of stencil and in particular to photo-stencils based on gelatine. To get round this difficulty, a newly stretched nylon screen should be treated with caustic soda, and this treatment should be repeated as a routine precaution before attempting to fix any new stencil. Stand the screen upright in the sink, put on rubber gloves, and swab the mesh with a 4 per cent solution of caustic soda. Leave the solution in the mesh for about ten minutes and then hose down with a copious flow of cold water.

The polyester fibre is spun, like nylon, as a continuous monofilament thread. It is immensely strong, elastic, hard-wearing, non-absorbent

and easy to clean. It is undamaged by the usual range of printers' chemicals, but it is damaged by heat – it melts at 490°F (256°C).

Two kinds of polyester thread are used in weaving mesh material – monofilament and multifilament. The first consists of the simple continuous fibre, the second is a yarn built up by twisting together several monofilament strands.

The caustic soda treatment recommended for nylon applies equally to a polyester mesh. If this is neglected, the printer can expect difficulty in getting his stencils to stick. A multifilament thread is less likely than a monofilament thread to shed its stencil.

A printer who has worked with all these materials will have a very clear understanding of the way they behave. He will know which kind of mesh to use for which job. Any serious amateur in search of this knowledge should try to find a printer willing to explain by practical demonstration. If this is not possible, he should experiment first on cotton and then work through to nylon or polyester fibre.

There are two other important considerations: the thickness of the thread and the fineness or coarseness of the weave. No mesh can be finer than the threads from which it is woven. Even the finest Egyptian cotton cannot be spun as fine as silk, and silk cannot be spun as fine as nylon. The cotton used in mesh materials comes in one gauge only, the finest compatible with strength. Silk comes in several gauges designated by the old silk code letters, s – standard, x – medium, xx – heavy duty. The man-made fibres use a different code, s – light, m – light to medium, t – medium, hd – heavy duty.

The fineness or coarseness of a mesh is measured by laying a ruler along one of the weft threads and counting the number of warp threads that cross it in a centimetre. The higher the thread count, the finer the mesh. A fine mesh will give a thinner deposit of ink and, generally speaking, a more faithful and sensitive reproduction of a delicate original. With a coarse mesh, the ink deposit will be thicker, and the woven texture will be clearly visible in the print. In fact, the ultimate limit of fineness in the screen process is set by the diameter of the thread and the size of the aperture in the mesh. Few printers can afford to stock more than a small selection of mesh materials, and the problem is to know which ones to choose. A thread count of about forty-three will carry most of the day-to-day work; fine photographic work involving mechanical tints and small lettering should be given a mesh with a count upwards of fifty threads per centimetre.

When putting a new mesh on a screen frame, the aim is to stretch the material as tight as a drum. The tension should be uniform over the whole surface, and the warp and weft threads should be straight and at right angles to each other.

Cotton and silk can be stretched well enough by hand. Cut the material with enough allowance to turn up on all four sides. Begin by laying one of the selvedges along one of the sides of the screen frame: this will give a firm, straight base line. Put in a couple of pins or staples

at one end, pull along the selvedge as hard as possible, and pin the other end. Fill in along the selvedge with a double staggered row of pins spaced about $1\frac{1}{4}$ in. (3 cm.) apart.

Now go back to the first pin and from there try to follow the line of a thread running at right angles to the selvedge. Pull along the line of this thread as hard as possible, put in a pin at the end, and then fill in with a double staggered row of pins spaced about $1\frac{1}{4}$ in. (3 cm.) apart. The mesh is now fastened along two sides at right angles to each other.

Now take the remaining free corner and pull the material as hard as possible across the diagonal of the frame. Anchor this corner with a cluster of pins. The two last sides are now stretched by pulling straight across the frame. The best way is to start with a pin at the middle of each side, and then to halve the space to the left and right. Continue subdividing in this way until all the slack has been taken up. Always pull along the line of a thread, and resist any temptation to pull diagonally.

A mesh fastened simply with pins can be used straight away if the job is urgent and speed is more important than first-class prints. But for serious work the pins should always be supported by an adhesive. The most suitable of the old-fashioned glues is casein. Mixed with cold water and applied through the mesh with a stiff brush or mop, it will dry to a hard cement, resistant to water and unaffected by printing ink solvents.

Nylon and polyester cannot be stretched tight enough without some form of mechanical assistance. Stretching machines can be bought from the specialist suppliers, or the printer can make his own. The apparatus consists of a rigid outer frame to which four floating bars are attached by long bolts and wing nuts. The dimensions should be made to fit the standard screen frame used in the workshop. When the floating bars are pulled up tight against the rigid outer frame, there should be a gap not less than $1\frac{1}{2}$ in. (4 cm.) wide between the inside edge of the floating bars and the outside edge of the screen frame. A channel about $\frac{3}{4}$ in. (2 cm.) deep by $\frac{3}{8}$ in. (1 cm.) wide is cut out of the top surface of each of the floating bars, and a strip of oak or other hardwood is prepared to fit loosely in each of the channels. A length of tacky tape, such as double-sided 'Sellotape' (Scotch tape), is laid along one face of each of the oak strips.

Lay the stretching frame on a table and arrange the screen frame inside it. Slack off all the wing nuts and bring the floating bars into contact with the outside edges of the screen frame. The face of the screen frame must be a little higher – say $\frac{3}{16}$ in. (5 mm.) – than the surface of the floating bars, and strips of card should be packed underneath if necessary to achieve this.

Stretching a screen on this machine can be done single handed, but it is easier with a helper. Cut a piece of mesh material to the over-all size of the rigid outer frame. Lift out all the oak strips and lay them, tacky side up, on the table outside the frame. Take a selvedge and, keeping it as straight and tight as possible, lay it along the tacky surface of one of

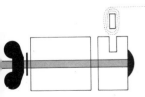

The stretching frame: plan and section of corner detail.

the oak strips. Now, with the thumbs on top and the fingers underneath, roll the strip under the mesh as if it were the spindle of a roller blind. Continue rolling for three or four turns, and then press the rolled-up strip into the groove on its floating bar. Next, go across to the edge parallel to the first edge, lay it along the tacky surface of its oak strip, roll it up, and press it into its groove. The mesh should now be in position and held at moderate tension between the two rolled-up edges.

When the two remaining edges have been rolled up on their oak strips, it is time to begin tightening the wing nuts. Do this carefully and methodically, walking round and round the table and taking up half a turn on each nut. As the floating bars are drawn towards the outer frame, the mesh will be stretched tight. Nylon and polyester can be extended on this machine by 3 per cent of their initial length. Cotton and silk can be stretched equally well, but not to the same degree of extension: the printer's instinct will tell him when these fibres have reached their limit.

When the mesh is fully stretched, it must be fastened to the screen frame. This could be done with staples, but it is very much better to use one of the modern resin adhesives made specifically for this purpose. Cut a piece of stiff card as a spreader, and force the adhesive through the mesh, making sure that it is well filled. These resins set hard in about twenty minutes, and as soon as setting is complete, the screen can be cut out of the stretching frame and the cut edges smoothed with sandpaper. With this machine and this type of adhesive, a screen can be stretched and put into use in less than one hour.

It is impossible to exaggerate the importance of getting the screen stretched tight. Most of the difficulties in printing can be traced to a slack mesh.

Hand-made stencils

When designing for the screen, the artist must never forget that the area available to him for his stencil is considerably smaller than the area of the screen. This is because the squeegee needs plenty of room to overshoot at both ends of its stroke. On a small screen this distance would not be less than $2\frac{3}{4}$ in. (7 cm.) at each end, on a large screen not less than $5\frac{1}{2}$ in. (14 cm.). There must also be a margin, not necessarily quite so wide, down both of the long sides. The normal procedure, therefore, is to place the stencil in the centre of the mesh, and then to fill in the space between the stencil and the frame with gummed paper strip.

It is always safest to work from a master drawing: experienced printers can take short cuts, but beginners do so at their peril. A master drawing shows what the finished print will look like; it is drawn true to size, and it is not reversed left to right. If there are several colours, each colour will need a stencil to itself, and all these stencils will be traced off the master drawing.

Stretching the mesh: the mesh, rolled up on the hard wood strip, is about to be pressed into the groove in the floating bar.

Stencil making is often regarded as a simple matter of tracing or copying, the hand following the line and the mind elsewhere. It is better to think of it as a part of the creative process.

The simplest type of stencil is made from tracing paper. Lay a piece of tracing paper over the master drawing and make a tracing of the image. Remove the tracing to a hard flat surface such as a sheet of hardboard, or better still glass, and cut out all those parts that are to print. The best tool for this is a stencil-cutting knife, but a sharp-pointed scalpel or similar tool will do. From time to time hone the cutting edge on a fine grain stone.

Lay the stencil on a sheet of clean newsprint and lower the screen into contact, ready for printing. When the first print is made, the printing ink will stick the stencil to the mesh, and no other adhesive is needed. In the case of a stencil with several detached pieces, put a dab of fish glue or gum arabic through the mesh here and there. This will hold everything in place until the first print is made. A cut paper stencil will give hundreds of trouble-free prints. At the end of the run the stencil is simply peeled off the mesh, the printing colour removed with screen wash, and any spots of glue sponged out with hot water.

If the master drawing is intricate, it is better to cut the stencil in one of the proprietary laminated sheets. There are several versions of these sheets on the market, and they are listed by all suppliers of screen-printing materials. The original version, 'Profilm', invented in 1930, consists of two thin, more or less transparent sheets held together by a temporary latex bond. The top layer is a sheet of cellulose acetate coated on the surface with a film of shellac, the backing sheet consists of tissue paper impregnated with paraffin wax.

With a few strips of adhesive tape, fasten the master drawing to a hard flat surface, preferably plate glass. Cut a piece of Profilm 4 in. (10 cm.) longer and 4 in. (10 cm.) wider than the drawing. Lay the Profilm, shellac side up, over the drawing, with an equal margin of 2 in. (5 cm.) on all four sides, and fasten down with adhesive tape.

Sharpen the stencil-cutting knife to a razor edge, and cut round the outlines of the parts that are to print. The knife blade should cut right through the top layer and just bite into the backing sheet; it should not cut through the backing sheet. To do this neatly requires skill and experience, but it is not as difficult as it sounds. If the outline has been well cut, the piece outlined can be lifted out cleanly with the point of the knife and thrown away. As soon as the whole stencil has been cut, it can be lifted off the drawing and put on the screen.

Shellac-coated stencils are fixed by dry heat, and this is usually done with an electric iron set at 'silk heat'. Have ready a sheet of hardboard slightly larger than the stencil. Cover the hardboard with clean newsprint, and lay the stencil on this, shellac side up. Lower the screen into contact with the stencil, and cover the inside of the mesh with one thickness of clean newsprint to protect the mesh from direct contact with the iron. Move the iron slowly with moderate pressure until the

shellac melts and rises up into the mesh. The sign that this is happening is the appearance of an amber or caramel colour in the mesh. Do not continue ironing too long. As soon as the shellac has been melted over the whole surface, and while the stencil is still warm, turn the screen over and peel off the backing sheet.

It is now time to fill in the area of open mesh surrounding the stencil. This is best done with ordinary gummed paper strip. Begin from the middle and work outwards until the screen frame is reached. The first strip should overlap the stencil by at least $\frac{3}{8}$ in. (1 cm.), and the succeeding strips should overlap each other by the same amount. If the strips are made really wet and then laid out gummed side up for five minutes before being put on the screen, they will stick better and dry flatter. For a perfect finish, turn the screen over and iron lightly from the inside, not forgetting a sheet of clean newsprint to protect the mesh from the iron. Finally, cut four pieces of gummed strip, damp them, and lay them round the inside of the screen to seal off the line where the mesh joins the wooden frame. This is the standard method of filling in the mesh round a stencil, and it applies to all types of stencil.

Shellac-coated stencils are at their best on cotton or natural silk, and when printing with oil-based printing inks. Used in this way, they have proved their dependability in commercial printing studios for over forty years. Of all the laminated stencils they are the easiest for a beginner to use, and success at the first attempt is almost guaranteed.

The most obvious characteristic of a print from a knife-cut stencil is the sharp line that divides the positive from the negative areas. Grainy, scribbled and atmospheric qualities do not come naturally from the blade of a stencil-cutting knife. To get these qualities a liquid filler and a brush must be used.

There are innumerable excellent liquid fillers – gum arabic, photo-engraving glue, gouache or tempera colours, PVA emulsions, shellac, varnish. All that is necessary is that the liquid should be capable of clogging the mesh, that it should not be dissolved by the printing colour and, ideally, that it should be easy to remove from the screen at the end of the job.

Lay the screen over the master drawing, and trace the outlines of the parts that are to print. Draw straight on the mesh itself, using a soft pencil or a ballpoint pen. Now prop up the screen so that the mesh is clear of the table, and fill in the negative parts of the stencil with liquid filler. From time to time hold the work up to the window and scan it with one eye closed, to make sure that there are no pinholes of light in the parts that should be filled.

The filler can be applied with any kind of brush; it can be spread on with a scrap of cardboard, splattered on with a toothbrush or dabbed on with a sponge or with the fingers. While in a half dry state it can be removed or partially removed with a damp rag, so as to give areas of broken tone not unlike the tone produced by the halftone dot.

There is no reason why a knife-cut stencil and liquid filler should not

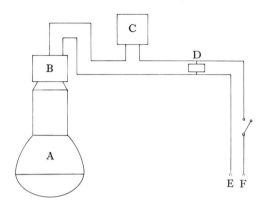

The mercury vapour lamp installation:
A 125w mercury vapour lamp MBR/U
B Edison screw lampholder
C ballast L 4125
D capacitor L 4008
E neutral
F phase (NB phase must lead to the centre contact of lampholder)
Circuit diagram by courtesy of Philips Electrical Limited.

be combined in the same screen. If a shellac-coated stencil is being used, this should be ironed on before starting work with the liquid filler.

Every beginner should take the first possible opportunity to examine his screens through a high-powered lens. He will then see for himself exactly how the process works. In a knife-cut stencil, the division into positive/negative areas is perfectly obvious. In a stencil made with liquid fillers the division may not be immediately obvious, but under magnification it becomes clear at once: the mesh is either filled or it is not filled.

It is not possible however, to make part of the stencil thin and weak so that it will print as grey. If a brush loaded with filler is drawn across a screen, the liquid will settle into the structure of the mesh and fill it square by square. The edges of the brush stroke will show a characteristic stepped or saw-edged profile. If a half loaded brush is drawn across a screen, a proportion of the squares will be filled, the rest left empty. If the stroke is repeated, a few more squares will be filled, and so on.

If the filler is left in the screen until it is half dry, and then wiped over with a damp cloth, something different will happen; the half dry film will begin to break down. The first sign of this will be the appearance of a small round pinhole at the centre of each square; this is the weakest place. Further rubbing will make the hole bigger. If too much has been removed, a fresh coat of filler can be brushed on, and the clearing process begun again. Working in this way with a cloth in one hand and a brush in the other, the screen can be made to generate its own halftone dot.

Photographic stencils

It is possible to make photographic stencils with very simple equipment. The sun can be used as a source of light, and the screen coated with gelatine applied by brush. But for serious, consistent, high-class work, there really is no substitute for a mercury vapour lamp.

The equipment can be set up in a corner of any room where there is a sink with running water, a supply of mains electricity, and space for a workbench about two metres long. There is no need for a darkroom.

The bench top should be surfaced with plain white laminated plastic sheet of the 'Formica' type. The programme of making a stencil will advance across this surface in three stages, starting at the left and ending at the right under the mercury vapour lamp.

The mercury vapour lamp should be suspended at a fixed height above the bench top. The higher the lamp, the larger the pool of light on the bench top. The general principle is that the diameter of the pool is equal to the perpendicular distance between lamp and bench top. Thus, a lamp fixed at a height of 21 in. (53 cm.) will illuminate any stencil up to 21 in. (53 cm.) long, and this is a very useful arrangement. The accompanying circuit diagram will enable any competent electrician to wire up the lamp, together with its ballast and capacitor. All these

components are available from suppliers of screen process equipment. The lamp should be fitted with a shade, so that the light is confined to the working area immediately beneath it.

Making a photographic stencil is, essentially, a type of contact printing. The artist's positive is laid face down on a sheet of sensitized material and exposed on the bench top under the mercury vapour lamp. The success of this part of the process depends on perfect face-to-face contact between the positive and the sensitized sheet. Rough work can be done under a sheet of clear plate glass held down by weights or cramps, but for fine work there is nothing to equal the contact formed in a vacuum.

The simplest vacuum former is listed by several suppliers as a 'copysac'. It consists of a large transparent plastic bag with a set of spring-loaded letter clips to close the mouth. A length of pressure hose leads from the far end of the bag to a water jet filter pump of the type supplied to laboratories. The pump is connected to the cold tap, and allowed to run into the sink.

To operate this strange piece of apparatus, the positive and sensitized sheets are taped to a piece of hardboard and loaded into the plastic bag. The mouth of the bag is folded over twice and closed with the spring clips. When the tap is turned on, the flow of water through the filter pump sucks the air out of the bag and forms a partial vacuum inside. The tap is left running throughout the duration of the exposure.

After the exposure, the stencil is taken to the sink and subjected to treatment by warm water, first by immersion and then by prolonged rinsing. A darkroom thermometer will be needed, a developing dish, and a sheet of plate glass or clear, stiff plastic about $\frac{3}{16}$ in. (5 mm.) thick. Both dish and sheet must be at least 4 in. (10 cm.) longer and 4 in. (10 cm.) wider than the largest stencil it is intended to make. When setting up a new installation, the sink should be large enough to allow the dish to be lifted in and out. If it can be even larger than this, so much the better. A small sink can be adapted by adding draining boards to one or both sides.

In addition to the cold supply, there must be a water heater with a capacity of at least 2 gallons (10 litres). Ideally, both hot and cold taps should be placed at the side of the sink, so as to leave the wall at the back perfectly clear. This is the place to build a large splashboard. The best material for splashboards is $\frac{1}{4}$ in. (6 mm.) marine plywood surfaced with plain white laminated plastic. Make the board as large as possible, screw the top edge to the wall, using brass screws, and set the lower edge slightly forward on blocks so that the water is shed into the sink. For additional protection, add side wings to the splashboard so as to make a three-sided cubicle. To support the sheet of plate glass and stencil during the rinsing process, screw a little horizontal shelf to the bottom edge of the splashboard. Arrange some good lights to illuminate the whole of this area, because the process of rinsing is critical and has to be watched very closely. So much for the installation.

During the exposure under the mercury vapour lamp, light passes through the artist's original and falls on the sensitized sheet. The action of the light hardens the sensitized material where it can get at it, but those areas protected by black in the artist's original will not be hardened, and during the rinsing process they will be dissolved and washed away. In other words, a positive mark on the artist's original will come out as an opening in the stencil, and this will give a positive mark in the final print.

The original drawing can be done in practically any medium, provided it really is opaque. Retoucher's opaque, indian ink, metallic paint, oil colour, wax crayon, soft pencil, these are all suitable. The best material to draw on is clear acetate or polyester drafting film; tracing paper is liable to warp, and it should never be used for fine work. The original need not be a drawing; it could be any flat opaque object such as a fern or a piece of black lace, or any collage of such objects. 'Instant' lettering, and the whole range of associated mechanical tints and symbols make perfect originals for reproduction by this process.

It must be emphasized that the photographic stencil cannot accept a range of greys: the original must be either black or clear. An ordinary photograph consisting of tonal gradations cannot be used as an original until it has been converted into a black-on-clear diapositive. This is a job requiring special skill and highly sophisticated darkroom equipment. Any artist lacking the necessary skill and equipment can put this part of the work out to a professional. Process cameramen are in business in most fair-sized towns, ready to make diapositives to customers' orders. A brief account of their work will be found in the Appendix (page 134).

To make a photographic stencil, the following materials will be required:

1 A roll of Autotype Universal Red gelatine-coated paper. This is not light-sensitive: it can be stored indefinitely in a cool place if kept in an airtight wrapping.

2 A roll of 'temporary support'. This is clear acetate sheet 0·002 in. (0·05 mm.) thick.

3 Potassium bichromate made up as a 2 per cent solution in water. This must be stored in a stoppered glass container shielded from direct sunlight and out of reach of children. As long as it keeps its bright orange colour it can be used over and over again; if it turns brown it must be thrown away.

4 Clear wax polish.

5 Small squeegee, small rubber roller, sponge, clean cotton rags, clean newspaper.

6 Rubber gloves (optional).

Items 1–3 can be bought from the specialist suppliers.

The whole process takes about half an hour. Once the work has been started there must be no interruption until the stencil is on the screen. So before starting make sure that everything is laid out ready. The

Alpha by John Furnival. One of a large series based on the Greek alphabet, created and printed by the artist using the screen process in a free way. Registration by the acetate sheet method (see page 30).
$20\frac{1}{2} \times 22$ in. (52×56 cm.). Photo: Ewen Wannop.

This space reserved
by General Franco
for Picasso's Guernica

belonging to Lute-playing.

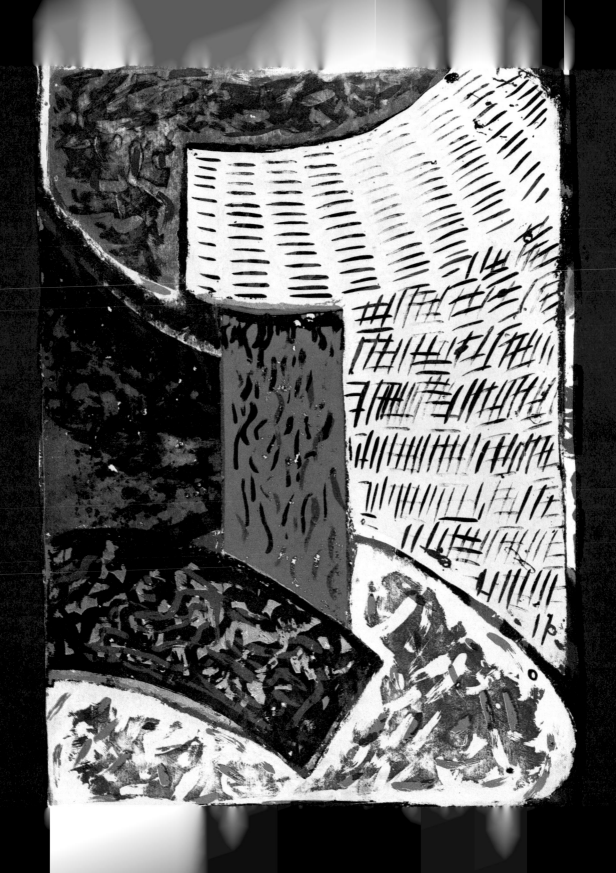

Untitled screenprint by David Timmins.
Liquid fillers applied direct to the screen
by brush.
28½ × 21 in. (72 × 53 cm.). Photo:
Ewen Wannop.

screen must be clean and de-greased. Screens with a cotton or silk
mesh must be sponged over with clean water to tighten the threads.

Cut a piece of Universal Red paper about 1½ in. (4 cm.) larger all
round than the image to be reproduced. Cut a piece of temporary
support about ¾ in. (2 cm.) larger all round than the Universal Red
paper. Wax and polish one side of the temporary support, finishing
with a clean dry cotton cloth. Strain the bichromate solution into the
developing dish. Immerse the temporary support, waxed side up, in the
bichromate solution. Immerse the Universal Red paper, red side up,
in the bichromate solution. Leave for two minutes.

Lift the Universal Red paper by two corners, turn it over, red side
down. Pick up the Universal Red paper and temporary support together,
face to face, and hold up to drain. Lay the sandwich on the working
surface, white side up, and with the little squeegee held at about 45°
press the two sheets firmly together, driving out at the same time any
trapped air bubbles. Wipe over with a dry sponge to remove surplus
bichromate solution. Now turn the sandwich over and lay it, red side
up, on a pad of newspaper. With a dry cotton cloth, clean and polish the
surface of the temporary support.

Now place the sandwich, red side up, on a piece of hardboard, and
arrange the original drawing or collage, face down, in the centre. The
drawing must be face down. Fix the corners with tape, and slide the
board into the copysac. Fold over the mouth and close with the clips.
Turn on the vacuum pump.

A mercury vapour lamp needs about four minutes to warm up, and
during this time the coypsac must be covered with a second sheet of
hardboard. At the end of four minutes, remove the covering and begin
to time the exposure. With a lamp set at 21 in. (53 cm.) above the
copysac, a normal exposure would be seven minutes. This figure is
given for guidance only, as in the matter of exposures there can be no
hard and fast rules. A weak or thin drawing may need a shorter exposure,
a bold and heavy one may take longer. A longer exposure will give a
thicker and stronger stencil at the risk of closing up fine detail. Every
printer must get to understand the requirements of his own installation,
and the best way is to run a set of progressive exposure tests. With
Universal Red photo-stencil paper, the useful period will lie somewhere
between five and fifteen minutes.

At the end of the exposure, switch off the light and the vacuum pump
and unload the copysac. Put the original drawing in a safe place, and
immerse the exposed sandwich, white side up, in a dish of water at
100°–110°F (38°–43°C). Rock the dish gently, and wait until red dye
oozes freely from the edges of the sandwich. Then very gently peel off
the backing paper and throw it away.

Lift the temporary support out of the dish and lay it, gelatine side
towards you, on the glass sheet. The image will begin to appear when the
gelatine is rinsed with water at 100°F (38°C). Rinsing should be done
with a fine rose; a bathroom shower can be used or, failing this, a

Rinsing the photographic stencil.

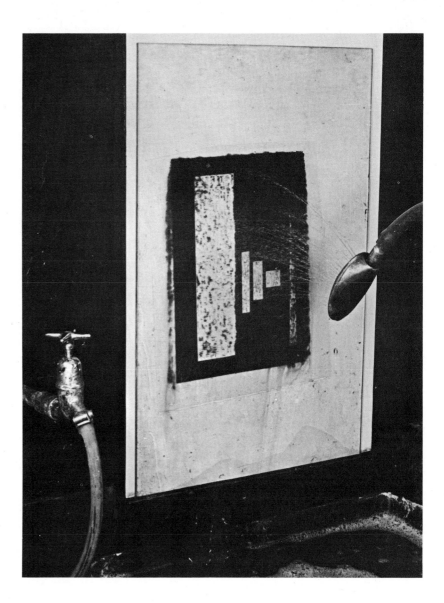

gardener's watering can. From time to time hold the stencil up to the light and scrutinize it very carefully. Continue the rinsing until all the open parts of the stencil are as clear as glass, with no trace of pink.

Now lay the temporary support, gelatine side up, on a piece of hardboard and lower the screen down on to it. The soft gelatine will immediately stick to the underside of the mesh. Cover the inside of the screen with two or three thicknesses of newspaper and, with the little roller, go over the whole surface with gentle pressure. Change the newspaper as soon as it becomes wet, and continue in this way until no more water is picked up. Remove the newspaper and leave the gelatine to dry out naturally by exposure to the air. When it is really dry, turn the screen

over and peel off the temporary support. This should come away cleanly and easily, leaving the gelatine stencil firmly attached to the mesh. If the temporary support refused to come away easily, this means that the gelatine is not yet dry.

Seal off the area around the stencil with gummed paper strip as described on page 21. The screen is then ready for use.

Registration

Freehand printing plays an important part in the day-to-day work of any screen printer. For example, the only reliable way to try out a colour, or to see the effect of one colour printed over another, is to pick up a spare screen and make a print. In this exercise it does not matter where the print falls on the sheet, because colour testing is a private affair and publication is not a part of the intention. But when it comes to making an edition, freehand printing is no help, because here the print must fall on the sheet in a controlled position, and the action must be capable of exact repetition any number of times. The word 'registration' is used by printers to describe the technique of controlling the position of the print on the sheet.

When buying paper, always allow plenty of spare sheets beyond the hoped-for number of perfect finished prints. In every run a few sheets will be spoiled, and in an ambitious piece of work with several colours, the proportion of spoils may be as high as 10 per cent of the total.

The first thing to do is to set aside one of the spare sheets for use as a control. Take the original master drawing and, with great care, arrange it on the control sheet in exactly the position it is intended that the print should fall. Tape the drawing to the control sheet, and do not remove it until the last colour has been printed. Now, bring up the screen carrying the stencil of the first colour, and connect it to the hinge bar. Lay the control sheet on the printing bed and lower the screen on to it. By peeping through the stencil it will be possible to see the master drawing. Move the control sheet about until the drawing coincides with the stencil. Lift the screen very gently and tape the control sheet to the bed. Lower the screen once more and peep through to make sure that nothing has moved.

When it comes to printing, all the sheets in the edition will have to be laid on the bed one after the other in the position at present occupied by the control sheet. This is best done by fixing to the bed a set of register stops which will establish the position of the sheet by edge-to-edge contact at three points. With a very sharp knife running against a steel straight-edge, cut out three strips of thin white card, each measuring about $1\frac{1}{4} \times 2$ in. (3×5 cm.). Set two of these strips against the left-hand edge of the control sheet, spacing them as far apart as possible. Set the third strip against the nearest edge of the control sheet about a quarter of the way along from the left-hand corner. Slide the strips until they make perfect contact with the edge of the control sheet, and then tape them down to the bed so that nothing can shift them until

every sheet of the first colour has been printed. Never use hard setting glue or tacks, because at the end of the run the stops must be peeled off and the bed left clear for the next job.

Once the register stops have been fixed in position the control sheet can be taken off the table, but before putting it away try this simple test. Pretend that the control sheet is about to be printed: put it back on the bed and slide it along until it butts up against the register stops. Lower the screen and peep through. The drawing and the stencil should coincide now as perfectly as they did before, and they should do so again and again however many times the sheet is taken off and put back. This test is a good rehearsal for the rhythmic action of printing, and it also shows very clearly the sort of error that will follow slapdash handling.

When the first colour has been printed, the screen carrying the stencil for the second colour is connected to the hinge bar, the control sheet is slid underneath, and the whole process of peeping through and setting up register stops begins all over again. The same process is repeated for each additional colour.

There is a technique for controlling the position of the print without the use of register stops. This is no substitute for the orthodox method, but it has the advantage that you can actually see the registration before making the print. Cut a piece of clear acetate sheet at least 2 in. (5 cm.) larger all round than the paper to be printed. Fasten it to the bed by a strip of tape running the whole length of the left-hand edge. Charge the screen with colour and make a print on the acetate sheet. Lift the screen and slide a sheet of print paper under the acetate sheet. Move the paper about until the best position has been found in relation to the print on the acetate sheet. Fold the acetate sheet right back out of the way, and make a print on the paper. There is a real danger that the paper may shift out of position as the acetate sheet is folded back. A vacuum table will prevent this.

Even when every care has been taken, it is difficult to avoid some error in registration. This will vary from one printer to another, and every printer should get to know the size of his own error. He will then be able to make allowance in his original drawings and in his stencils. The general principle is that wherever possible each colour should overlap the preceding colour by a small amount. This will ensure that no chink of white paper shows along the line where two areas of colour meet, or fail to meet. A close examination of any good exhibition of screen prints will show how well this trick is understood by the masters.

Printing

Before mixing up the printing colour, pause for a minute to make sure that everything in the workshop is ready and laid out in a rational way: printing table in the centre, stack of paper on one side, drying rack on the other, colour table behind. Check that the squeegee blade is clean and sharp. Check the fastenings of the hinge bar. Look over the screen

The acetate sheet method of registration.

for pinholes. Check the register stops. Have ready a stack of clean newsprint, a can of thinners and some clean cotton rags. Recruit a helper to rack the wet prints, and arrange if possible to complete the whole run in one unbroken stretch. If all the preliminary work has been well done, printing should be a smooth and trouble-free experience.

The rapid expansion of screen printing in so many branches of industry has led to a surge of activity in the laboratories of paint and colour chemists. Specific ranges of inks have been formulated for printing on glass, on metal, on ceramics, on textiles, and on all the various types of plastic sheet. The printer who intends to work on any of these surfaces should seek the advice of the ink manufacturers.

The artist concerned with prints on paper should ask for the range known as 'thin film' inks. These inks are based on an oil-modified alkyd resin tinted with extremely brilliant and pure synthetic colour lakes. All the colours can be mixed together in any combination without fear of precipitation or other chemical change. With good ventilation, drying time is about fifteen minutes for the first colour, a little more for over-printed colours. If a fan is brought in to accelerate drying, it should be set at floor level, because the solvent vapour is heavier than air. When dry, the colours are matt and more or less opaque. Transparent colours and glazes are made by mixing the ink with a colourless medium known as 'extender base'.

On the blade of a clean palette knife, transfer a little ink to a mixing tin, add white spirit, and work to a smooth cream. It is impossible to say how much white spirit to add; experience is the only teacher. Beginners should start with ink at the consistency of cold syrup and, as confidence grows, graduate towards a thinner mix. At the extreme limit, these inks can be diluted in the ratio of ink 60 : white spirit 40. Always make up plenty for the job, with a generous allowance for 'wetting out' the screen and for trial proofs: there is nothing more infuriating than to run dry half way through an edition. Anything left over at the end will not be wasted, because the thin film inks do not form a skin on the surface. A special shelf should be reserved for tins of mixed and diluted inks.

Switch on the extractor fan under the vacuum bed and leave it running until the job is finished. Use the control valve to open or shut the airway between the fan and the bed. The suction is cut off while the sheet is being laid against the register stops, and opened as soon as the sheet is in position. The vacuum grips the sheet while the print is being made, and while the screen is being raised at the end of the stroke. The suction is then cut off to release the print, and remains off while the next sheet is being laid in position. The cycle is repeated for every print made.

A small screen is usually attached to the table by hinges on one of its short sides. The printer stands facing the table and pulls the squeegee towards himself. A large screen is usually attached by hinges on one of its long sides, and in this case the printer has to twist his body so as to be

The master printer at work: the printing stroke (*left*) and flood coating.

able to pull the squeegee across from one side to the other. In either case, the print is completed in a single stroke. To give two strokes would make a thicker print, with the risk of a double impression. The normal practice is to give one pull, lift the screen, and remove the print. But this leaves the squeegee and the pool of ink at the wrong end of the screen. There are three ways of getting it back to its starting point:

1 Lay the next sheet on the bed, lower the screen, and make the return stroke a printing stroke. The disadvantage of this method is that screen prints always show a small drift in the direction of the squeegee stroke, and these prints will drift alternately up and down the sheet.

2 With the screen in the raised position, gather up the pool of ink on the blade of the squeegee, lift it through the air and deposit it in the well at the far end. Lay the next sheet on the bed, lower the screen and make the print.

3 With the screen in the raised position, sweep the squeegee back across the mesh, pushing the ink in front of it. This is called 'flood coating' and it is standard practice with trade printers. The idea is to fill the mesh with ink so that it cannot dry out; the ink hangs in the mesh ready to be forced through when the printing stroke is made.

The printing stroke is the critical moment when everything depends on direct manual control. Take the squeegee in both hands, with the thumbs in front and the fingers spread out behind like two fans. Drop

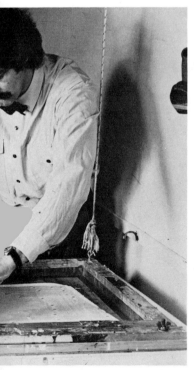
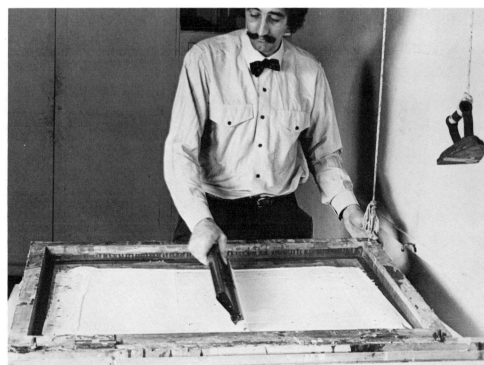

the blade behind the pool of ink, and incline the handle towards your-self at an angle of about 60°. Apply firm pressure and then, without hesitation or wavering, pull straight up the whole length of the screen in one stroke. The action is a combination of scraping and pressing; both aspects are important, but during early attempts the beginner should concentrate on scraping. If possible, get a demonstration from an experienced printer, because a skill of this kind cannot be transmitted through the printed word.

Cleaning up

If printing has to be interrupted for a short time, lay a sheet of newspaper on the bed and pull the ink up to the hinge end of the screen, scraping the mesh as clean as possible. Raise the screen and remove the news-paper. On resuming work, make a few waste prints on newspaper. The fresh ink will soften up the traces of ink left in the mesh, and after about three prints the screen should be clear.

If the work has to be left overnight, cover the bed with a thick pad of newspaper, lower the screen, and remove as much ink as possible, using a square-ended push knife or a scrap of card. Then soak a cotton cloth in white spirit and clean the whole of the inside of the screen. Change the cloth for a clean one, and remove the top sheets of news-paper as soon as they become saturated. Continue in this way until the screen is clean. Never rub the underside of the mesh as this might damage the stencil. Leave the screen in the raised position, and next morning begin with a few waste prints on newspaper.

When the edition is finished and the stencil is to be taken off the screen, the first thing to do is to remove every trace of printing ink. Lay the screen, mesh side down, on a flat table with a white plastic top. Flood the inside of the screen with screen wash and, with an old

An improvised drying rack.

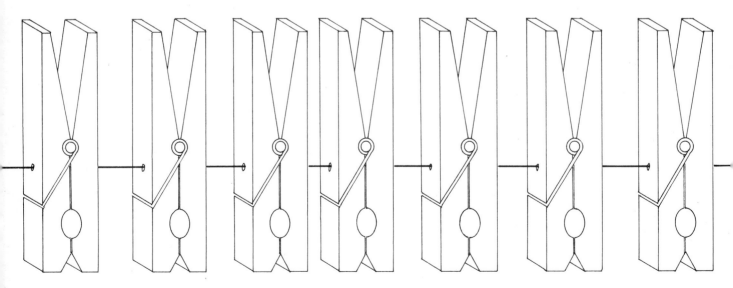

squeegee, push the liquid about this way and that. Lift the screen and, again using the squeegee, sweep the table top clean. Flood the screen and repeat the process once or twice more. Then take a cotton cloth soaked in screen wash, and swab over the mesh, inside and out. While the screen wash is still wet, carry the screen to the sink and drench it with a strong solution of detergent in hot water. The action of the detergent is to emulsify the oily solution, and render it soluble in water. If the mesh still seems to be oily, add more detergent until bubbles appear. Stand at the side of the screen, take a nylon brush in each hand and with one at the back and one in front, scrub the mesh vigorously up, down and across. By the end of this treatment the screen will have shed not only the printing ink but also the gummed paper strip and any water-soluble filler.

To remove a shellac-coated stencil of the Profilm type, proceed as far as the scrubbing process just described, and then dry the mesh. Lay the screen once more on the cleaning table and flood the inside with methylated spirit. Cover with a waste piece of plastic sheeting and leave for fifteen minutes. Then lift the screen, remove the plastic sheeting, and peel off the stencil. With a cotton cloth soaked in methylated spirit mop up the residue of dilute shellac. Change the cloth for a clean piece, and continue until the mesh is perfectly clear. Leave to dry by evaporation.

To remove a Universal Red stencil, lay the screen on the cleaning table and flood the mesh with lactic acid. Cover with a waste piece of plastic sheet and leave for an hour or so. Then take the screen to the sink and scrub with detergent and hot water. This method is safe on all types of mesh. Universal Red can be removed very quickly by swabbing over with sodium hypochlorite bleach. Stand the screen upright in the sink and rinse with a copious flood of cold water as soon as the stencil begins to disintegrate.

N.B. Hypochlorite must never be used on silk or cotton.

Removing the stencil may reveal a few patches of printing ink still lodged in the mesh. These should be attacked first with screen wash and then with detergent and hot water.

The last job is to de-grease the mesh. Stand the screen upright in the sink and mop over the whole surface with a 4 per cent solution of caustic soda. Leave the solution in the mesh for fifteen minutes and then rinse off with a copious flood of cold water, inside and out.

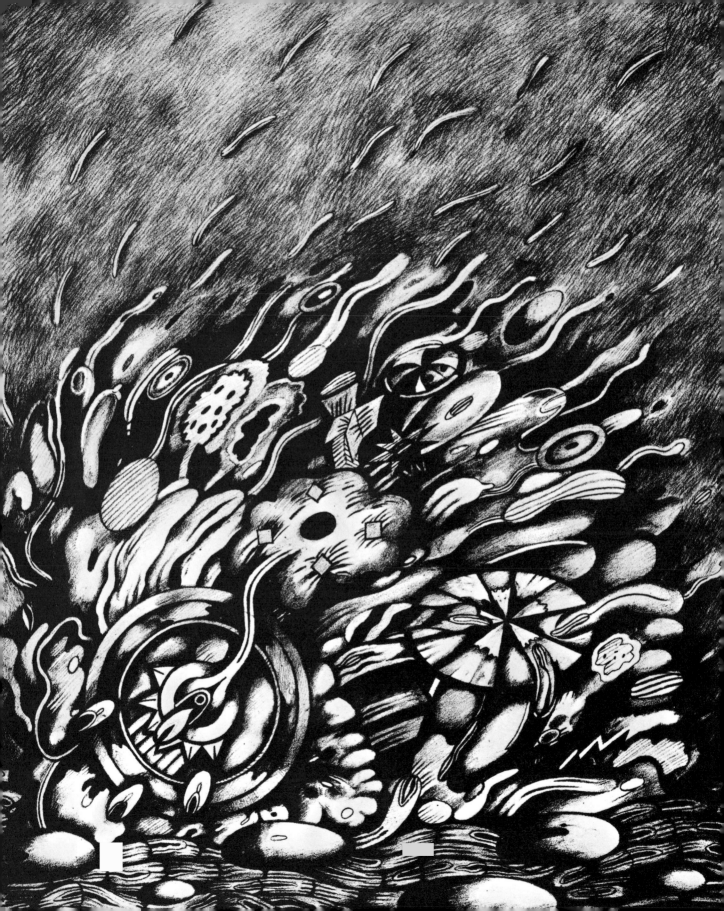

Lithography
by Alan Cox

Lithography is a planographic process in which the printing and non-printing areas of the stone or plate share the same surface, unlike the wood block or intaglio plate. The basic principle of the lithographic process is the natural antipathy of grease and water. The sensitized stone or plate is drawn upon with a grease-based material, such as liquid ink or chalk, which is instrumental in making the positive marks of an image. The surface is then treated chemically by means of an etch, which desensitizes the undrawn areas of the stone to the reception of further grease during the printing process and stabilizes the drawn image. ('Etching' in lithography should not be confused with 'etching' in the intaglio process, as its effect is not to bite physically into the stone or plate.) The grease image which has been stabilized on the stone through the etching process is then 'washed out' with a grease solvent; the original drawing material is washed away, leaving a grease deposit which has been absorbed into the grained surface of the stone. The surface is then dampened with water which rides away from the grease areas; when a roller charged with oily ink is passed over the surface the ink is attracted only to the greasy areas of the stone, the water film on the non-image areas acting as a barrier to the ink between roller and stone. The plate or stone now has an image holding printing ink and is ready for printing.

Lithography is perhaps the freest of the autographic media with a wide scope for linear, tonal and chromatic possibilities achieved by the most direct and spontaneous means. It offers a freedom in the formation and working of an image that even painting cannot always achieve. Areas may be deleted, new textures and qualities introduced, the order of colour plates interchanged throughout the proofing stages until the artist's conceptions are realized.

In any printing medium the time factor, the often expensive provision of facilities and the necessary temperament to cope with the technicalities involved cause most artists to work with a professional studio workshop where the printer is responsible for the processing of plates, working through proofing stages to the *bon à tirer* and finally pulling the edition. The variety of approaches, methods and effects possible from working with lithographic materials on to plate or stone may confuse the artist new to the medium and the printer must be able to give him reassurance, working in close collaboration with him through all stages.

Studio equipment
The first requirement is a room or rooms of adequate size and

Nightwatcher by Stuart Berkeley. One-colour lithograph, chalk work on zinc. 16 × 13¾ in. (40·5 × 35 cm.).

proportion. The floor must have sufficient loadbearing strength to accommodate the weight of a press and other heavy items. The room should be free from damp as paper and plates will suffer from damp conditions. Electricity and water supplies and adequate lighting are obviously essential. Stone storage should be as close to the graining sink as possible to eliminate unnecessary cartage of stones and also within easy access of work tables and press. All these surfaces should be at the same height for easy handling of stones; a movable stone table, also of the same height, on heavy-duty casters may be employed to transport the stones and slide them from one surface to another as required. Paper should be stored away from inking or processing areas to eliminate the possibility of spoiling through chemicals, damp or dirt. Drawing up benches are best arranged close to a natural light source and they should be constructed of stout timber to take the weight of several stones, as should the stone and plate racks.

As much natural light as possible is preferable, but an even distribution of artificial lighting ('Daylight Fluorescent' lights) must also be provided. The coldness of fluorescent lighting can be counteracted by the use of supplementary incandescent bulbs.

GRAINING SINK The graining sink must be strong and durable as it is used constantly and has to bear the weight of stones. It should be constructed of hard timber lined with sheet metal or an epoxy resin and should be large enough to accommodate the largest plates or stones to be used, allowing a good 6 in. (15 cm.) margin. It should contain a removable 'duck board' to support the plate or stone and incorporate a waste trap to avoid blocking drains with abrasives.

A simple method of trapping waste is to project the drainage pipe

Cross section of the graining sink:
A removable 'duck board'
B inlet from sink
C waste outlet
D waste sediment

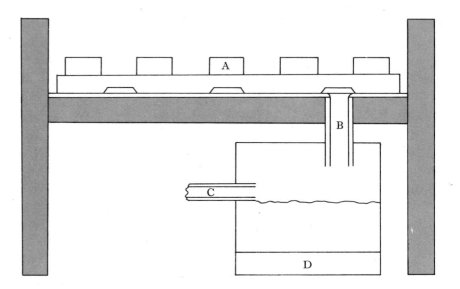

approximately $4\frac{3}{4}$ in. (12 cm.) above the bottom of the sink, providing a constant reservoir of water into which waste settles and which can be periodically cleaned out. Alternatively, a waste trap can be constructed from a metal tank or drum, with an in and out flow pipe as illustrated. A flexible hose from the tap allows an even distribution of water over the whole sink. A more satisfactory attachment is a flexible hose with a shower nozzle attached which gives a powerful, dispersed jet of water.

PRINT DRYING RACKS There are several good commercially made print drying racks of various sizes and methods of operation. The welded steel and wire type consists of upwards of fifty frames which are sprung-hinged at the rear for easy placing of prints on to each wire frame. This rack, fitted with casters, has the advantage of being mobile. The ball rack, strung on pulleys, enables rack and prints to be hoisted to the ceiling out of the way while prints are drying.

A simple rack can be constructed from two parallel strands of wire with spring-operated clothes pegs threaded opposite each other at intervals, into which the paper can be clipped. A simple and efficient unit can be made from a wooden frame strung with piano wire stacked within a basic frame attached to a movable base.

PLATE AND STONE RACKS Stones may be stored horizontally on stout shelves. Each shelf should take one stone since stacking stones increases the possibility of breakage and, moreover, may ruin their surface. Alternatively, stones may be stored vertically, separated with wooden battens. Shelves carrying large stones should be fitted with heavy-duty roller casters.

Plates should be kept in a cool, dry area to prevent oxidation, interleaved with acid-free tissue. Do not use newsprint slip sheets as these absorb moisture and contain chemicals that aid oxidation. Store plates flat in drawers or specially constructed shelving, or, alternatively, store them on edge with angled uprights in a 'V' formation to avoid buckling.

LEVIGATOR The levigator is used for graining stones. Quicker and more efficient than a lithographic stone, it consists of a steel disc approximately 12 in. (30·5 cm.) in diameter and $1\frac{1}{4}$ in. (3 cm.) thick with top and bottom edges bevelled; the bottom is machined smooth and the handle is set and secured towards the edge of the steel base. The handle is of wood or steel and may have bearings that reduce wear and facilitate easier rotation of the levigator. Motorized levigators are commercially available but they are expensive and are rarely found outside larger workshops.

ROLLERS One of the most expensive items of equipment is the lithographic roller. It requires a great deal of care if it is to give the best results for as long a time as possible. To store rollers vertically, construct shelving with holes bored to take the handles; a simple box with grooves to take the handles is adequate for horizontal storage.

There are two basic types of hand roller: the nap leather roller and the rubber and composition roller. One of each is a minimum requirement; 12 in. (30·5 cm.) to 15 in. (38 cm.) sizes are adequate for most work though larger rollers are made on request by most manufacturers. Smaller hand brayers are essential for spot printing; these will normally be of the rubber or composition type.

The nap leather roller consists of a wooden core, wrapped with heavy flannelette, covered with tanned calf-skin. The new leather must be conditioned before use to make it soft and pliable, and to remove excess and loose nap. This lengthy process is essential if the roller is to work efficiently over a period of time. The procedure for conditioning is as follows:

1 Russian tallow, castor oil or olive oil is rubbed into the surface of the roller, several applications being necessary over a period of several days. After each application the roller must be scraped and stored in waxed paper, aluminium foil or polythene to keep it dust free.

2 The roller is rolled in progressively stronger grades of lithographic varnish, starting with the lighter varnish and allowing three to four days' rolling up in each grade, rolling and scraping several times each day, and keeping dust free between each operation. Excess nap will be pulled from the roller on to the rolling slab. It is important to clean this and recharge with fresh varnish after each operation; the softer oils will gradually be removed as the process is continued.

3 The roller is charged with rolling up black (provided it is not to be used for colour work), continuing the process as in stage 2, scraping the roller and cleaning the slab between each operation. This should be continued for about one week by which time the roller should begin to take on a velvety texture. Gradually the roller may be brought into use though the nap will continue to be released at a decreasing rate over a period of months until it is fully broken in. These processes should be continued without interruption unless the roller is covered with tallow to prevent the varnishes and inks drying.

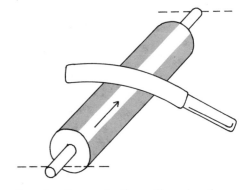

Scraping the nap leather roller using the edge of the spatula.

Periodically the leather roller nap surface will become smooth and matted with emulsified ink. To restore the nap to its velvety texture the old ink must be scraped from the surface. This is done with a spatula, and care must be taken not to cut the roller surface. Rest one handle of the roller against the abdomen and the other against the inking slab, leaving both hands free to hold the spatula, the edge of which is drawn up the roller removing old ink. Continue this process, wiping the spatula and turning the roller slightly until the surface has been completely scraped. Finally turn the roller end to end and scrape again. This final scraping should be in the direction of the grain of the leather to bring up the fibres. Mark one of the roller handles to indicate the direction of the grain.

A leather roller that has been allowed to dry with ink on its surface will need reconditioning. Apply paint remover and scrub with a suede brush until the ink begins to soften, then remove it with alcohol.

Repeat until all the dried ink has been removed, blotting off excess alcohol by rolling out on newsprint. Cover the roller in tallow or leather conditioner, then wrap it and leave it for a few days until the tallow has softened the leather and restored the velvety texture necessary for printing.

To avoid flattening one side, store rollers in a rack. If they are to be stored for any length of time the ink should be scraped from the surface, the roller covered in mutton tallow and wrapped in plastic sheeting, greaseproof paper or tin foil to protect it from dust. Before re-using, the tallow should be scraped from the surface, the roller washed in alcohol and re-scraped.

Synthetic rollers are available in various diameter sizes and lengths. Some have lightweight aluminium cores and others wooden. Gelatine rollers are best avoided as they readily lose their shape. Rubber and composition rubber are advised; they may readily be cleaned with turpentine substitute, making colour changes an easy task and they should be cleaned directly after use. Dried ink damages the surface and is difficult to remove. Again, store in racks and avoid leaving on a flat surface.

DIRECT PRINTING PRESS The flatbed printing press is probably the most suitable machine for the artist printer. It may be manually operated or motorized and is available in varying sizes. The old machines are robust and give excellent service, but they are becoming a rarity as many commercial printers have scrapped them. It is now possible to buy modern machines.

The direct printing press gives a reverse image as the printing paper is face to face with the stone or plate. The stone is placed on the bed of the press. If plates are used they may be put on a stone used to raise the level of the bed; a better alternative is a strong wooden or steel base which can be removed when the press is required for stones. The image is transferred from stone to paper through pressure via the scraper bar; the bed travels through the press motivated by the drive cylinder which has been brought into contact with the underside of the bed by operating the pressure lever, raising the bed and 'sandwiching' the stone or plate between scraper bar and drive cylinder. The drive is a simple friction drive between the cylinder and a series of steel strips on the underside of the bed; consequently the cylinder should remain free from grease and oil which will cause slip. Some presses have a reverse action in that the bed will stay on the same level with the cylinder but the scraper bar may be lowered.

The scraper bar is bolted into its holder which remains movable at both ends and is pivoted in the centre by the pressure-adjusting screw. This movement allows the scraper to compensate for any unevenness. The scraper leather should always be kept in good condition as it will directly affect the quality of the print and any excessive wear or grit in the leather can also damage the tympan. New scraper leathers should first

be soaked in water until fully saturated and then fitted; finally apply tallow or vaseline.

Many materials may serve as a tympan providing they are smooth and flat and non-absorbent. Older presses were fitted with brass or zinc sheets, but now there are many stable plastic substances that are lighter, wear well and withstand heavy pressures. Unlike the drive cylinder which has to be dry to facilitate a friction drive, the tympan must be liberally greased with tallow, vaseline or cup-grease to reduce friction.

OFFSET PRESS The offset press produces an image which is a replica of the one drawn on the plate. The inked image passes from the plate on to a rubber blanket which is stretched over a steel cylinder. The cylinder passes over the plate, picks up the image as a reverse and is transferred back down on to the paper lying on a second bed at the other end of the press, the image now being the same way round as it was drawn.

One disadvantage of the offset press is that the ink film is reduced, so it is impossible to achieve a comparable density of ink to that of the direct method.

Preparing the stone

Lithographic stone is almost pure limestone; the best comes from Solnhofen in Bavaria and is called Kellheim stone. Stones range in colour from a bluish grey to yellow cream. Grey stones are older and more dense, qualities that allow grease to penetrate their surface more uniformly and enable finer graining. Some stones contain faults – iron salts (brown in colour), chalk marks or silicon veins – and they should be avoided if possible as they may affect the image. Choose thicker stones as they obviously have a longer life; very thin stones may crack under pressure.

LEVELLING THE STONE Before and after graining, check that the surface of the stone is level.

Place a straight edge across the stone, trapping a piece of tissue paper underneath at two or three points – it should not be possible to move the tissue without tearing. Repeat this process, testing the stone in many places and in many directions. Any depressions in the surface should be levelled by spot grinding with a levigator or small lithographic stone.

GRAINING THE STONE
1 Remove any old ink from the stone using a mixture of 5 drops carbolic acid mixed with 30 ccs. of turpentine.
2 Remove old gum arabic with warm water.
3 Saturate the stone with water and sprinkle evenly with a layer of 80s graining sand or carborundum powder.
4 When using the stone to stone method for grinding, select a stone of similar size and place printing surface to printing surface. Alternatively,

The direct printing press.

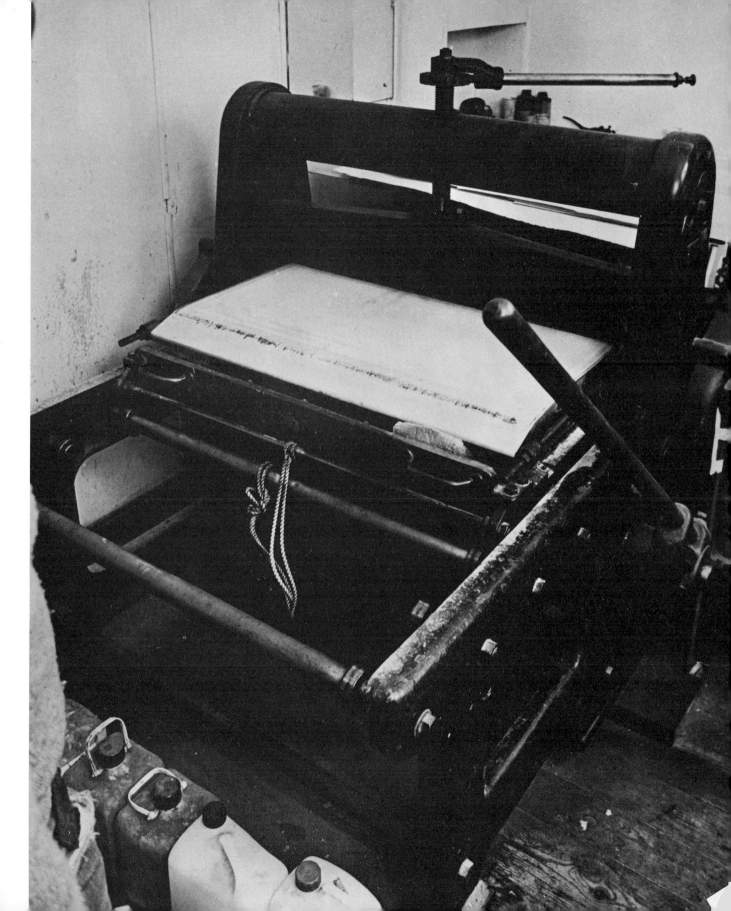

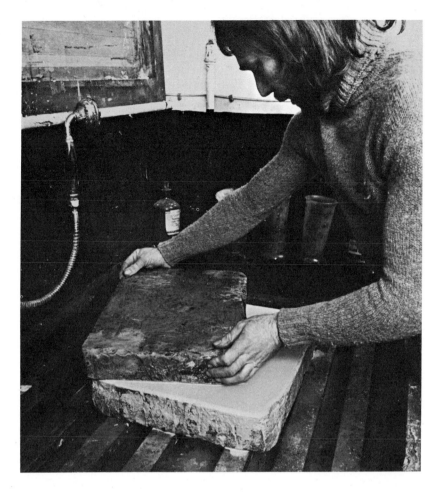

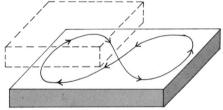

Graining the stone using the stone to stone method. Move the stone over the surface in a figure of eight pattern.

use the levigator for grinding. Move the stone or levigator over the surface in a figure of eight pattern. Continue to grind evenly, adding a little more water and abrasive if necessary as the paste thickens.

5 Wash off stones and levigator and repeat stages 3 and 4 until the old image is removed. To check that the old image is removed, soak a rag in turpentine and black ink, dampen the stone and rub the ink rag over the image. If the image area does not attract the ink then it has been completely erased and the stone is ready to proceed to the next stages. Wash off the ink with turpentine and water.

6 Making sure that no particles of coarser grade abrasive are left on the levigator or stones, proceed to a finer grade 150s and repeat the graining procedure, each procedure to be repeated two or three times.

7 Carry out the procedure using 220s sand or carborundum if a fine grain is required. Some work may require a coarser grain, in which case it will be necessary to stop at an earlier stage. At all times ensure that no coarser grits are introduced into finer grade procedures as scratching of the surface may occur and the lines will pick up ink in the printing.

8 Check again with the straight edge and tissue to make sure the surface is even and check stone thickness at various points with callipers; if the stone thickness is not even there will be a loss of pressure on the lowest points.

When using a stone rather than a levigator for grinding, the stones may stick through suction. Do not try to force the stones apart with any violent pressure as they will easily break. Try to squirt water between the two surfaces or gently prise apart with a thin blade; as soon as air is introduced between the surfaces they will part.

9 Round off the edges of the stone with a coarse file to prevent denting of the tympan, damage to rollers or ink collecting around sharp edges when printing.

10 To make sure there is no powdered limestone left in the grain, rinse the surface with 5 ccs. acetic acid diluted in 200 ccs. of water and finally rinse liberally with water, remove excess water with a squeegee and fan the stone dry. The prepared surface is now ready to take the drawing. If the stone is to be stored ensure that the surface is fully protected against dirt and grit.

Drawing on the stone

Materials used for drawing on the stone contain a high proportion of grease – pigments such as soap, carbon black and shellac.

The shellac content in litho crayons and pencils determines their grade or hardness. British and American manufactured crayons are graded from 'oo' very soft to No. 5 hard and extra hard 'copal'. (The French grading is the reverse of this.) The harder the grade the more the grain of the stone will be revealed as the wax is deposited only on the high peaks of the grain. Softer grades penetrate further into the grain, giving more solid tones. Crayons may also be used with water to give rich line work or dissolved in turpentine to make washes.

Chinagraph pencils are successful both on plate and stone and are generally useful for tracing down on acetate sheet, etc. Lead pencils register on plate but not on stone. 'H' or 'HB' grades are the most responsive. Printing ink should be applied to the plate before etching.

Oil pastels reproduce on both stone and plate giving a very rich line as the oil content is great and their softness enables the pigment to penetrate the grain.

Some felt tipped pens register both on stone and plate provided they are not of a water-based medium. However they must be encouraged to take ink from the roller before etching; use a slow but firm rolling pattern. Alternatively they may be filled with a thinned asphaltum solution, multilith intensifier or other high-grease content fluid. Lithographic pens are of the ordinary 'dip and scratch' type except that the nibs are tempered to withstand abrasive action.

Stick tusche is a drawing ink supplied in solid stick form. It must be diluted with distilled water, turpentine or a mixture of turpentine and water, alcohol, lacquer thinner, etc. Each gives a distinctive textural

Drawing on the stone:
(*top*) Detail of toothbrush spatter.
(*below*) Tusche and distilled water wash.
(*opposite*) A variety of drawing techniques have been used to create different effects.

pattern when applied to stone or plate as the grease and non-grease substances separate. The stick must first be made into liquid form by gently heating the distilled water, turpentine or mixture of both in a container and rubbing in the stick until a solution is made. Test the strength of this on the side of the stone. Various strengths may be obtained depending upon the quantities of stick ink to liquid.

Liquid tusche is obtainable from most lithographic suppliers and although it does not involve the process of melting down it has the disadvantage of not always being able to withstand the etching processes. It is sometimes less resistant to acids and more readily soluble in water after drying.

Rubbing ink is available in three grades, hard, medium and soft and may be applied directly to the stone or plate or rubbed in with the finger, rag, etc. It may also be rubbed on to a material and offset on to the stone by running through the press, thereby using the material textures. Many fine gradations of tone can be achieved by using rubbing ink either alone or in conjunction with other drawing materials. Experimentation will provide a knowledge of effects, difficulties and virtues to be drawn upon at will.

Conté crayons or chalks will not pick up on stone or plate because they do not contain grease. They are useful for making preliminary sketches directly on to stone or plate in order that ink or litho chalk may be added later. Should the conté or chalk be applied too heavily it may act as a resist for the grease-based drawing materials. This may be used as a conscious approach, otherwise care should be taken to use them lightly.

Use gum arabic as a stop-out for various areas of the drawing. Methyl violet dye may be added in order to see the gum more readily on the stone. Liquid wash work over gum must be turpentine based as distilled water-based washes dissolve the gum. There is no problem with chalk work.

A wide range of brushes may be used for drawing on the stone. Tooth brushes are effective for building up spatter effects and may be used in conjunction with paper stencils. Air brushes may be used for fine spray work. These may be used with asphaltum; if used with liquid tusche ensure that the dilution is of a fluid enough consistency and contains no lumps.

Plates are particularly sensitive to the grease in carbon paper and this may be used for producing fine line drawings by laying directly on to the plate, then laying over a sheet of paper and drawing with pencil on to the paper, thereby reproducing the drawing through the carbon on to the plate.

MATERIALS FOR ERASURE A variety of stones are available for erasing drawn areas—pumice-stone, scotch stone and snake slip. Razor blades may be used on stones to scrape down tones. These materials should be used with care as excessive use destroys the grain. Pencil erasers may be

used on plate or stone and are particularly useful for small areas. Benzine or Erasol may be used on plates and a nitric solution on stones for taking out areas (see page 56). One of the characteristic advantages of liquid erasure is that it may be applied with a brush and so may become a way of producing fluid negative line work in chosen areas.

TRANSFER PAPERS Transfer paper is lightweight and easily transported. It may be cut up and collaged together; rubbings may be taken on to its surface. Prints from transfer paper on to plate or stone print the same way they were drawn, eliminating any problems of drawing a reverse image. Where an edition is to be pulled from a difficult plate or stone a transfer may be pulled from the stone before editioning and if the image breaks down during printing, the transfer image can be put down on to a new stone.

Transfer paper has some disadvantages, however: some of the techniques available when working directly on to the stone are not possible, abrasive techniques for example. Most papers have a water soluble surface, consequently water-based washes and gum stop-outs are not possible, though acrylic paints may be substituted for gum or transfer paper cutouts may be pasted on to the surface.

German 'Everdamp' is a light ochre-coloured transfer paper; it must be stored in an airtight container.
1 Lay the paper face down on the stone or plate. Pass through the press three times with a news sheet and blotter backing.
2 Carefully check that the image has transferred well. If not, dampen the back of the transfer paper with warm water and a sponge, replace backing sheets and run through the press again two or three times.
3 Rosin and talc the image, gum etch and wipe with a soft rag.
4 Allow to dry for twenty minutes.
5 Wash out, roll up and etch as usual.

Everdamp transfer paper may also be used for transferring an image from plate to plate or stone to stone. Ensure that one-third retransfer ink to two-thirds rolling up black are used when rolling up the image to be transferred. Take a pull on to transfer paper and follow above procedure.

Charbonnel transfer paper is a white paper. Use usual turpentine washes, crayons, asphaltum, etc.
1 Lay the paper face down on the dampened plate or stone, back with news sheet and blotter and run through the press two or three times with medium pressure.
2 Remove the backing and dampen back with hot water and a sponge. Replace backing and run through the press with increased pressure three times.
3 Repeat stage 2 with no increase in pressure.
4 Gum etch and wipe down with soft cloth and allow to dry for twenty minutes.
5 Wash out, roll up and etch as usual.

INDIRECT DRAWING This is similar in method to monoprint.

1 Cover a sheet of paper in ink using a mixture of one-third retransfer ink to two-thirds rolling up black.

2 Scrape through the ink, removing it down to the paper either with a sharp instrument, or with turpentine to wipe away areas; these may print a tone.

3 Lay paper on to stone and pass through the press under medium pressure.

4 Delete or add work where necessary. Dust with french chalk and gum etch.

A similar method is to ink a sheet of heavy paper generously, lay it gently on to the plate and draw through the back as one would with carbon. Light pressure may be used with the fingers to register areas of tone. The resulting line work will have a soft furry quality. Remove the paper, french chalk the image and gum etch.

Processing the stone

In the processing of the stone the image and non-image areas are secured in their respective roles of receiving or rejecting ink. The etch releases the grease particles of the drawing ink and allows them to be absorbed on to the stone's surface. Simultaneously the undrawn areas are made more resistant to grease and more sympathetic to water.

The antipathy of grease and water.

Processing procedures require their own brushes, sponges, cotton swabs, rags and containers. These should be kept for their specific allocations since acids will be used, and harmful results may occur if materials and containers are interchanged. Cleanliness and a methodical working procedure are essential.

Before the etch is applied the drawing should be dusted first with powdered rosin and then with talc. The rosin is an acid resist and helps protect the image against the etch. French chalk helps to absorb the surface grease from the image and thus enables the etch to be laid evenly over its surface and ensures its adherence to the edges. Dust lightly with a soft cloth or cotton wool and after each application remove the excess powder from the image.

It is usual to give a plate or stone two or perhaps three etches before it is ready to withstand prolonged printing. The etches vary in strength at each stage but it is also necessary to alter their strength according to the grade of the stone, as alkali content varies. Another factor which determines etch strength is the type and strength of work on the stone and the gum acidity. It is difficult to give precise indications since there are so many variants, but with experience the etches (listed below) may be adjusted to suit varying requirements. The reactions of particular stones will also become apparent and it is advisable to mark the stones and record their behaviour for reference.

	Gum arabic	Nitric acid
Weak Etch	1 oz. (28g)	6–12 drops
Moderate etch	1 oz.	13–18 drops
Moderately strong etch	1 oz.	19–26 drops
Very strong etch	1 oz.	27–33 drops

Drawings made with hard crayons contain a minimum amount of grease and should therefore receive a weak etch applied to the drawing for two or three minutes. Water tusche washes of light tone also require weaker etches. Correspondingly stronger etches should be used as the grease content of the drawing materials is increased. Tusche washes that use turpentine as a diluting agent have a stronger grease content than water-based washes. Solid black or linear work requires only a moderately weak etch: too heavy an etch may burn through the work, weakening and reducing its richness. As most images are likely to have a combination of all these variants it is necessary to have several etch dilutions at hand before the etching procedure commences. Each should be clearly labelled, with its own swab or brush for application.

FIRST ETCH
1 Dry the image, rosin and talc the stone.
2 Using a wide brush coat the stone evenly with undiluted gum arabic solution.
3 Starting with the lighter areas apply weaker etch solution and continue adding correspondingly stronger solutions to greasier areas until the strongest etch has covered the greasiest areas of the image.

Long Barrow I by Alan Cox, published by Modern Prints, London. Six-colour lithograph. 35½ × 38 in. (90 × 71 cm.). Photo: Ewen Wannop.

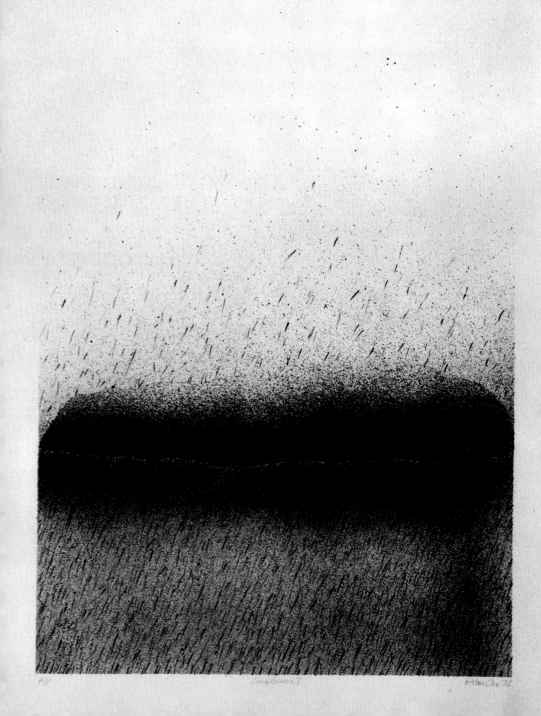

A/P Coney Billiard I Helen Cox 72

Suburban Shrub I by Ivor Abrahams, published by Bernard Jacobson, London. Eleven-colour lithograph. 32 × 24 in. (81 × 61 cm.). Photo: Derrick Witty.

4 Blot off excess solution with a sheet of newsprint and wipe down to an even thin film with a soft rag or cheesecloth. If at the end of the allotted etching time the earlier etch applications have dried, cover the whole surface with pure gum solution before blotting off, dissolving the dried areas and enabling the blotting and wiping down procedures to be carried out. It is important that the gum is wiped down to a thin film. If it is too thick globules may settle and dry on the image areas, making it impossible to wash out the drawing ink at points. Also, thick gum tends to crack on drying and the washout procedure rubs grease through the cracks and penetrates the stone, giving unwanted marks.

5 When the stone is wiped down, leave it to stand for two hours before washing out.

If the etching procedures have not been carried out on the press, position the stone centrally on the bed and butt it against a wooden block at the back edge of the bed to prevent it sliding when the bed is run through under pressure. It is essential to place linoleum or rubber matting under the stone to absorb unevenness which might break it.

Finally, before washing out, prepare the rolling up black and nap roller. With a flat push knife spread a thin band of ink across the inking slab. If the roller is under tallow, scrape this down before use. Proceed to roll out the ink, twisting the roller every two or three strokes to ensure an even distribution of ink.

WASH-OUT

1 Pour turpentine over the surface of the stone and with a soft rag wash out the drawing ink. Do not rub too hard – this could break down the gum or, because turpentine has an abrasive quality, it could erode the grease areas.

2 With a soft rag rub up the image with asphaltum solution which has a high grease content and ensures that the image is held. Rub down to a thin film and fan dry.

3 Wash the stone with a rag and water. The gum coating will be removed and the asphaltum-coated image will appear clearly.

4 Damp down and remove excess water with a sponge and proceed to roll up the image in black ink. The stone must not be swimming in water – there should be only a thin film – as an excess of water may cause scumming or water marks on the final printed image.

ROLLING UP Ink build up on the image should be gradual. The roller and ink on the slab should have a velvety look; if the ink on the slab is too thick and tacky the deposit on the stone will be too great. Roll up the image from several directions to eliminate roller marks. Before the image is fully inked it may be necessary to re-dampen the stone and recharge the roller with ink. Experience is the only way to judge when a stone is adequately inked. At first it may be necessary to proof the stone once or twice to even the ink film before the secondary etching steps. Roller marks are difficult to avoid on some images,

53

Processing the plate:
(*left*) Dust the image with rosin to protect it against the etch.
(*right*) Pour turpentine over the face of the stone and with a soft rag wash out the drawing ink.

(*opposite*) Rolling up the image in colour

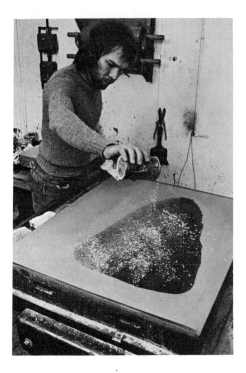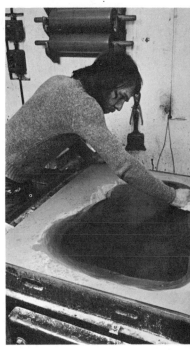

particularly hard-edge images. A technique which helps an even roll up in these circumstances is one of 'feathering'. The roller is not returned to its starting position but is rolled away from the printer towards the centre of the stone and lifted before it reaches the centre. This technique should again be carried out from several directions.

Proofing the stone

Before the image attains its correct density it may be necessary to proof in black, perhaps three or four times. It should be noted that the black image will show all tonal variations quite clearly. But the image is likely to appear different when it is printed in colour as the contrast between ink and paper is not so extreme.

1 When the image is fully inked, place the proofing paper on the stone. (News sheet is sufficient for early proofing stages.)

2 Back the proofing paper with news sheet (so the back of the print is kept clean) and cover with two sheets of blotter.

3 Lower the tympan over the paper and stone.

4 Slide in the press bed until the scraper bar is just over the edge of the stone and mark the position of the bed with a piece of tape attached to the bed and a corresponding piece on the press frame. This will eliminate any subsequent need to align the scraper with the edge of the stone.

5 Pull down the pressure lever and adjust the pressure screw until the scraper is in contact with the tympan.

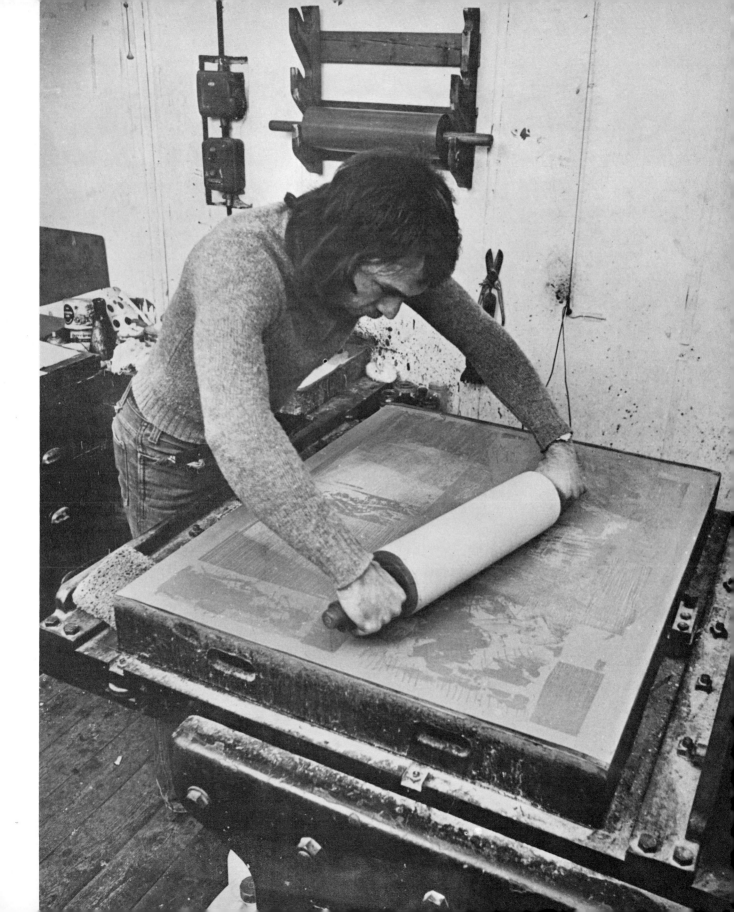

6 Release the lever and add another half to one turn. After the first impression it may be necessary to make slight adjustments to the pressure. Avoid too great a pressure as this could break the stone or squash the ink over the edges of the image and cause filling in of fine textures or tones.

7 Spread grease or tallow on to the tympan in front of the scraper and take the first pull.

8 Continue to proof the stone until the image is clear and up to strength. Each proofing should help to decide in which way the image is best rolled, how much and when ink has to be added to the slab, how often the stone has to be dampened and if the pressure is set correctly. Through these procedures a confident working system will evolve.

ADDITIONS AND DELETIONS After the first proofs have been taken it may be apparent that alterations will be necessary to the image. These should be carried out while the image is under proofing black as this has a stronger resistance to acids than colour printing inks, enabling greater control with caustic solutions and reducing the danger of immediate burning and erasure of areas, should the acid be splashed or applied where it is not wanted.

Abrasive techniques
1 Dry the stone and dust with rosin and talc.
2 Dampen the area to be deleted with a sponge and proceed to take down the area with snake slip, pumice-stone, razor blade, sandpaper or a variety of abrasive materials. Take care not to destroy the grain of the stone. Every so often, sponge down the area to assess the progress made.
3 Re-etch the area and dry after the process has been completed.

Caustic removal
1 Dry the stone and dust with rosin and talc.
2 Using strong solutions of gum arabic and nitric acid, apply these to the areas to be deleted or made lighter in tone. Some experience will be necessary in using these solutions effectively. Their action will be determined by their strength and the amount of time the solution is allowed to stand. Sponge away the solution using a fair amount of water and taking care not to spread it over other areas of the image.
3 Continue applying the solutions until the desired effects are achieved.
4 Gum up and dry down the stone.

The stone must be re-sensitized or counter etched before any additions can be made. A solution of nine parts water to one part glacial acetic acid will form the counter etch solution.
1 Dry the stone, rosin and talc.
2 Swab the solution on to areas to be re-drawn and allow it to stand for two minutes.
3 Wash thoroughly with water and fan dry.
4 Re-draw.
5 Rosin and talc the drawing.

6 Cover the stone with gum arabic, spot etch the re-drawn area, rub down and fan dry.

7 Wash out the whole image and follow roll up procedures.

8 Proof the stone.

SECOND ETCH

1 After the image has been proofed to strength recharge the image with ink and fan dry.

2 Rosin and talc.

3 Cover the stone with undiluted gum arabic.

4 Etch as described earlier.

5 Dry down the etch and leave the stone to stand for at least one hour.

PROOFING PROBLEMS AND REMEDIES

PROBLEM	POSSIBLE CAUSE	REMEDY
Image filling in or too heavy	Too much ink on image	Reduce ink on roller and work roller smartly over image picking off excess ink
	Too much varnish in ink	Stiffen ink with magnesium carbonate
	Excess pressure	Reduce pressure
Image too light	Ink too stiff	Add extender or varnish to ink
	Too little pressure	Increase pressure
	Burned image from too strong an etch	Wash out using asphaltum to strengthen image or re-sensitize and re-draw
	Hollow stone	Pack paper between leather and scraper bar to correspond with hollow areas
	Paper too hard or highly textured	Use softer paper
Streaks or bands on image	Faulty scraper bar	Replace leather and/or renovate wooden bar
	Damaged tympan	Replace tympan or temporarily use more blotter for backing sheets
	Creased backing paper	Replace backing sheets

PROBLEM	POSSIBLE CAUSE	REMEDY
Circular marks on stone and image	Incorrect graining	Re-grain
Reappearance of image in erased areas	Incorrect erasure	Erase again and spot etch
Scumming	Excess extender or varnish in ink	Add magnesium carbonate to ink or add more ink
	Grease on stone or plate	Ensure water is clean, re-gum beating stone with saturated gum sponge. If still scumming on stones, rub areas with solution of calcium carbonate and gum, re-etch. For plates, talc and clean with calcium carbonate and gum solution and gum etch
	Under etched stone or plate	Roll up, rosin and talc and re-etch
Shine on printed surface	Too much varnish in ink	Add magnesium carbonate or a matting medium to the ink
Chalky patterns on unused plates	Oxidation due to damp	If very bad, then re-grain. Otherwise, re-sensitize plate
Roller marks on image	Improper rolling	Re-roll using feathering technique
	Ink too stiff	Thin ink with varnish or magnesium carbonate and turpentine mixture
	Damaged roller	Replace or re-surface roller

Registration

In colour lithography where more than one plate or stone is used one must ensure consistent register on every print throughout the run. Since no method of registration is completely infallible, maximum care should be taken in drawing up key tracings, in the precise placement of register marks, and eventually in lowering the paper on to the printing

surface. As some wastage is inevitable, it is necessary to overrun the edition: the number of extra prints necessary will depend upon the experience of the printer.

KEY TRACINGS These are taken from the original drawing; they should include registration marks which must be transferred to the printing surface. Tracings are best made on to acetate sheet or some similar stable material, as tracing paper has a tendency to cockle and to expand and contract in certain atmospheric conditions. Dust the tracing with grease-free chalk or conté crayon, or place a piece of chalk-coated paper (available from suppliers) between the tracing and the stone like a normal carbon paper (this eliminates the dusting of the tracing), turn the tracing over and trace down on to the stone. Reversing the tracing on to the stone will ensure that the image is printed the correct way round. (This applies to direct transfer presses only.)

POWDER OFFSETS Should the key image be of such a complex nature that a tracing would be impractical, a powder image may be offset on to subsequent stones.

1 Roll the key stone in black, including registration marks and pull several proofs on smooth paper; one proof per anticipated colour plus three or four extra should they be needed.

2 When the proofs have been taken and while still wet, dust them with methyl-violet set-off powder. Lay the proof on a flat surface and pour approximately $\frac{1}{4}$ cup of powder on to the print; holding the print at each end, tilt it backwards and forwards until the powder has adhered to all the printed areas.

3 Tip off excess powder on to the next proof and repeat the process through all the proofs adding more powder as required.

4 Remove surplus powder by holding up the proofs and sharply flicking the back of the sheet or by running a little dry sand over the surface. The powdered proofs may now be stored until required for offsetting.

5 Damp the stone with a solution of 75 per cent water to 25 per cent methylated spirit and fan until almost dry.

6 Place the powdered proof centrally and face down on to the stone, add backing sheets and run once through the press under firm pressure. Lift off the offset and the powdered image will be transferred to the stone. The stone may now be drawn upon, as the powder will not interfere with the normal processing procedures. Check that registration points have been satisfactorily transferred and secure them by drawing in with tusche or by boring, according to which registration procedure is being used.

PAPER EDGE REGISTRATION The simplest form of registration is to align the edge of the paper with the edge of the stone or plate. The paper must be the exact dimensions of the stone and the stone must

(*opposite*) Laying down the sheet using pinhole registration.

The cross method of registration: cut a triangular segment from the paper in each cross.

T-line registration.

have 90° corners. Alternatively, use a printing paper of smaller dimensions than the printing surface and draw lay marks on the stone in the form of right angles conforming to the corners of the paper. The paper is then laid up to these marks. It must be noted that there will be some movement in registration using this method, particularly where deckle-edged papers are used; consequently, this system is recommended for prints which do not require precise registration or for single colour printings.

REGISTRATION CROSSES The cross method of registration is mostly used in commercial lithography where paper is often trimmed after printing. It may be used in the printing of fine prints but only if the paper is to be trimmed up to the image, as it is not aesthetically desirable to see register marks on print borders. The crosses are drawn down on to the stone or plate with litho crayon or ink, one at each end of the image, placed centrally to the image and about 1½ in. (4 cm.) away from it. The crosses are inked and printed along with the image. On the first colour impression cut a triangular segment from the paper on each cross. The paper can be laid accurately on to succeeding stones or plates as the edge of the cut out section can be aligned with the corresponding crosses on each successive stone.

T-LINE REGISTRATION This form of registration again relies on the edge of the paper. It is more accurate, however, than 'paper edge' registration methods and requires that the paper should be approximately 1½ in. (4 cm.) smaller than the plate or stone. Each sheet must first be marked on the reverse side; these marks are then aligned with corresponding marks on the printing surface. On the back of each sheet, pencil a line approximately ⅜ in. (1 cm.) long, centred each end of the paper and parallel to the sides. Cross the left-hand line with a second line to enable the printer to distinguish one end from the other. Then place a marked sheet over the image and extend the register marks from the paper on to the stone. Remove the paper and draw a vertical line across the end of the left-hand mark, forming a 'T' which coincides with the crossed line on the paper. When printing, align the marks on the paper with those on the stone. For registration of further stones make a tracing from the first or add registration marks to colour separations.

PINHOLE REGISTRATION This is probably the most accurate of registration methods as it depends on the mechanical location of hand-held wire needles into holes bored on the printing surface.

Register marks required on the first stone or plate are very fine dots drawn in with tusche, one at each end of the stone, outside the image area and of equal distance to top and bottom. When the paper is laid on the stone these marks should be set in no more than 2 in. (5 cm.) to the paper's edge to facilitate easy handling of the register pins and paper. To print the first colour, register the sheets using lay marks (see paper

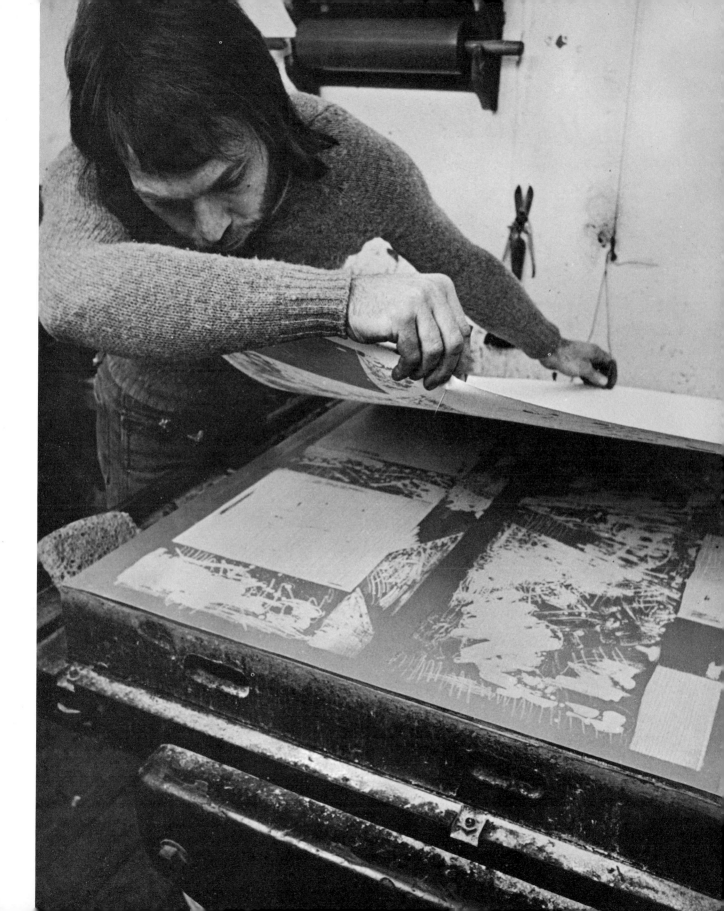

edge registration). Ensure when the image is rolled up that the registration dots are accepting ink; these will then print on the first impression. On subsequent stones or plates a hole has to be bored carefully on each registration point. In the case of stones any undue pressure or uneven movement of the awl or boring instrument could chip or flake the stone. The hole has to be only deep enough to prevent the registration pins, when engaged, from slipping out.

For the second printing the printed dots on the sheets should be punctured with the registration pins. The sheet is then turned over, the pins inserted in the holes from the back and, holding each end of the paper between first and second finger and simultaneously holding the pins between thumb and first finger, the left-hand pin is located in its registration point followed by the right-hand pin. The paper is then released and allowed to drop down the pins on to the image. Carefully remove the pins and while lightly holding the paper in position, place down the backing sheet. Continue printing in the usual way and repeat registration procedure for each subsequent colour.

It is also possible to use diagonally opposite corners of an image as registration points and for these to be pierced. In this case the paper is held corner to corner, one pin inserted on the registration point, the paper swung round and lowered on to the second corner.

Register pins may be made from sewing needles or hat pins set in balsa wood handles or into a piece of dowel.

Printing in colour

Although it is wise to plan a colour image as far as possible, the use of more than one stone or plate in hand lithography opens up many areas for experimentation. Though the image, colour and order of printing may have been decided, fresh ideas and approaches may occur through the proofing stages if the order of printing is changed. A plate originally intended as the final colour may give a more interesting effect if printed as the first. More than one colour may be used on one stone where small areas of colour are sufficiently far apart on the printing surface to allow the use of small brayers for rolling up. The use of a colour blend or rainbow roll may be an effective way of incorporating more than one colour on the printing surface. Colours are laid out on the slab in bands butting up to each other; they should not extend beyond the width of the roller. The colour is then rolled on the slab, moving the roller alternately slightly to the left and right until an even blend of colour is achieved. The blended colour is then rolled on to the image.

It may be necessary to print colours while still wet to expedite proofing within a short period. In such cases the previous printing should be dried on the sheet by dusting with anti-set-off powder, magnesium carbonate or french chalk. Dust the sheet thoroughly and remove surplus powder by gently rubbing over with a soft cloth. Finally wipe over with a humid sponge. Repeat this for each subsequent colour. If

colours are printed wet, the previous wet impression will set-off on to the plate or stone which, when rolled up, will mix on the roller with the current colour and change it. Also, if colour is persistently transferred to the printing surface in this way, it can eventually take hold and start to print with the intended image.

A good impression is not possible when printing wet on wet as an uneven and blotchy ink surface results. When printing off the edition it is wise to let the ink dry naturally, which will take six to ten hours depending upon room temperature. Lithographic inks contain a certain amount of drying agent. However, their drying time may be hastened by the addition of more drying agent, supplied in both liquid and paste form. Caution must be taken in using these agents as too much will cause the ink to dry on the slab and the roller while printing is in progress. Note the manufacturer's instructions on the particular agent being used.

Stones and plates are prepared for colour printing in the same way as for black and white but care should be taken that all processing black is removed in the wash-out and, rather than using asphaltum, a soft mixture of the colour and turpentine is used to avoid discoloration of the printing ink.

Inks

Most lithographic inks are transparent even in concentrated form. The addition of white makes colours more opaque and, of course, heightens their key. Ink manufacturers make a neutral transparent base that may be added to the colour; the amount used determines transparency and may be used to take the colour down to the lightest tint.

The consistency of ink varies from pigment to pigment or from manufacturer to manufacturer. Temperature plays a part: in warm temperatures inks become softer and if too soft may cause scumming or filling in of the image. Should this problem arise add a small amount of magnesium carbonate powder to shorten the body of the ink. Magnesium carbonate may also be added to the sponging water to help eliminate scumming. Use this only once or twice per printing and change the water and wash-out sponges as continued use will harden and solidify ink on the roller.

If the ink from the roller is almost completely released on to a part of the image in the first revolution, making roller lap marks on the image, the body of the ink is too short. The roller accepts moisture from the plate which prevents the remaining ink from being laid down (moisture blockage) and may eventually cause blisters on synthetic rollers which will not accept ink. Soften the ink by adding varnish or a small amount of vaseline.

Inks vary in permanence and this is an important consideration when purchasing stock. Manufacturers have coding systems as to the permanence of various pigments and these should be noted; obviously it is wiser to use inks that are most resistant to fading. Be wary of using

fluorescent inks; they may have many seductive qualities but they lack light fastness.

Papers

The lasting quality of the printmaker's work is largely dependent upon the quality of stock he uses. There are basically three kinds of paper available: hand-made, mould-made and machine-made.

Hand-made papers are manufactured as waterleaf or sized papers. Waterleaf is the softer and more absorbent of the two and is excellent for printing fine wash tones and delicate work. Because of its absorbent quality, it is not recommended for damping and any excess water on the surface of the stone when printing will mark its surface. Sized papers have a naturally harder surface which is excellent for coarser types of work and accidental marks are more readily erased. Hand-made papers have an irregular deckle edge, formed by the pulp seeping under the edge of the frame which contains it in the mould.

Mould-made paper is probably the most widely used. An excellent quality rag paper, it too comes as waterleaf or sized. Because of its machine manufacture it is more readily available, is cheaper and has a more uniform deckle edge and thickness.

Both hand-made and mould-made papers are available in a variety of sizes and will contain a distinguishing watermark or emblem which is formed by the weave of the mould wires in the making process.

Machine-made papers are readily available in many surfaces and sizes. However, their qualities for finished work are inferior as their construction is mainly of wood pulp or reconstituted paper and they are prone to discoloration. The best machine-made papers are wood free and are marked W.F. Machine-made papers are used mainly for proofing or as press backing sheets. Newsprint stock is the cheapest and possibly one of the most useful machine-made papers in the studio, as backing or interleaving paper, or for rough first proofs when proving a stone or plate to strength.

Japanese papers are available in heavyweights through to very lightweights and in a variety of surface textures and colours. The lightweight papers are extremely delicate and difficult to handle; they should be printed dry and used for single colour work only, as registration is difficult. Inks should not be too stiff as this will cause plucking of their surface.

Plate lithography

Metal plate lithography was developed and was in use as early as the 1890s, its advantages of lightweight manoeuvrability and cheaper cost making it commercially attractive. Zinc and aluminium plates can be re-grained in machines, several at a time. While these advantages also affect the artist, they may not be the sole reason for using plates, as plates and stones have unique qualities.

Zinc plates are an alloy of cadmium, lead and a small quantity of iron.

They are oleophilic (water repellent and receptive to grease). Acids affecting them are nitric, hydrochloric and sulphuric. Commercially, aluminium plates have replaced zinc and are cheaper to buy. They are hydrophilic (receptive to water and grease repellent) and are less sensitive to scumming problems. Acids affecting aluminium are hydrochloric and sulphuric; they are resistant to nitric.

The grain on zinc plates may be varied between 100s, 180s to 220s. Too fine a grain can cause clogging of the image and, as with stones, the grain should be chosen that is most sensitive to the type of work in hand. Graining is normally done outside the studio by commercial grainers, and because of their tendency to oxidize, plates are normally grained to order.

Before drawing upon it, it may be necessary to counter etch the plate to eliminate any spots or grease marks that may have appeared through handling or storage. The chemicals used differ, but the methods of application are the same for both aluminium and zinc. The counter etch for zinc consists of 50 parts saturated alum solution with 1 part nitric acid; or 1 part phosphoric acid with 100 parts water. Commercially made 'Prepasol' solution may be used, diluted with water (3 parts Prepasol to 1 part water).

The counter etch for aluminium is made of 1 part oxalic acid to 20 parts water; or 1 part phosphoric acid to 100 parts water.

Application of counter etch
1 Flood the plate with water and drain off excess.
2 Pour counter etch solution into centre of plate and tilt back and forth to ensure complete coverage.
3 Rinse with water and repeat as in 2.
4 Rinse thoroughly and drain.
5 Blot off excess moisture and dry immediately to prevent further oxidation.

ETCHING PLATES There are many commercially-prepared etches. They may be bought in liquid form or in gum form. However, the following solution may be made up for etching zinc:

> 16 oz. (450 g.) isopropyl alcohol
> 5½ oz. (155 g.) cellulose gum
> 7 pints (4 litres) water
> 1½ oz. (42 g.) magnesium nitrate crystals
> 1 oz. (28 g.) phosphoric acid

For etching aluminium mix 4 oz. (113 g.) phosphoric acid (85 per cent) with 1 gallon (4·5 litres) gum arabic.
First etch Dilute the solution with 50 per cent gum arabic and stir well.
1 Dust the image with talc.
2 Apply the etch solution with a wide brush, soft cloth or sponge. Keep the etch moving over the surface for approximately two to three

minutes. N.B. Light wash tones will not require so long.

3 Wipe down gum etch to thin film with a soft cloth and dry.

4 Allow to stand for approximately fifteen minutes.

5 Wash out the drawing with turpentine.

6 Cover the drawing thinly with asphaltum and fan dry.

7 Wash off the gum coating with a damp cloth.

8 Dampen the plate with a sponge and proceed to roll up image in process black.

Second etch For zinc the second etch may be stronger than the first and the solution diluted with only 25 per cent gum arabic. For aluminium the second solution is the same as the first.

1 Dry the plate and dust with french chalk.

2 Make any additions or deletions.

3 Apply the etch following steps as in the first etch.

ADDITIONS ON PLATES Additional work may be added to plates, using the appropriate counter etch solution:

1 Roll up in black and dry the plate.

2 Talc the image.

3 Counter etch the chosen area, applying with a cotton swab for approximately two minutes.

4 Wipe off with a wet sponge and fan dry.

5 Re-draw.

6 Talc the new work.

7 Etch the entire plate.

8 Wash out and roll up.

DELETIONS ON PLATES Areas may be deleted using abrasive materials as used for stone; care must be taken not to destroy the grain of the plate completely. Follow the procedure as described on page 56. Finally, etch the plate for two to three minutes.

Large areas may be deleted by applying lacquer thinner, benzine or any other solvent and giving the deleted areas a strong etch.

ACID BITING Some caustic solutions are available from manufacturers ready mixed ('Erasol' or a saturated solution of lye and water may be used). Care must be taken when handling these solutions and rubber gloves should be worn.

1 Talc the image.

2 Apply solution with cotton wool wrapped around a stick. The length of contact and the strength of these solutions will determine whether an area is taken down in tone or completely removed.

3 Flush off with water.

4 Rub over the area with a piece of felt to remove loose ink.

5 Repeat procedure if necessary.

6 Dry and talc the image.

7 Etch plate.

PHOTOGRAPHIC PLATES Photographic plates may be incorporated in work along with hand-drawn plates and most commercial platemakers will make these up from artwork supplied by the artist (see Appendix, page 134).

N.B. The image has to be reversed left to right when put down on to the plate, if it is to be printed by direct transfer press. Aluminium plates are normally used and they should be at least ·012 in. (·3 mm.) thick as thinner offset plates will tend to buckle on hand presses. Photographic plates will be completely prepared and etched at the platemaker's and before beginning printing it is only necessary to wash off the gum coating.

To store, talc the image, gum up and wash out ink with turpentine, rub up with asphaltum and dry. The light-sensitive surface on photographic plates consists of a thin film of egg albumen and ammonium bichromate and the image is transferred to the plate via negative or positive film, the plate then being exposed under arc lights and processed.

PHOTO TRANSFERS Images from newspapers and magazines may be transferred to lithographic stones or plates, provided they are recently printed copies.
1 Counter etch plate or stone.
2 Cut out and place image face down on to plate and secure with tape around the edge.
3 Brush benzine or lacquer thinner sparingly on the back of the image.
4 Carefully burnish the reverse side of the image until it is transferred.
5 Remove the cutting and rosin and talc the image.
6 Use a diluted gum solution – 50 per cent gum to 50 per cent water – and etch the image. Wipe down thinly and fan dry.
7 Wash out using asphaltum.
8 Roll up. If the image is weak apply more rosin and roll over rosined surface. Repeat until the image gains required strength.
9 Talc and etch.

Photo transfers may also be taken from halftone letterpress engraved plates by the following method.
1 Ink engraved plate using a fairly hard brayer to avoid clogging the halftone image.
2 Using a composition roller with a circumference larger than the dimensions of the engraving, roll over the engraving and transfer the image to the roller.
3 Retransfer the image by rolling on to stone or plate.
4 Rosin, talc and etch.

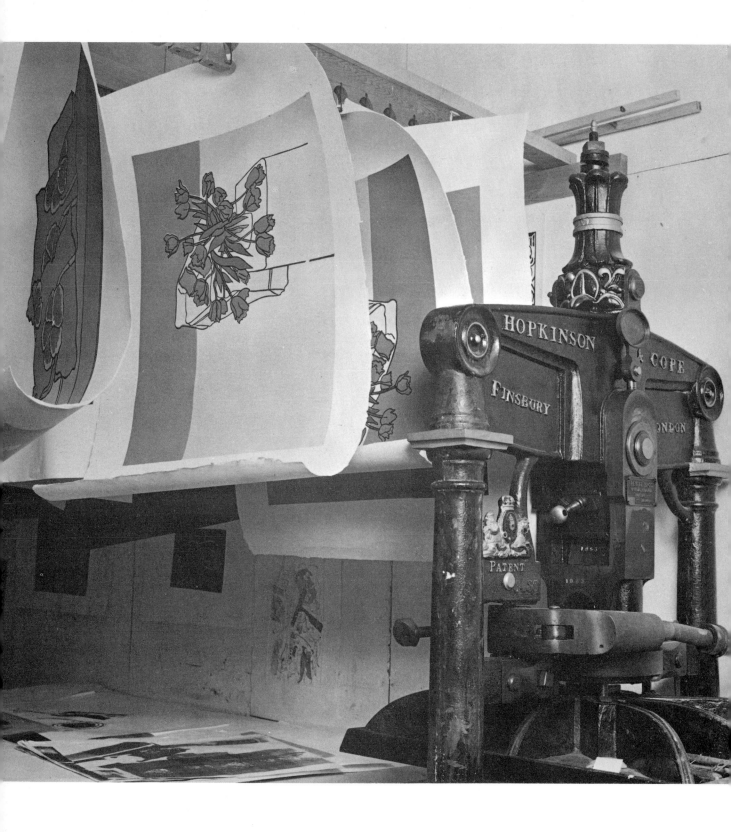

Relief Printing
by Trevor Allen

In relief printing the flat surface of a block is cut into, removing the non-printing parts of the design, so that the desired image or pattern provides a printing surface. The surface is inked with a roller and printed in a press or burnished by hand using a wooden spoon.

Wood-cutting, wood-engraving and lino-cutting (linoleum-block printing) are the established methods of making relief blocks, producing strong, direct prints. One carves into the block, changing its surface, cutting a series of disciplined lines or shapes. Today the list of methods can be extended to include etched linoleum (see page 93), cut card (see page 97), etched zinc (see page 98), and almost any 'found object'. Found objects such as scrap metal and plastic cartons, or pieces of timber whose structure has been weathered or changed by woodworm or dry rot, can produce unusual textures and qualities otherwise impossible for the artist to create.

The main difference between wood-engraving and wood-cutting is that wood-cutting is usually done on a much larger scale, and the wood used is plank wood – wood cut in the direction of the grain. The cutting is direct and energetic. For wood-engraving the end grain is used, and the hardest and best wood is boxwood. Small blocks are used, the work being fine and delicate. The woodcut finds the artist looking for, and using, the natural characteristics and textures in the block. Linoleum is flat in comparison, having no noticeable texture. It is easily cut, giving the artist greater control over the material.

Equipping the studio

Equipping and arranging a studio is a very personal matter: each individual has his or her own idea of what is required and where each item should be located. One can assume, however, that the designing and cutting work should be arranged round a large bench, while the materials for printing should be near the press and the inking bench.

There should, of course, be a sink with running water. Heat, lighting, and power points will also need to be considered. My own studio is quite small, formed into a rough square by the press, inking tables, workbench and a plan-chest. They are placed close to the walls, leaving the centre area free and uncluttered. The drying rack is positioned above a small trolley that holds tissue paper on the top shelf and cutting tools on the shelf below. The trolley can be moved to where it is needed, to the workbench when cutting blocks, or to the press, when prints need stripping with tissue.

The studio, equipped with workbenches and drying racks centred around the press. The bench on the right has a white plastic surface, ideal for mixing and rolling up inks.

THE PRESS The platen and bed are the two essential parts of the press. The sheet to be printed is placed on the block, which lies on the bed, and the platen is lowered until it comes into contact with it; the force with which the two come together causes the impression.

It is important that the bed should be movable, so that once a print is taken it can be easily removed and the block re-inked for another impression. The bed is therefore mounted on a carriage running on two rails. The carriage is driven backwards and forwards by two girths, of webbing or leather, attached to a wooden cylinder called the rounce. The rounce is located under the track and is turned by the rounce handle to move the carriage forwards or backwards.

Hinged at the end of the carriage is the tympan whose function is to keep the packing in place while running the bed under the platen.

The earliest presses were made almost entirely of wood and employed a large wooden screw, turned by the printer, which drove the platen down on to the block to be printed. In the nineteenth century the wooden presses were superseded by iron presses, such as the Stanhope press, devised by the 3rd Earl Stanhope in 1800. By 1820 the Columbian press had been introduced into England by Clymer of Philadelphia, and was closely followed by the Britannia, the Imperial and the Albion.

In the Albion press the platen is pushed up and down by means of a

The Albion.

collorn which is connected to a set of levers. Power is gained by making an inclined piece of steel, jointed like an elbow, perpendicular. This elbow-shaped piece of steel is called the chill, and when it becomes perpendicular the platen is forced down. The impression takes place at the moment the chill occupies a vertical position. In order to effect the return of the platen there is a powerful coil spring fixed at the top of the press in the spring box.

The Columbian press employs a different system of levers. The head, or crossbeam, is itself an enormous lever attached by a large bolt to one side of the frame, or staple. In its centre is a column carrying at its base the platen. To control any lateral movement there are guide plates fixed to either side of the frame, and to raise and lower the plate a hand bar is pulled across the press. This causes compensating weights and levers to dissipate the great effort that would otherwise be needed to move the main beam. The Columbian is perhaps the most ornately splendid press of the nineteenth century.

A few years ago it was possible to pick up a Victorian press from a commercial printer for its scrap value. It is now virtually impossible to get such a press because of the growing demand from schools and colleges. Print engineers are now almost the only source.

More modern proofing presses are available, but they are not cheap. Usually they take up less space than the old Albions and girl students find them easier to operate than the big, heavy Victorian presses. Though less adaptable than the platen press, the proofing press will print colour editions rapidly and with less effort.

The older type of mangle, geared, with wooden rollers, can be provided with a hardboard bed and Dexion side runners to make an efficient printing press.

Galley proof presses are used for printing type, wood-, letter-, and lino-blocks mounted on a suitable base. Presses are available in a variety of sizes and usually consist of a metal bed with a single roller that traverses back and forth. They are extremely easy to use.

The self-inking platen press, used for printing type, small wood blocks or linoleum, accurately mounted type high, can be worked by hand, treadle or power and is used where numerous prints are required (e.g. cards for an exhibition). There are many different makes; the most common in the smaller size is the Adana.

CUTTING TOOLS A knife, V tool or veiner, and the gouge are the basic tools used for cutting linoleum, wood and hardboard.

The knife is usually the first tool used when cutting begins on wood, the cutting being of a linear nature. Two types are useful: the Japanese, small-bladed, wood-cutting knife; and a mat knife or Stanley knife which has a large firm handle, used with heavy duty blades. On linoleum the V tool or veiner, which has a wide or narrow V-shaped blade, is more commonly used. Unlike the single narrow line of the knife, the V tool cuts a broad channel.

Gouges have hollow-ground blades, either flat or rounded. They vary in size and shape: large gouges are used for clearing open unwanted material, while the small gouge is used for clearing small confined spaces and to cut lines that will be broader than those produced by the knife.

Two handles are made for the V tool and the gouge – the chisel handle and the engraver's mushroom-shaped handle.

The multiple tool is a square-shaped instrument; its underside is ribbed with cutting teeth; depending on its size it will cut eight or more channels at once. The multiple tool is more generally used for wood-engraving, held fairly flat against the block. Used on linoleum it has a tendency to bury itself and cut one broad line because the material is soft, and the fine lines crumble. However, if it is held almost vertical and drawn towards the body, the lines will be scored fairly deeply.

It is most important that any cutting tool has a keen, sharp edge. Arkansas and Washita (natural stones), used with plenty of thin oil, are the best sharpeners.

To sharpen any tool takes time and practice, and the main problem is to keep the tool at a steady angle. When sharpening hollow-ground

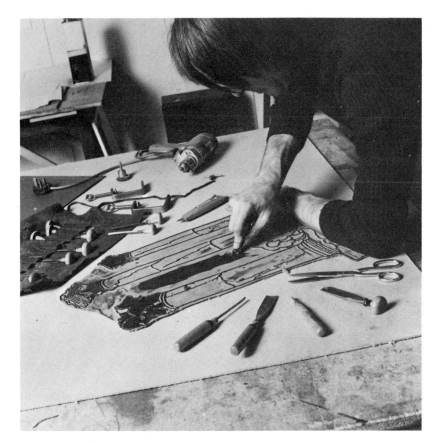

(*left*) A wide gouge can be used to remove unwanted linoleum from the proofed block. Each cutting tool must have sharp edges: use a flat stone to sharpen the edges and a slip stone to remove the burr (*above*).

gouges rotate the wrist as the tool passes along the stone, or roll the tool between the thumb and fingers so that the curve is sharpened evenly. Sharpen the V tool on both sides, holding the bevelled edge flat against the stone. Great care has to be taken where the edges meet because it is here that it has to be treated in the same way as a hollow-ground tool.

Use a slip stone to remove the burr created when sharpening the tools. The slip stone is wedge shaped. The rounded end is used flat against the inside of the hollow-ground gouge, while the other end is used against the inside edges of the V tool.

POWER TOOLS Electric power tools are now in fairly common use in colleges and studios. Whereas gouges and knives are used in a fairly disciplined way, power tools used with various attachments such as valve grinding heads, circular wire brushes and sanding discs can be used very freely, creating textures and movements that are unobtainable with hand cutting tools. The primary use of the power tool is to speed up the preparatory work.

The circular wire brush, with practice, can be used to clear away soft wood to heighten the grain. The sanding disc can be used to smooth down rough wood or metal. A jigsaw attachment is useful for trimming mounted blocks and for cutting wood or metal. There are two blades – one for metal and one for wood work. Some printmakers prefer to buy an expensive self-contained unit.

ROLLERS The ink roller is a standard part of the printer's equipment, and its function is to apply an even film of ink to the printing surface.

It is a good idea to have a selection of rollers in varying sizes, from 2×2 in. (5×5 cm.) to $10 \times 2\frac{1}{2}$ in. ($25 \cdot 5 \times 6 \cdot 5$ cm.) diameter. Very large rollers are extremely useful, but often they are too expensive for the private studio, although they are found in general use in most colleges.

The main materials used for making rollers are gelatine, rubber or polyurethane. They are either soft or hard. Hard rollers are used to ink the flat relief areas of the block, while the soft roller is used, with a little hand pressure, to ink the lower parts of the block if required.

Gelatine rollers are perhaps the oldest type in use today, and if they are well cared for compare with polyurethane ones, being equally supple and pliable. The main drawback to gelatine is its sensitivity to temperature change; if left in direct sunlight for any length of time it is likely to melt and sag, and in damp conditions it can absorb moisture and expand off its shaft. Like all rollers they should be well cleaned and stored in a cool, dry cupboard when not in use.

Rubber, the hardest of the materials, retains its true surface and is unaffected by damp or sunlight. Rubber rollers are the most appropriate for schools as they can be used with water-based inks.

Polyurethane, when new, is transparent with a highly polished

surface. Polyurethane rollers have the advantage of being supple and pliable. They can be used hard, when inking fine linear work, or soft, when a little hand pressure will cause the roller to adapt its surface to levels below the surface or to follow the contours of uneven, warped timber.

Polyurethane rollers which have been in constant use begin to soften after five years. If thumb pressure leaves an impression on the roller it is time to replace it, even though the handle and frame may still be in good order.

Care and attention will extend the life of most rollers. When in use the roller should be resting on the frame. If it is left for any time on a flat surface it will flatten and lose its shape. After use it should be stripped down (by removing the nuts and withdrawing the metal spindle) and carefully cleaned, using one of the following solvents: petrol (used only in the studio), which evaporates quickly and allows for faster colour changes when proofing; turpentine substitute, which is a lot cheaper and safer than petrol; and paraffin which is the cheapest and does not smell as strongly as the other two.

After cleaning, each part should be wiped with a clean cloth before reassembling. It is a good idea to screw a cup hook into the base of the handle so that the roller can be hung out of the way. A dusting with french chalk or talcum powder after cleaning will help preserve it.

Rubber or polyurethane rollers that have been badly neglected may be restored in a solution of caustic soda and water, mixed in a suitable plastic container (see notes on caustic etching, pages 93–4). Immerse the roller in this solution for half an hour or longer until the ink has been etched off. The frame can be cleaned in the same solution, but avoid letting the solution come into contact with the handle as this will lift the varnish. After cleaning rinse the rollers and frames thoroughly in clean water and allow to dry. When reassembling add a little oil to the nuts and spindle. Finally, dust with a little french chalk or talcum powder.

N.B. Rollers should not be treated with this corrosive cleaning method too frequently.

DRYING RACKS The cheapest method of drying prints is to use a clothesline with attached plastic pegs.

The ball rack is perhaps the most efficient. It is a single length of wood with twenty-five holes drilled to hold twenty-five glass marbles, which are held in position by L-shaped metal clips. The ball is able to move freely within the hole, but once a print has been fed into the hole the weight of the marble holds the print safely until the marble is lifted to take the dry print down.

The racks are sold in single lengths, and joined together to make a rack that will hold twenty-five large prints or fifty small prints. If they are placed back to back as they are clipped into the rack many more prints can be hung to dry. Make sure the rack is positioned against a wall, high enough to be reached, leaving a clear space below.

PRINTING INKS Both water- and oil-based inks are used in relief printing. Water-based inks are used mainly with young children, who tend to work in a happy, messy way. They are much easier to clean up, dry rapidly by evaporation and by absorption into the paper, and fairly rich colours can be printed on most of the cheaper papers. For these reasons water-based inks form a valuable part of the art class materials in schools.

Oil-based inks are widely used by professional printmakers and most art schools. Inks can be obtained from the specialist artists' materials dealer who covers a whole range of printmaking requirements and through the commercial printer's-ink manufacturer. For the amateur who is likely to use less ink it is better to order from the specialist artists' materials dealer who is likely to sell his ink in tubes. The tube inks are very economical as very little of the ink is exposed to the air. Once the ink is squeezed out, the cap must be screwed back on. Because of the vast outlets to the printing industry, commercial suppliers are usually cheaper. Their range of inks and additives is wide, and they will generally send colour books on request. These are useful because the 'trade inks' have unusual names which can be confusing.

When buying oil-based inks for relief printing from the commercial ink manufacturer the order is prefixed with the words 'letterpress inks', and the inks are supplied in kilo tins or larger.

Metallic inks are available in various shades of gold, bronze, silver and zinc. There are two forms: a fine powder and a paste. When using the powder the area to be printed is first printed with a colour that is sympathetic to the shade of metallic powder. While this colour is still tacky it is dusted with the powder. The residue is shaken or blown off.

Metallic paste is a true form of ink, and is supplied in three parts: base size, varnish and metallic paste. Mix the metallic paste with the varnish, according to the maker's instructions, until it becomes smooth and velvety. Print the base size on to the sheet and when it is almost dry overprint the metallic ink mix.

White, black (fairly stiff) and vermilion are used more frequently than any other colours. Chrome yellow, ultramarine and viridian are used frequently. Other useful inks for the studio are: lemon yellow, monastral blue, jade green, burnt umber and raw umber.

Additives are used to thin down stiff inks: transparent reducing medium, tinting medium (produced by the commercial ink manufacturer) and linseed oil, or copperplate oil (produced by the artists' materials dealer). All additives are colourless, some are opaque, and some are transparent. As well as for thinning down a stiff ink, they are also used to produce a transparent colour. When using linseed oil only a few drops should be added at a time. If too much is added to a colour it can separate away from the printing to form a stain in the paper.

To speed up drying time, a small amount of paste drier (available from the commercial ink manufacturer) may be added to a colour when mixing.

Persian Girl by Philip Sutton. Four-colour jigsawn woodcut, using oil-based letterpress inks on Japanese Hosho paper.
18 × 18 in. (46 × 46 cm.).
Photo: John Hunnex.

Strawberries on a Summer's Day by
Trevor Allen. Linoleum block print,
using oil-based letterpress inks on
Japanese Hosho paper.
24 × 22 in. (61 × 56 cm.).
Photo: John Hunnex.

PAPER Almost any paper can be used for relief prints, although the more absorbent papers give the best results. Newsprint and cartridge form the main bulk of papers used for proofing, school work and for runs of students' prints. Filter paper, made primarily for industrial filtering, has become popular with printmakers as it has many of the qualities associated with hand-made papers. It is marketed in sheets and rolls. For editioning purposes hand-made paper is preferred.

European hand-made paper is made from rag which is broken down into fibres long enough to form a sheet. After a long process of boiling and softening, a liquid white pulp is poured off into a vat. A team of men (couchers and vatmen) work round this vat dipping a wooden mould with a wire mesh base into it. Each sheet is formed by shaking the pulp contained in the mould. This is turned out on to a felt blanket to be covered by another blanket ready for the next sheet. Once a stack of paper, interleaved with blankets, is made it is put into a press to squeeze out excess moisture. The paper is then dried in a ventilated loft. Later the sheets are sized and hot pressed between highly polished plates to give a smooth surface.

Japanese papers are hand-made from fibres taken from the inner bark of certain trees. Unlike European moulds, which employ brass wire to create the mesh, Japanese moulds are constructed from bamboo and the mesh is of bamboo grasses.

Japanese Hosho is the whitest paper available. It has a flat, smooth surface and the underside is matt. The papers are made from the inner fibres of the Kozo tree and from the wood pulp from Western conifers. The Japanese also produce those splendid papers which have various grasses, seeds and coloured threads enriching the sheets.

CLEANING MATERIALS Equip the studio with a good supply of cleaning materials: turpentine substitute, paraffin, rags, paper tissues, newspaper and magazines. Turpentine substitute is cheaper in five-gallon drums. For convenience it should be transferred to a container with a tap at its base so that smaller containers may be filled with ease. To avoid loss through spillage when pouring turpentine from a five-gallon drum, place a funnel in the top of the tapped container. The full drum of turpentine is held with its opening at the 'top', for a smooth flow, and directly above the funnel.

A way of working

In this section I shall describe my own method of working on linoleum from the conception, through the proofing, to the final print and editioning. The methods I use can be easily adapted to suit individual needs.

An idea for a print may come from previous prints, drawings, sketches or magazines. From these materials an idea develops which emerges as a line drawing with attached rough colour notes. As the print develops the colours may be changed, and this gives the print continued

freshness. With a Grant projector I enlarge the line drawing on to heavy gauge tracing paper, using thick felt tip pens to give the lines some breadth. Now the cutting can begin. The linoleum should be new and supple. Old linoleum, if used cold, is likely to be the direct cause of cut hands, as the cutting tools tend to slip and skid. To avoid this I usually warm the linoleum on a hot plate.

At this stage I am only concerned with the lines that make up the image. I use the V tool, and take great care to retain the original character and freshness. When the block is finished brush it with a wide decorator's brush to remove any loose bits of linoleum. Place the block on the press to check the pressure. It may need one or more sheets of soft packing. When the pressure feels satisfactory the block can be removed for proofing, using newsprint or the back of unwanted proofs.

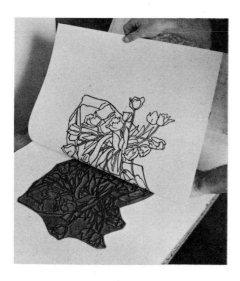

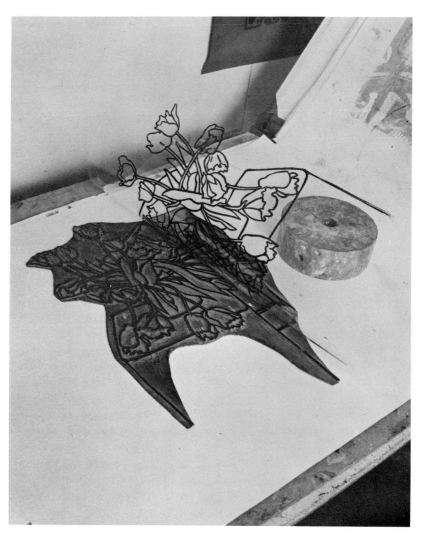

A number of proofs are taken (*above*), the last on to acetate sheet. With a weight to hold the acetate in position, the print is checked (*right*).

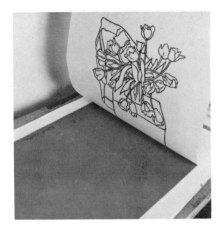 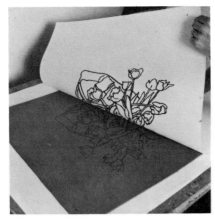

Counterproofing: place a well-inked proof face down on the uncut linoleum and pull it through the press. This process may be repeated using fresh wet proofs to make a counterproofed block for each colour. Now the cutting can begin.

At this stage there is no registration sheet, and it is only necessary to ensure that the paper is laid carefully, covering the block.

If I am happy with the image the block is re-inked, and a number of proofs are produced, re-inking each time and taking care not to over ink. The last proof is taken on to a clear sheet of acetate or heavy-duty polythene. This is dusted with french chalk, and hung in the ball rack to dry. It will be used later when registering. Clean the key block and put it aside as it will not be required for some time.

Use the proofs while the ink is wet. They should be placed conveniently near the press, together with enough blocks of linoleum, cut to approximate size, for each colour. Now 'counterproof': place a well inked proof face down on the second block and pull it through the press. The resulting transferred image should be dried and fixed with french chalk or talcum powder. Using another proof, block three is counterproofed. This process is repeated until there is a block for every colour to be used for the print.

On each block indicate where its particular colour is to be, and cut round the area with a V tool or knife. The unwanted linoleum is cleared back from the outline shape with a large gouge.

Because linoleum has a tendency to curl up, which can be a nuisance when registering or inking, mount each block on hardboard using a contact ahesive. When firm, use a power jigsaw to cut away and clean up the blocks and the hardboard mountings.

Now the print taken on to heavy-duty polythene comes into use. It is used as an overlay to position each block in register. (See also notes on registration, page 86.)

The backing, or registration sheet, is placed on a table, the printing paper is positioned on to this, and a steel edge is placed against the bottom of the paper. Move the paper up a fraction, and draw a line along the steel edge. Replace the paper on this line and weight it. Move the steel edge to the left-hand side of the paper and draw another

Use the acetate sheet to position each block in register on the backing sheet:
1 and 2 Place the key block under the acetate sheet and fix its position.
3 Mark round the block.
4 Place the second block in position under the acetate sheet.
5 Turn back the acetate and mark the position of the second block.
6 and 7 Repeat procedure for blocks three and four.

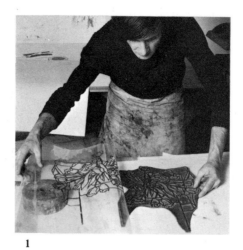

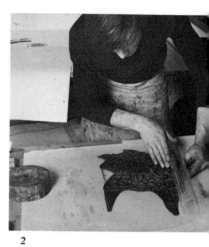

1 2

line; also indicate the top and right edges of the paper. The steel edge and paper are now put aside.

Glue card or linoleum stubs in position at right angles to each other against the drawn lines in the left-hand corner and along the bottom right side. The stubs are used to slot the paper into position and restrict further movement when printing.

The transparent overlay carrying the linear printing is now positioned by cutting it to fit against the paper stubs. The right-hand side is uncut, and extends beyond the position of the paper. It is weighted down on to a block which has been built up to raise the overlay level to the linoleum blocks. The key block is placed under the sheet, and is moved until it corresponds with the printed key image. Turn back the overlay, and using a black felt tip pen, mark round the block on to the backing sheet, having fixed its position. Remove the key block, and place the second block approximately in position. Turn down the overlay and check against the paper stubs to ensure it has not moved out of register. Check the second block and move it until it corresponds to the key image. Again, turn back the overlay, and mark the sheet around the edge of the block. To avoid confusion when printing use a different coloured pen for each block.

This procedure is repeated with each block. Finally the overlay and the built up block can be put aside. The overlay may not be used again, but in any case it is kept flat in a drawer.

PROOFING A number of prints are taken to allow the printmaker to assess and criticize his work. The culmination of his ideas and efforts are now seen in print form.

Proofing allows adjustment to be made to such errors as a block slightly out of register.

Now the prints start to come alive. Colours are selected and mixed, and with each proof the artist may choose to change the whole colour

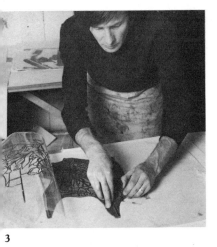

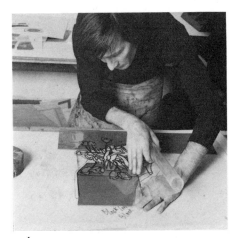

3

4

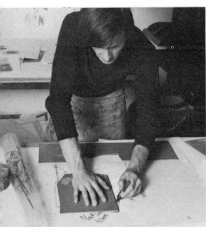

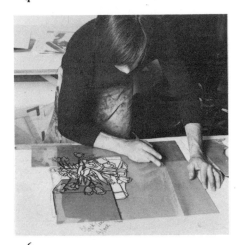

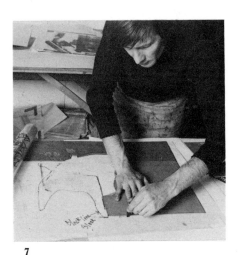

5

6

7

scheme. The order in which the blocks are to be printed is resolved. It is an advantage if a number of blocks can be printed at the same time. Not only does this speed up the printing and reduce the number of times the press has to be used, but it also helps to ensure that the pressure from the descending platen will be evenly spread.

At the end of the proofing the artist may well have a number of proofs. Each may differ in the colours used. As each proof is developed a 'colour match' should be made. This record is extremely important once a decision is made as to which print is to be editioned. If the artist has an agent he may choose to collaborate with him over the choice of a print.

KEEPING A COLOUR MATCH A record should be kept of every colour used during the proofing of each print, and the method I have evolved seems to work very well.

Once a proof is finished cut a strip of paper, 21 × 5 in. (53 × 13 cm.)

PAPER STRIP

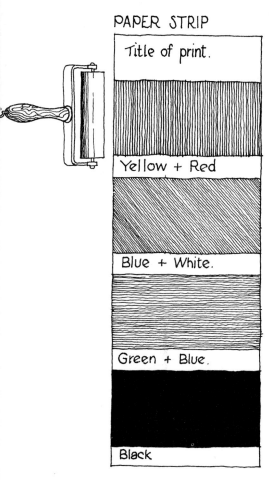

TRACING PAPER

Fold

Keeping a colour match.

(preferably the same type as that used for the proofs), and squares of tracing paper 4 × 4 in. (10 × 10 cm.). At the top of the strip write the title of the proof, then roll out each colour on to the strip; beneath each colour, list the colours that were mixed to make it. Give each colour band a number. Take a sample of each colour from the inking bench, and place it on the squared tracing paper. Fold the tracing paper in half, and fold in the two sides, two or three times. Finally fold down the top and slip on a paper clip to seal in the colour. Number the sachet to correspond with the number on the colour strip, and clip the sachet to the strip.

The colour strip is especially useful when it comes to printing the edition, as the recipe for each colour is recorded under the colour bands. The colours are selected and mixed; to check accuracy, the sachet is snipped at a corner and the sample is squeezed out. The colours can be compared by tapping a little of each on to some paper. Once the new mix is satisfactory, the sample can be repacked in a new piece of tracing paper, numbered and clipped back on the colour strip. Colours wrapped in tracing paper will keep for two or three years.

Editioning the colour print

Very few artists have the financial support of a dealer, nor can they afford to have their editions published by a professional printer, so gradually they acquire their own workshop. My first studio was in a garage, shared with a car that had not moved for years. The press was small and the conditions terrible, but it gave me a measure of independence. Of course, it is only when you print your first edition that you begin to see the problems.

The size of the edition has to be decided, how long the job will take, and if any assistance will be needed; production costs should be carefully worked out, especially if an art dealer is taking the whole edition, and is likely to pay less than the private buyer. Using a dealer has its advantages, though. Few artists have the time or inclination to be their own salesmen, and an edition of fifty or more prints takes a lot of hard selling unless the artist is very well known. The work reaches the public

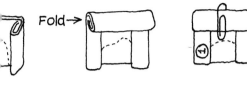

very quickly through a dealer, and payment is made to the artist a month after the edition is delivered. The returns must be enough to cover any assistance, pay for one's own time, replace stock of materials and at the end show some small profit.

With an edition larger than thirty prints it may be an advantage to spread the printing over a period of weeks, completing a small batch at a time; printing each colour in turn on all the sheets can become very boring and laborious, especially with a very long run.

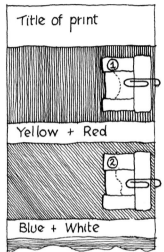

PAPER When using hand-made paper with deckled edges, the left-hand corner and part of the bottom edge will need trimming so that each sheet fits the registration stubs. Stack the sheets face down on a table close by the press ready for use.

BLOCKS Select the blocks that are going to be used for the day's printing; clean them and place them at one end of the inking bench.

PRESSWORK The top of the platen has a number of shallow troughs, and these can be used to hold weights, beeswax, wooden spoons and a number of 'card grips' (made of thin folded card). As it is impossible to have clean hands all the time the card grips are used to prevent finger marks being transferred when sheets are handled.

PACKING CHECK Place an un-inked block with the registration sheet on the bed of the press and run through to check the pressure. Usually the packing is adjusted when proofing, but it is better to check now rather than later when the block is inked up.

MIXING COLOUR Assemble the colour strip and sachet on the inking bench together with the cans of ink, according to the notes. Mix the colours and compare with the colour squeezed from the sachet; check until they correspond. Put aside the cans of ink, leaving the area clear.

POSITIONING THE PAPER I always put each sheet of paper in register before laying the blocks. Place weights at each corner on the right-hand side of the sheet. Turn it back and hold it in position with a bulldog clip against the upper right edge of the tympan.

ROLLING UP Choose rollers to correspond in size to the blocks. The block or blocks are rolled up and given an even film of ink. Then position them on the registration sheet. Release the paper from the bull-dog clip and carefully lower down on to the blocks. Remove the weights and place them on the platen. Add the packing, and lower the tympan. Run the bed under the platen, pull the lever, and take a print.

The printing of the edition has begun. As the first sheets begin to come off make direct colour comparisons with the artist's proof. Repeat this at intervals – perhaps every sixth print – and, of course,

when a colour is re-mixed. After printing hang each sheet in the ball rack to dry.

The key block is printed last.

Always check the quality of the printing before moving the sheet off the bed. Put weights at one end of the sheet to keep it in contact with the block. Using a paper grip, turn the sheet back half way; if the print is satisfactory the weights can be moved to this end of the sheet and the other half checked. If small areas of the block have failed to print this can be remedied by burnishing with a wooden spoon through the back of the sheet. A metal spoon should not be used for this work as it will absorb the heat developed by the friction of rubbing.

If the print is found to be over inked it can be 'stripped' while still in the press. Place a sheet of absorbent tissue between the print and the block and take another print. There will be a marked difference in the print as the tissue will have taken up much of the excess ink. A large area may be 'under printing', because of under inking or because more top packing should be added. Colour and depth can be improved by the addition of one or two sheets of top packing, and under printing is generally remedied in this way. Weights hold the rest of the print in contact with the block, the sheet is held clear and the block carefully re-inked. The sheet is lowered, the weights removed and a reprint taken.

At the end of each day's printing collect colour and wrap it in sachets. Clean the blocks and put them aside. Rollers are stripped down, cleaned thoroughly and reassembled. Before putting away the rollers dust them with french chalk. Finally, clean the inking bench, and put out the cans of ink and blocks that will be used next day.

When the edition is finished check it carefully. Number each print, and directly below this number write the size of the edition. The two numbers are divided by a line and are generally placed at the bottom left side of the sheet, with the title in the centre. The artist signs the print in the bottom right corner. The signature means that it is the artist's original print and also that he has approved the print.

Registration

Registration is the method used to position correctly various blocks that make up the image. Even when only one block is used registration enables the image to be placed correctly in relation to the surrounding paper margin.

Registration in relief printing is only approximate and can never be compared with the sophisticated techniques of the highly technical printing industry. In some cases the printmaker may deliberately put a block out of register to achieve a special effect – he may be overprinting this same block again, this time in register producing an optical effect.

The standard way of obtaining register is to use a backing (or registration) sheet. This is a sheet of fairly stiff paper which is larger than the blocks and the printing paper. The backing sheet carries cardboard or linoleum stubs as well as a series of lines which indicate where paper or

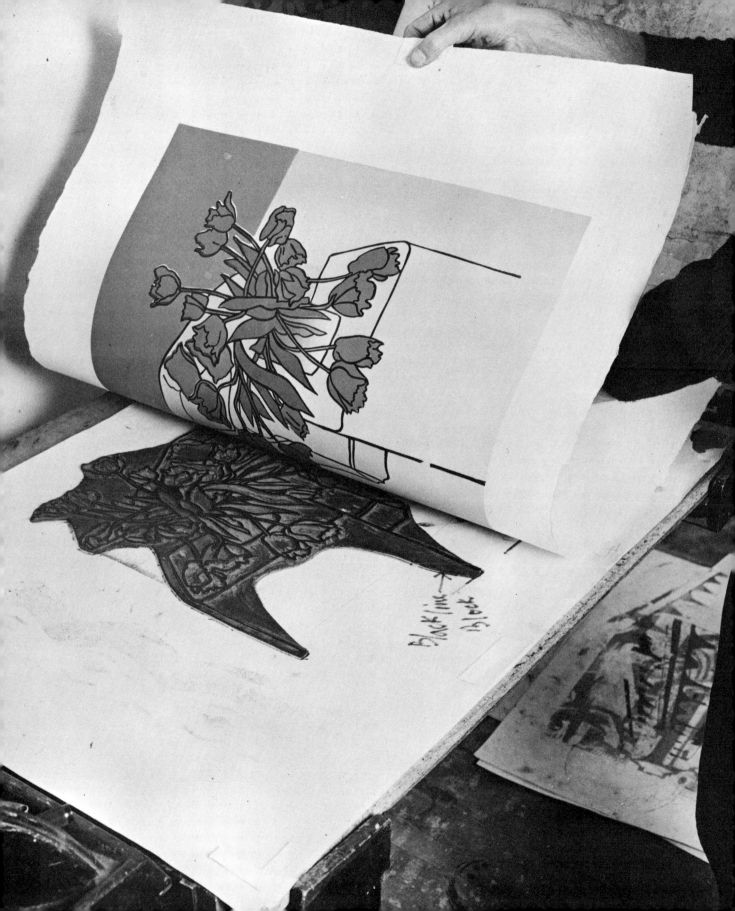

blocks are to be positioned. To ensure an accurate register the stubs should have a good straight edge, and be thinner than the block to be printed. The stubs are glued into position at right angles to each other at the bottom left-hand corner of the register sheet and along the bottom edge.

SIGHT REGISTERING In its simplest form one need only lay the edges of the paper against the edges of the block each time a print is taken. Normally in relief printing the paper is placed on top of the inked block, soft packing is added, and a print taken. However, it may be found useful to reverse the procedure, especially when card printing (see page 97). The printing paper lies face up on the registration sheet and the inked block is placed on top in alignment with the surrounding margin. After printing the block is removed and the next block is placed against the previously printed colour. This continues until the print is finished.

A simpler method is to mark the paper lightly with pencil to indicate where the blocks are to be positioned. This is useful when printing a block that forms a repeat pattern.

Printing without a press

HAND BURNISHING Many printmakers prefer to work without a press, and some materials, like the logs used by Tadek Beutlich, are too large to fit under the platen. Hand burnishing is the simplest and most direct way of taking a print, and the only tool required is a wooden spoon.

Place the printing paper face down on the inked block and rub the spoon over the back of the paper. A little beeswax rubbed into the back of the spoon will ensure a smooth, easy action. Hold the spoon with the first and second fingers pressed against the belly of the spoon, and the thumb and other fingers wrapped round the handle. The hand and arm work together to produce short movements, working carefully across the back of the paper. To tell whether a woodcut or linocut has been printed by hand turn it over; the contours of the print will appear smooth and shiny.

A new spoon can be improved by sanding down the underside of the bowl to reduce its thickness, thus allowing the printmaker a much closer and more sensitive contact with the block beneath the paper. This is particularly useful when a block has irregularities and uneven surfaces.

Tadek Beutlich invented a method for printing very large, flat areas of colour, in which a roller is attached to a wooden box. The box, approximately $2 \times 6 \times 6$ in. $(5 \times 15 \times 15$ cm.), has a hole in the centre, and through this hole the handle of the roller (unscrewed from its frame) is inserted and screwed back in position. The frame is placed directly under the box, and heavy weights are placed at each end of the box. The inked block is positioned on a strong table, the paper is laid on

Hand burnishing: ink up the block (in this case the lid of a large can), place the printing paper face down on to it and systematically rub the spoon over the back of the paper, holding it firmly in place. Carefully lift away the paper and check the image.

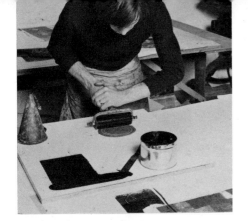

and pressed down. The roller, carrying the box of weights, is then rolled gradually backwards and forwards across the paper.

OFFSET PRINTING In the simplest terms, the first roller is used to ink up the texture (i.e. cotton waste, string, paper, wire mesh, scissors, or whatever). The second roller, which must be perfectly clean, is passed with care, once only, across the inked surface. The image that is picked up is now offset or transferred on to the sheet of paper by rolling under firm pressure. Another method is to use one roller: place the texture in position on to the sheet of paper. This time the inked roller is rolled under firm pressure across the texture. The resulting image will be a negative of the texture (see illustrations, page 90).

Offset printing is a way of working suitable for school children of most ages. It is practical and uses only rollers, paper, inks, palette knives and some cleaning materials.

After some experiment with various materials and textured surfaces, prints can be developed and, using torn or cut paper, stencils can be used to control the images. As there are no registration problems prints can be worked on quite freely.

With a group of young children I once improvised a press, using heavy wallpaper sample books. The children inked their linoleum blocks, placed paper on top of them and interleaved them in the sample books. They then jumped on the books. This was very successful—the prints were well printed and the children enjoyed the jumping!

TRANSFER METHOD This is another process suitable for schools, and it is quick and easy. Place a sheet of printing paper on a clean flat surface. Choose a colour page from a glossy colour magazine, cut it out and position it face down on the sheet of paper. Screen wash solvent is then either sprinkled or wiped over the back of the colour page with a rag. Work a soft pencil across the page as though shading the whole area. This results in the image being transferred to the sheet of paper. Sometimes the image can be transferred just by wiping the back with a rag soaked in screen solvent, but this depends on the quality of the colour magazine.

MERGING OR BLENDING COLOUR Basically this is very simple, and the same method is used as when inking up with one colour. The colours are selected and mixed, then each one is run in a horizontal band across a section of the roller. At this stage they do not come into contact with each other. Using a palette knife for each colour, spread a little on to the roller and roll out across the inking area and then return it to the horizontal reservoir to pick up more ink. Continue rolling up in the normal way, but allow the roller to travel slightly to the right and then to the left, so that the colours blend and merge, creating other shades. Care should be taken when blending the colours by this sideways movement of the roller to ensure that a strong dominating colour

1

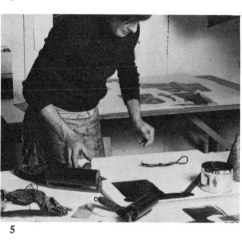

2

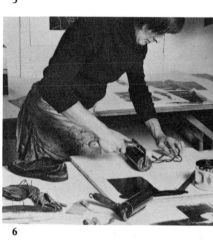

3

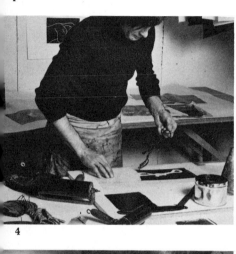

4

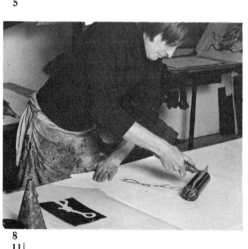

5

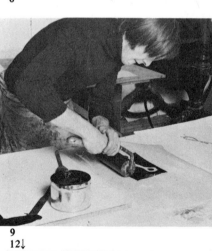

6

7
10↓

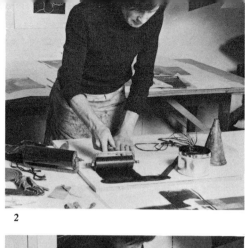

8
11↓

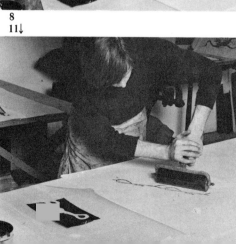

9
12↓

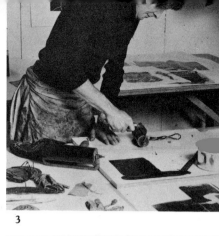

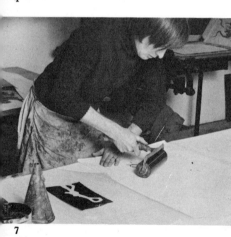

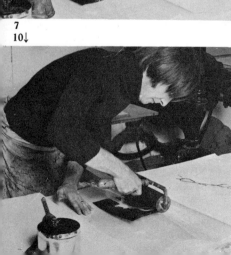

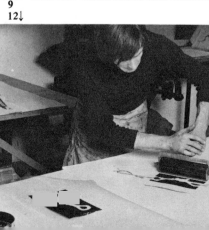

(*opposite*) Offset printing:
1 Place the ink on the slab.
2 Use one roller to carry the ink.
3 and 4 Transfer the ink to a textured surface (a piece of twine).
5 and 6 Pass the clean roller across the texture, picking up the image.
7 and 8 The image can be offset on to paper a number of times but, as the ink is offset, the image gets lighter.
9 and 10 An alternative method is to pass the clean roller across the negative image (illustration 4) and to offset it in the same way.
11 and 12 The negative and positive images can be used in combination.

(*right*) The transfer method:
1 Cut a picture from a magazine.
2 Place it face down on a sheet of paper and wipe over with screen wash solvent.
3 Work a soft pencil across the back of the image.
4 Lift away the picture to reveal the transferred image.

1

2

3

4

does not spread into the weaker colours which will then be effectively lost. Having charged the roller with ink the block can be inked or rolled up in the normal way (see illustrations, pages 92-3).

Prints produced in this way are known as Iris prints. The transitional zone which is formed is called an Iris blend.

MARBLING This method, based on the antipathy of oil and water, was once used a great deal to colour the endpapers of books. The prints give unusual, rich patterns and movement, and can be used effectively in combination with relief and screen printing. No two prints are the same, and often the print can be developed further by reprinting.

The method is simple. Oil-based inks float on water, which provides the working surface. Fill a container (for example, a large acid bath, 27×24 in. ($68 \cdot 5 \times 61$ cm.)) with about 2 in. (about 5 cm.) of water. Select the colours to be used and mix with turpentine substitute, using a separate container for each colour. A little letterpress varnish can be added at this stage to prevent colours becoming dull when dry. The colours should be fairly thin when mixed. If they are too thick they will sink to the bottom when poured on the water.

The colours are then gently poured, or dripped, on to the water, and as they spread out can be stirred with a stick or brush to create swirling shapes and movements (see illustrations, pages 94-5).

Carefully lower a sheet of paper on to the surface, leave it for a moment, then lift it off, examine it and place it on blotting paper or newsprint. More prints can be taken until the water's surface clears of ink, at which time fresh colour can be added to the container. Each print should be placed on blotting paper.

To create a more unusual effect the paper can be pressed under the water in a number of places. This will force water carrying ink to rush into the depressions, giving limited control as to where marbling will occur. To avoid printing the wrong side of the sheet hold two sheets firmly together, protecting the underside of the top print.

Another interesting effect is obtained by adding methylated spirits to the water. As contact is made with the colours they disperse violently.

As the prints dry the colours may become dull or matt. This is caused by the thinning with turpentine. It is possible to overcome this by silk screening with a clear screen ink varnish when the prints are dry.

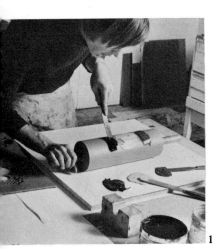
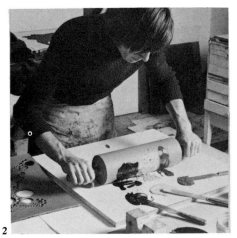

1 2

3 4

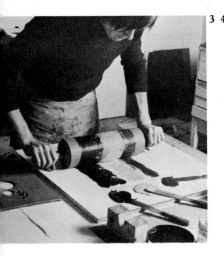
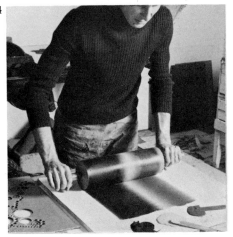

Merging or blending colour:
1 Spread a little of each selected colour on to the roller.
2 and 3 Roll out across the inking area.
4 Allow the roller to travel slightly to the right and then to the left so the colours blend and merge.
5 Now the block can be inked in the normal way.

Strawberries on a Summer's Day
(illustrated on page 78) shows the use of this technique in the sky.

Alternative methods of making relief blocks

ETCHED LINOLEUM The alkali, caustic soda (sodium hydroxide), added to water becomes an effective etching agent. It attacks some of the constituents of linoleum leaving a rough grained texture.

The depth of the bite depends on the strength of the mix, and the length of the etching. Paraffin wax (candle wax) is used to resist the soda: used hot it gives the relief printer the freedom to paint and retain his actual brush strokes. The wax can be used in several ways: by painting the image direct on to the linoleum; by painting the whole block and engraving into it with fine or coarse engraving tools thus exposing the linoleum; by flicking or splattering and so building up a pattern.

At Goldsmith's College in London we have developed two ways of etching linoleum: the localized method and the bath method.

The localized method is employed when the student wants to etch small areas of a block. One dessertspoonful of caustic soda is gradually

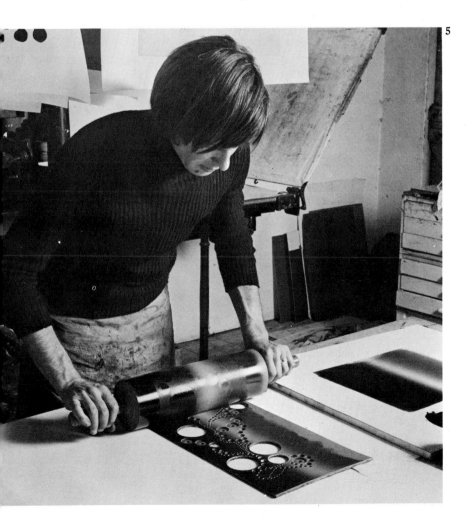

5

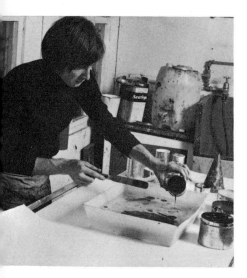

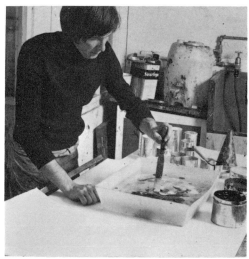

2

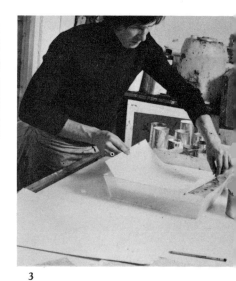

3

added to a pint (20 fl. oz.) of cold water in a polythene jug. This is stirred continuously to prevent particles of soda forming crystals at the bottom of the jug.

Allow the mix to cool (the chemical action causes it to heat up). The areas to be etched are de-greased and dried. Round the area to be etched build up Plasticine walls $\frac{1}{4}$ in. (7 mm.) high to contain the caustic mix. Slowly pour the caustic into the contained areas, taking great care not to spill any. Leave the block for two hours, although it can be checked at any time after one hour. Pour off the liquid, taking care not to move the Plasticine walls, and rinse the block under lukewarm water, using a toothbrush or nylon pastry brush to clear the etched area. Check the depth of the bite, and if it is necessary to re-etch pour more mix into the trough.

When the etching is complete remove the Plasticine walls and rinse the block, scrubbing hard to remove all etched particles. Blot it dry with blotting paper or newsprint. The block is now ready for printing.

The bath method is useful when several students are working together and large blocks can be used. A plastic or polythene acid bath, $36 \times 24 \times 4$ in. ($91 \times 61 \times 10$ cm.) is filled with cold water to a depth of 3 in. (7·5 cm.). Slowly add $\frac{1}{2}$ to $\frac{3}{4}$ lb. (300 g.) of caustic soda, stirring thoroughly; allow the mix to cool. (This mix will keep for about six weeks in a cool place.) Clean the block with scouring powder and then wipe it over with methylated spirits. Brush the hessian backing with Unibond, Marvin Medium or PVA liquid plastic mixed with water to give a complete covering and then allow it to dry. This plastic emulsion becomes hard and transparent when dry and protects the underside and edges of the block, and prevents false biting.

In a double container heat the paraffin wax and keep it very hot. Apply it with a brush to those areas that are to remain in relief. Work

Marbling:
1 Pour the colours into the bath of water.
2 As they spread out, the colours can be stirred to create swirling shapes and movements.
3 Carefully lower a sheet of paper and leave it for a moment.
4 Lift off the paper and look at the image. Each print should be placed face up on blotting paper to dry.

94

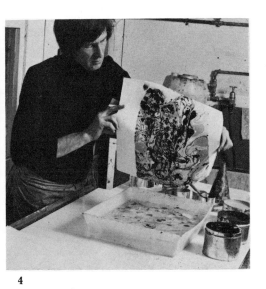

4

quickly, as the brush will only retain heated wax for a short time, and if cool wax is applied it will turn opaque and trap air between itself and the linoleum. When etching this will cause false biting as the caustic can penetrate beneath the wax to the linoleum. If the hot wax is applied at the right temperature it will sink into the block. The surface, however, cools quickly enough to retain painted brushmarks.

A shallow bite, which gives a halftone or an aquatint effect, takes about one hour to complete; a deeper bite will take four to six hours. During this time it is advisable to wash off the old, tired caustic and apply more. This must be done very carefully to avoid removing any of the wax resist. Use a soft brush and warm water. When the block is clean apply fresh caustic.

To check the depth of bite, rinse and clean a small area of the block so that it is possible to see the actual depth bitten; if it is satisfactory the whole block can be cleaned.

To clean the etched block, immerse it in a sink full of water and, using a plastic or nylon scrubbing brush, wash off the old solution. This can be done fairly vigorously. At the same time some of the wax will melt and come off. The water in the sink will probably have to be renewed several times until the block is completely clean. The remaining wax is removed by covering the block with newsprint and drawing the wax into this with a hot iron.

Inking and printing the etched block For surface printing, ink the block in the normal way, but if the etching is shallow and one wants to retain the fine aquatint that is produced, a combination of hard roller and light pressure should be used when inking. If the etching is deep and is required as part of the design, use a soft roller with increased pressure.

Finally, adjust the packing and pressure on the press, position the block on the registration sheet, lay the paper in position and take a print.

Inking the etched block for intaglio printing This method is similar to that used by S. W. Hayter: more than one colour is used and the block is printed only once. The block is etched twice, giving three different levels, each printing a different colour.

Using letterpress inks, a fairly stiff colour is stippled into the lower intaglio area with a dabber made with felt cuttings 4×6 in. (10×15 cm.) from an old etching blanket. The surrounding surface is wiped clean with a rag and then tissued. This is then rolled up using a soft hrller large enough to cover the block with one rolling under pressure. othis second colour needs a little medium copperplate oil added to it so Tat it will not lift away the first colour when applied to the block.

Finally, a third colour is rolled on to the block. This time the roller must be hard, and the ink fairly stiff. It is rolled over with little or no pressure so that only those areas in true relief carry this colour.

The block is now ready for printing. Printing paper must be dampened ready for use.

The relief press is used with the addition a soft etching blanket placed on the paper to give a soft squash to the packing.

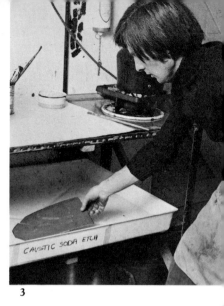

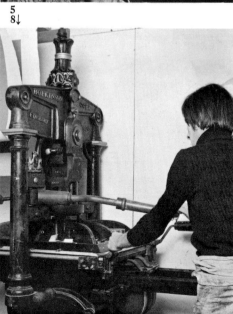

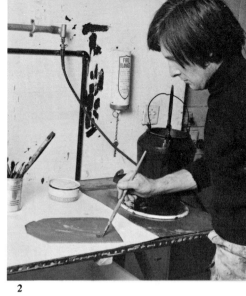

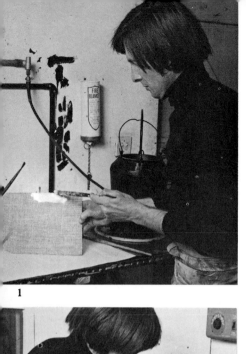

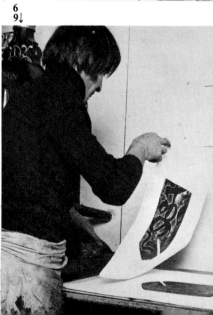

1

2

3

4
7↓

5
8↓

6
9↓

Etched linoleum (the bath method):
1 Coat the underside of the block with plastic emulsion to protect against foul biting.
2 Using hot paraffin wax, paint the positive image on to the linoleum block.
3 Place the prepared block in the etching bath.
4 and 5 Remove the block from the bath, hose it with water and scrub it to remove all traces of the etch.
6 Use a hot iron and newsprint to dry the block and remove the remaining wax.
7 and 8 Inking up the block and printing.
9 The printed image is removed from the bed of the press.

ELIMINATION METHOD This has the great advantage of using only one block of linoleum, and therefore only one set of marks need be provided to register the block throughout the whole process. The linoleum is trimmed to size and registered on to the backing sheet; it is then only necessary to indicate where the paper is to be positioned with card or linoleum stubs. The block is first printed uncut with the artist producing perhaps fifteen prints, with the identical square of plain colour.

While the prints are drying the first cuts can be made into the linoleum. A new colour is mixed, the block is inked up and printed in register over the first colour.

Place the prints in the rack to dry, clean the linoleum and cut away more material. Using another colour, re-ink the block and print it in register over the two previous colours. Repeat this procedure until the print is finished.

A design that has been worked out beforehand should be planned so that the elimination of the block is carried out in the right order: the simplest method is to draw a series of small sketches indicating the step-by-step cutting and printing stages.

Perhaps the liveliest way of using the elimination method is to work without preconceived ideas, allowing the block and prints to evolve. This gives a freshness and vitality that cannot exist when the print has been planned in advance.

THE JIGSAW PRINT At first the jigsaw print appears to have limited applications, but one has only to see the prolific output of the painter Philip Sutton to realize this is not so. The method has many clear advantages: there are no real registration problems and, unlike any other form of printing, the blocks can be turned over to print the image in reverse. The proofing stage is perhaps the most exciting as it is a simple matter to obtain a number of colour variations.

Use a sheet of close grained plywood $18 \times 20 \times \frac{1}{4}$ in. ($46 \times 50 \times 0.6$ cm.) thick. A drawing is made on to the wood and using a band saw or a hand-operated jig-saw the block is then dissected. The pieces may have to be sanded to give a slight bevel which prevents the inks touching when under pressure. Position the blocks together on a backing sheet, draw a line around the block and glue stubs to the sheet against the lines. Paper is registered in the normal way (see page 86).

Set out on the inking bench the colours to be used, mixed ready for use. Ink up the blocks, carefully position them, and take a print. Great care should be exercised when inking, as any failure in printing will be difficult to rectify once an impression is taken.

CARD PRINTS This method of printing is relatively inexpensive, and if the drawing and cutting are simple it can be very useful in schools. It has the attractions associated with jigsaw puzzles, and, indeed, when the card cuts are no longer wanted they can be used as puzzles.

The card needs no pre-treatment if it is of reasonable quality. Once a print or two have been taken the ink remains on the surface and will not sink into the card.

Any sharp knife can be used for this work, but I find a surgeon's scalpel most useful as the blade is extremely sharp with a fine, thin point. Keep the work simple to begin with: if the cutting is too complex then problems will arise that only experience can solve, and the student becomes frustrated and disheartened.

To establish the design draw directly on to the card with a fine felt tip pen (do not use a ballpoint as any mark left on the card can mix with the oil bound inks when inking).

Having established the design, the card is ready for cutting into sections, and it is advisable to have a new blade. (If a blade is at all blunt it will draw and tear through the card.) Although scalpel blades appear to be delicate they are quite sturdy and should cut cleanly through the card with very little trouble. Special care should be taken, however, when cutting curves.

The blocks are now ready for printing, and are inked and assembled on the registration sheet on the bed of the press. Place printing paper on top of the inked blocks and take a print.

Although you can see the print in its entirety there will obviously be a slight separation where the scalpel has cut through the card, and this leaves a white line between adjacent colours. This can be avoided, if one wishes, by printing the blocks separately, i.e. the first block is printed and removed, the following block is laid carefully against the previously printed area and is then printed. This is repeated with each block until the print is complete.

If this method is adopted the top packing should be placed under the registration sheet, the printing paper laid on top and each block should be positioned in turn, face down on to the paper (see registration, page 86). When employing this method there is no need to wait for each colour to dry before printing the next block; simply place the block to be printed on the paper and lay a sheet of tissue paper over previously printed areas. This will protect the wet colour.

TISSUE PAPER STENCILLING Tissue paper laid over an inked block before printing will, when printed, form a stencil. Because of its structure this stencil allows partial colour penetration on to the paper. The effect produced is similar to that of a coarse aquatint. This can be enriched by cleaning and re-inking the block with a different colour. Tissue paper is again placed between the block and the paper, and this time the effect will be 'mottled'.

The same tissue can be used a number of times while still wet, and this will produce a mixture of mottled colours.

ETCHING ZINC PLATE Zinc plate is the most commonly used metal for relief etching.

The design is painted on to the plate using an acid-resistant varnish, such as 'Straw hat' or any varnish that would normally be used in the etching process.

Once the design is complete and dry, it is etched in a solution of nitric acid and water, the time taken to complete the etching depending on the strength of the solution and the depth required, the non-printing areas being etched away.

When a sufficient depth is reached, rinse the plate and blot it dry; any excess metal can be cut away, using either a power jigsaw (with the appropriate metal-cutting blade), or tin snips.

Clean off the varnish with methylated spirits. The block can now be inked and printed in the normal way. The only difference between this method and the actual etching process is that it is the relief surface rather than the intaglio areas that carry ink, and the block is printed as a relief block.

It may be found necessary to mount the plate on to hardboard; it will then be approximately the same height as linoleum.

PHOTOGRAPHIC IMAGES Photographic engraving and etching is dealt with in the Appendix, page 134. Once the plate is made, if it is a line block the printing follows the normal relief methods. Halftone plates are difficult to print on the old platen presses, but good results are achieved when the work is carried out using the modern cylinder presses. The blocks are mounted to type high, the inking is done automatically, so the film is thin and even, and the printing pressure is light and constant.

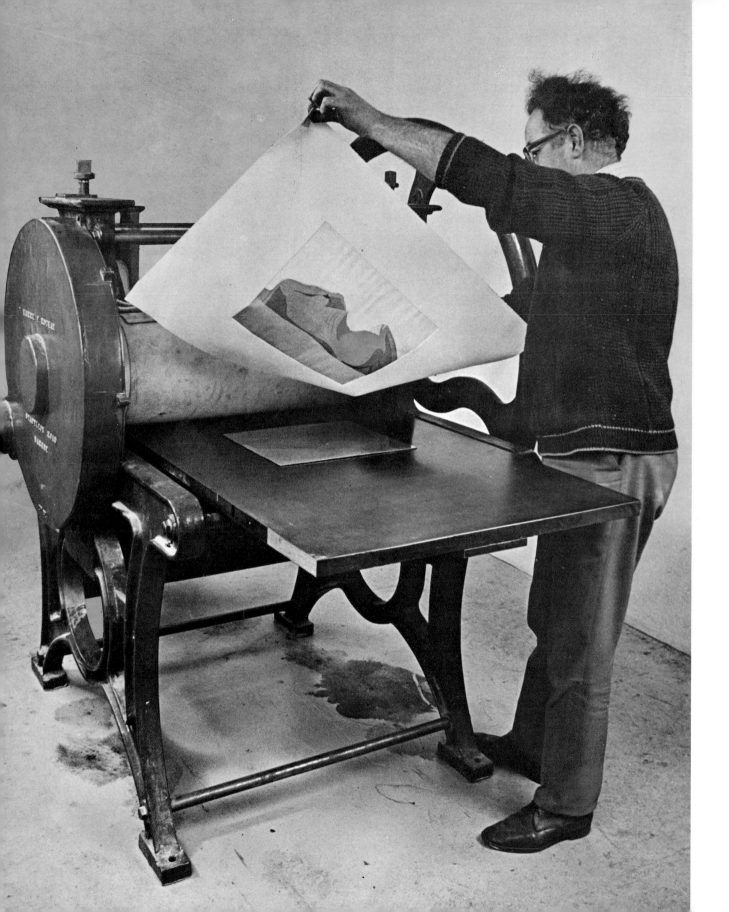

Etching and Engraving
by Jack Shirreff

ETCHING

Etching is a process that uses the reaction of acid to 'bite' selected lines or areas below the surface of a flat metal plate. This produces a second level in the plate which is known as the intaglio. The surface which has not been touched by the acid is known as the relief surface.

Prints are made from the intaglio by wiping oil-based inks over the whole surface of the plate, forcing the ink into the bitten lines. The surface is then wiped clean, the ink in the intaglio being held in place by the sides of the bitten lines or the 'tooth' or 'key' created by the small dots of aquatint. The inked-up plate is then transferred to a press and a sheet of printing paper is laid on top of the plate. The extreme pressure of the press forces the paper into the bitten lines and allows it to lift out the ink.

The intaglio print is easily recognized by the moulded shape of the paper, which exactly imitates the contours of the plate, the black lines of the image standing out in relief on the paper surface. These lines or areas have a velvety richness because of the quantity of ink which is drawn from the intaglio.

Acid is the basis of all etching. By understanding how acids react with metals, the etcher can accurately control the location, quality and depth of the mark being bitten into the plate. Acids have known reactions according to the strength and temperature of the solution used. This allows the etcher to use specific acid-resistant waxes and varnishes in order to block the reaction of the acid. The acid-resistant wax compounds are called grounds. A 'hard ground' is normally used for direct drawing and a 'soft ground' for impressing textures. The varnishes are shellac- or bitumen-based solutions which are painted on to the plate surface with a brush. This is known as 'stopping out' and is used to mask areas of the plate or to correct lines drawn through the ground, before the plate is etched. The third most commonly used acid resist is pine resin which, when ground down into a powder, can be sprinkled on to the plate surface. When heated, this resin melts without spreading, and adheres to the plate, blocking the reaction of the acid. This technique is known as 'aquatinting' and is used to produce ranges of tones from white to black.

When approaching the problem of image-making on metal, it is sometimes mistakenly assumed that there is a set formula for the order in which different techniques are used. This is not the case. The method of drawing, handling and printing plates is dependent on the artist's

personal approach. This section on etching explains as far as possible the chemical and physical nature of the metals and acids commonly used. Once these are understood, working procedures become a logical progression of events.

Acid-resistant techniques

The nature of the acid-resist material dictates the quality of the mark produced on the metal. The main elements in etching grounds are beeswax, bitumen and resin.

HARD GROUND This acid-resistant compound is hard enough to rest the hand on without marking when drawing, soft enough to 'draw' the ground off cleanly and evenly, and dark enough for the artist to see exactly what has been drawn on the plate before putting it in the acid bath. When a point is drawn through the ground it leaves a clean line of the exact width of the instrument used.

To apply a hard ground, first cut the plate to the correct size and round off the sharp edges with a file. De-grease the surface with a mixture of french chalk or whiting, a few drops of ammonia and water. It is best to make up a mixture in a plastic container to the consistency of cream. The cloth used to de-grease the plate must be clean and without trace of solvents such as turpentine or paraffin. Rub the mixture over the whole plate, then immediately wash off with water, using a clean cloth to dislodge any residue. Dry the plate with a clean sheet of blotting paper and then place on the hot plate and lightly rub over with a very clean rag to remove any residual chalk or water stains. Avoid touching the plate at this stage, as grease from the hand or fingers can cause the ground to lift or false bite.

When the plate is hot, 194° to 230°F (90° to 110° C), melt the ball of hard ground on to the plate. Using a black rubber or leather roller, about 3 in. (7.5 cm.) long, distribute the ground evenly over the whole plate. If the roller is too long, it can be difficult to even out the ground when the plate starts warping with the heat. Thin zinc plates, of 18 gauge and under, tend to distort badly when heated, especially if they are large. If the plate is too hot the roller will simply slide all over the place; if too cold the roller will pick up the ground from the plate. The ground on the plate should be the colour of milk chocolate. The general rule is the faster you roll, the lighter the ground will look, the slower the rolling up, the more ground will be deposited on the plate. When satisfied with the coating, remove the plate and place it face down in the hanging clamp. Light a bunch of a dozen tapers and move the flame systematically over the whole surface of the plate. Observe the way the ground changes from matt brown to smoky black to gloss black. Do not let the flame remain in one area too long as this will cause burning of the ground which will appear grey brown and smoky. This will also happen if the ground has been rolled on too thin. Do not allow the tapers to touch the surface of the plate as this will mark the ground.

A Nice Bit of Skirt by Colin Beckenbridge. A collage of printed matter and drawings done in different media, transferred on to process film as a line image. The line image was exposed on to a PVA photo-engraving enamel resist using a 16-gauge zinc plate. A preliminary etch established the image and then conventional etching techniques of aquatint and hard ground were used. The enamel resist stayed on throughout the process and during printing.
The printing was done by rainbowing the colours on to glass and transferring them to the plate using large, hard rollers. Selected areas in the intaglio were inked up before the colour was rolled on to the plate.
19 × 23 in. (48 × 58 cm.). Photo: Ewen Wannop.

(*below*) Place the plate face down in the hanging clamp and move the flame systematically over the whole surface.

A nice bit of skirt: ...t the explored pilgrims. Report by ... photograph by Peter Saunders. **Page 26**

THE SUNDAY TIMES *magazine*

Going, Going, Gone!

A nice bit of skirt: a look at this year's long cool skirts by Meriel McCooey; photographs by Eva Sereny. **Page 36**

Dressed to chill: salads for the summer season by Margaret ... illustration by Alan Cracknell. **Page 38**

THE SUNDAY TIMES, NOVEMBER 5 1972

Untitled etching by Roger Deakins. A conventional photographic image was transferred on to line film and exposed on to a 16-gauge zinc plate using a PVA enamel resist. The unusual depth of the image was achieved by etching the plate to different levels, the deepest almost biting through the plate.
12 × 15 in. (31 × 37 cm.). Photo: Derrick Witty.

The reason for smoking the ground is that originally most plates were of copper and, before smoking, hard ground is only slightly darker than the metal, making it very difficult to see what has been drawn. With zinc the drawing is easier to see, but it is always advisable to smoke a hard ground as this will show up any defects very clearly. Smoking the plate also evens out the texture left from the rolling up. After the plate has cooled, it is ready to draw on.

In intaglio printing, as in direct litho, the image must be drawn in reverse so that when printed it will appear the right way round. To transfer an image on to hard ground, therefore, draw the image the right size on a piece of cartridge paper with a soft pencil. Dip this paper into the paper bath allowing only the back to get wet, or damp it with a wet sponge. Place the front of the drawing on some blotting paper and absorb the surplus water from the back. Place the drawing face down on the plate and run this through the press. When the cartridge paper is taken off, the pencil lines will show clearly on the black surface of the ground. Using this as the guideline, expose the metal by drawing into the ground.

SOFT GROUND This acid resist is pressure sensitive. It will show the texture of any material that is pressed into it: crumpled paper, glass fibre matting, plumbers' hemp and lace. The ingredients are the same as for hard ground but tallow, oil or grease are added to stop the ground from setting hard when it cools. Apply in the same way as hard ground, making sure that the temperature of the hot plate is 104° to 122°F (40° to 50°C) and that a different roller is used for rolling up. (Always have two rollers marked 'hard' and 'soft' near the hot plate. If either is used for the wrong ground, it must be completely cleaned and the plate redone.) Apply soft ground only when ready to be worked on, otherwise it will harden. A soft ground rolled on to zinc should be light gold in colour. If the plate looks yellow, the texture is likely to be obscured by false biting. Once the ground has been rolled on the plate, place the pieces of material on the surface of the plate. Avoid moving them once placed as this will mark the ground. Lay the plate on the press and cover with wax paper and a sheet of blotting paper to absorb any undue pressure and to protect the blanket. Reduce the pressure of the press to the point where little effort is needed to turn the handle but the bed moves through without slipping. Oversize objects should not be put through the press as they will cut the blankets. On removal from the press the materials must be lifted from the plate very carefully. Paint out with acid-resist varnish as close to the image as possible to prevent false biting of the non-image areas.

To imitate a pencil or crayon line draw through paper on to a soft ground. The pressure of the pencil lifts the ground on to the paper. Lay the soft ground as described above and, when cool, place a piece of paper over the plate. The paper can be as thin as tissue paper or up to about 72 lb. (155 gsm.) in weight. The thinner the paper, the finer the line; the thicker the paper, the broader the line. Place the design made

105

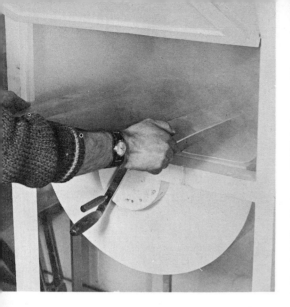
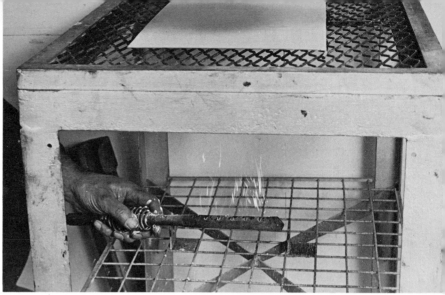

on thin translucent paper, face down on the paper (the image will appear back to front) and tape to the top of the bench. Trace over the image, applying pressure to the pencil to force the paper in contact with the plate, thus lifting off the soft ground. As the drawing progresses, check the plate to see if enough pressure is being used. The quality of the line can be altered by the hardness or softness of the pencil used. Hard will produce a sharp line and soft a crumbly line. The quality of line can be altered in the acid. The deeper the etch, the darker and coarser the line.

STOP-OUT VARNISHES Most etching varnishes consist of shellac and other resins in a volatile solvent, such as methylated spirit. They are applied to the plate in a thin film by means of a brush or by splattering techniques with a toothbrush. Etching varnishes are called 'stop-outs': when painted on to a plate they quickly harden and block or stop the action of the acid. Their main purpose is to cover non-image areas of soft grounds and the back and sides of plates and to delete wrong lines drawn into hard grounds. When using progressive bite techniques, acid-resistant stop-out is applied to the dried plate to allow the remainder of the plate to continue etching.

Varnishes should be applied in a thin film to allow the solvent to evaporate quickly. If left in an open container the stop-out will become more viscous and it is then useful for making hard-edge lines by masking with tape (strip the tape off before the varnish dries to prevent the edges from cracking).

Not all varnishes have the same degree of resistance to acid. A careful watch should be kept during etching. Stop-outs are soluble in methylated spirits and wax grounds in turpentine, paraffin or benzine. Aquatints are also soluble in methylated spirits so any mistakes made in stopping-out will mean re-laying a fresh tint. A bitumen or asphaltum varnish can be used. This is soluble in benzol (one part bitumen to

(*left*) Applying a rosin aquatint using an aquatint box. The rosin is agitated to form a cloud of dust in the chimney of the box. Place the plate in the centre of the box and close the lid. Do not jolt the box or large lumps may fall on to the plate.

(*right*) Melting the aquatint with a gas poker. Hold the flame well below the plate. When the tint melts, it adheres to the surface to the plate and appears transparent.

(*opposite*) Progressive enlargements of a textured (reticulated) tint showing the wide variety of shapes made by the tint.

five parts benzol). It is advisable to make this mixture and leave it for a day before use. (The container must be well sealed.)

AQUATINT This rosin powder which protects the metal from the reaction of the acid is used to create the effect of a flat tone, texture or wash. The aquatint box is used to lay the powder on the plate or it may be applied through a fine mesh or sprinkled on by hand. The purpose of the rosin is to protect very small areas of the metal from being etched. The network of exposed metal between the grains of rosin is exposed to the reaction of the acid and can therefore be etched to varying depths. The deeper the metal is etched the greater the volume of ink held in the intaglio and the darker the tone of the printed image.

Without an aquatint open areas in zinc and copper etch down flat, printing as a pale grey, however deep the etch. By using an aquatint varying amounts of ink can be held in the intaglio by the 'tooth' created by the acid-resistant grain of rosin.

Aquatint box techniques De-grease the plate as for hard ground. Dry the plate and allow it to cool. Place it on a sheet of black card with a 4 in. (10 cm.) margin all round. This stops the edge of the plate having a lighter tint than the centre because of updraught in the box, and the density of the tint will show up against the black colour of the card. Turn the handle of the rosin box vigorously to disperse the grain in fine suspension in the chimney of the aquatint box. Allow the larger grains to settle and then place the plate and card in the box. The amount of tint that falls on the plate is directly related to the amount of rosin or bitumen and the time that the plate is left in the box. Take the plate from the box carefully and place on the burning-in stand. Do not disturb the dust: any draught or heavy breathing will snowball the rosin powder, leaving 'runs' over the plate. (If this happens, start again.) Heat up the plate evenly on the stand with a gas poker or bunsen before trying to melt the rosin. As soon as one part of the rosin turns transparent, move the flame on. Bitumen turns black when melted. When all the tint has melted, remove the plate from the heat. It is difficult to see a rosin tint, so check with a magnifying glass, angling the plate to the light to see if the tint is dense enough and evenly distributed over the plate. If the tint is too light, apply some more and melt it as described above.

For a fine tint, wait until the larger grains have settled and then place the plate in the box two or three times until it has a fine, even layer of dust (check with the magnifying glass).

A medium tint needs only one application. Make sure that there is enough aquatint in the box, turn the handle and place the plate in the box when there is still the appearance of a moderate cloud of aquatint. Take it out when the black card looks light grey.

For a reticulated tint, proceed as for the medium tint, placing the plate in the box a second or third time until it is almost completely covered with aquatint with nothing more than fine worm casts meandering through the surface where the metal is still exposed.

Pepperpot tint.

For textured or pepper-pot tints, sprinkle the aquatint over the plate using a fine mesh gauze as illustrated. Larger particles left in the mesh can be sprinkled on by hand. Melt in the normal way until the required texture is obtained. For controlled use of tints, place aquatint or bitumen in a small jam jar (the pepper-pot) and cover the mouth with a nylon stocking secured to the lip with an elastic band. Sprinkle on to the plate – if the deposit is too heavy fold over another layer of nylon until the right deposit is obtained. Variations are achieved by covering the mouth of the jar with different meshes.

The sugar-lift tint is a positive method of working aquatint. In other words, those areas where the sugar solution is painted come out black or grey, depending on the duration of etch. First lay the aquatint on the plate as before and melt it. Then stir sugar into indian ink until it becomes saturated. This solution should be runny enough to paint with but it should become tacky when it starts to dry. Test with the fingers before starting. With a brush, paint the solution on to the plate. This does not affect the aquatint as it is insoluble in water – but do not scratch the tint or it will come off. Use the brush to make marks from thin lines to broad areas of wash or stipple. After applying the sugar solution, use a large brush to cover the plate quickly with a thin layer of stop-out varnish. This dries almost immediately. Place the plate in a bath of warm water. Brush gently with cotton wool or an aetspinsel mop and in a few minutes the sugar will absorb the moisture, start swelling, and break the skin of the varnish. Help this process along until all varnish on the image areas has been lifted and only the aquatinted metal is showing. Etch in the usual way from light to dark as for normal aquatint progressive bites or use the aetspinsel mop to brush a strong solution of acid on to particular areas of the plate (see brush tinting, page 116).

The plates

For etching plates it is advisable to get metal from a merchant who supplies the printing trade. The quality is assured and it will arrive well packed, without the surface being scratched. These firms supply metal with an acid-resistant (grey back) backing which stays on throughout the etching process, thereby saving a lot of time and inconvenience. It is best to buy metal in one gauge to avoid having to alter the pressure of the press every time a thinner or thicker plate is printed. The standard wire gauge (SWG) specifies the thickness of the plate: 16 gauge $= \frac{1}{16}$ in. (1·5 mm.); 18 gauge $= \frac{3}{64}$ in. (1·2 mm.); 20 gauge $= \frac{1}{32}$ in. (0·8 mm.). The most useful gauge for handling and stability is 16. Zinc and copper are bought in sheet sizes: zinc 40 × 20 in. (101·5 × 51 cm.) or 34 × 24 in. (86·5 × 61 cm.); copper 28 × 22 in. (71 × 56 cm.).

Etching is a chemical process and therefore obeys certain natural laws. It is most important to choose the right metal for the job. In most cases, the choice is a matter of expediency, but if the quality and characteristics of the metal are known, many pitfalls can be avoided.

ZINC This is the most common metal used in printing today. Pure zinc is chemically passive. The metal used for crude etch purposes, where no degree of stability or exact definition is required, consists of about 95 per cent zinc, with cadmium and smaller amounts of lead and iron. A 99 per cent zinc plate is required where the fine grain of the metal, evenness of etch quality and durability are needed. These plates are mainly used for photo-engraving and other commercial platemaking processes with a defined limit of an 80 screen image (that is, a halftone image of 80 lines to the inch). For intaglio, a 120 screen image is possible but the depth of bite is limited before the shadow dot breaks down. Ordinary commercial zinc plate has a closely packed hexagonal crystal structure with a grain size the diameter of the highlight dot of a 120 screen. Owing to the large size of the crystal structure, the sides of the lines or dots are liable to etch roughly. Zinc is attacked by dilute hydrochloric and nitric acid; its melting point is from 778° to 812°F (419° to 433°C). Care must be taken, as zinc is considerably softer than copper and also more prone to corrosion. Only use acid free tissue paper to protect the surface of the plate.

COPPER This metal is both malleable and ductile, having a high conductivity of heat and electricity. It has a fine crystalline structure, four times finer than zinc, so that very small dots can be etched for relief and very fine cells etched into the surface. It is very hydrophobic and has a great affinity for printing ink. Copper resists most forms of corrosion, being unaffected by dry or moist air, providing it is free from carbon dioxide or acid fumes. It is the obvious choice for work with fine detail and good definition. The melting point of copper is 1982°F (1083°C).

BLACK MILD STEEL Used rarely by printmakers, this metal contains carbon, manganese, silicon, sulphur and phosphorus. As the sheet is not made for printing purposes, the surface is not as fine as the other metals. Steel has a soft grey colour when printed, and this can be used well by burnishing down for the white areas. Another useful quality of steel is that when open areas are etched, the resulting surface is uneven, giving a natural aquatint, or tooth to the metal. Steel reacts with strong solutions of nitric and hydrochloric acid, it oxidizes readily and should be covered in grease if left for any length of time.

ALUMINIUM Used mainly for fabrication work, this is a soft metal which marks easily and can be used for direct drawn work and etched images. It etches very slowly in diluted hydrochloric acid, but vigorously when the mordant is warmed up, releasing hydrogen gas. Aluminium reacts with sodium hydroxide, precipitating an alkali metal aluminate which will make the bath cloudy. It melts at a temperature of 1220°F (660°C).

Acids
There is a common belief that after the plate is drawn, nothing further

can go wrong. But an image is made or ruined by the action of the mordants. Whether a particular metal reacts with an acid depends primarily on the chemical activity of the metal but also on the acid.

NITRIC ACID This is a common mineral acid which, unlike hydrochloric, is a powerful oxidizing agent. The rate of etch is proportional to the concentration of acid. Zinc dissolves in a 10 per cent solution (1 in 10) of 36 Bé nitric to a depth of about 0·025 of an inch per hour. Therefore etching time is nearly doubled by using a 5 per cent solution (1 in 20). With solutions under 5 per cent no gas is evolved and ammonium and zinc nitrate are formed. For plates with aquatint and fine line work a solution of one part nitric to sixteen parts water tends to give the most accurate bite.

The rate of etching increases proportionally with temperature rise. A bath of 100°F (38°C) etches twice as fast as a bath of 50°F (10°C). At concentrations of one to five and under, a lot of heat is produced, especially if there are large open areas. The heat evolved during the etch will break down a soft ground and false bite in a hard ground.

The initial reaction to the acid is for the metal to become a soluble salt and for hydrogen to be evolved. This hydrogen is extremely active as a reducing agent, working with the acid itself to form most of the oxides of nitrogen, ammonia and hydroxylamine, which are given off as a gas. With high concentrations, harmful nitrogen tetroxide is given off.

Accidental splashing with nitric acid should be treated by washing immediately with water and then applying a saturated solution of sodium bicarbonate.

HYDROCHLORIC ACID This is a colourless acid of the halogen group. Commercial concentrated acid contains about 28 per cent of HCl by weight. In general, acids except nitric react with metals to form a metallic salt and evolve hydrogen gas. This evolution of gas is a hindrance to the printmaker, causing a rough etch and necessitating a fume cupboard. Hydrochloric acid can be used for zinc, producing a coarse bite, but it has little effect on copper, except when the mordant is warmed up. A more convenient and non volatile 'acid' for copper is Dutch mordant.

DUTCH MORDANT Made from a mixture of potassium chlorate, hydrochloric acid and water, this 'acid' is light blue in colour and smells strongly of over-chlorinated swimming pools. It is chemically an acid salt of hydrochloric, similar in reaction to ferric chloride. It produces a clean and accurate bite either face up or face down in the bath. It is very suitable for the finest aquatints and halftone plates. Various solutions of this bath can be made to etch fast or slow. The recipe for an average strength bath is known as Buckland Wright's bath: twenty parts hydrochloric acid (HCl), four parts potassium chlorate ($KClO_3$), eighty parts water (H_2O) (parts by volume). Dissolve four

parts of the potassium chlorate in ten parts water. Heat until dissolved. Pour seventy parts water into the acid dish and add hydrochloric acid. Stir the melted salts and pour into the acid dish. Quickly stir the mixture. On contact, chlorine gas is given off, a brown-green, pungent and poisonous gas which must not be inhaled. After a few minutes, the acid salt is formed and the bath is ready for use.

FERRIC CHLORIDE This yellow-brown, semi-opaque liquid is not strictly an acid. It is similar in action to Dutch mordant. Hydrochloric acid has little effect on copper and it is surprising therefore that the salt of this acid acts more vigorously than the acid itself. This is a much underrated acid, little used by colleges and printmakers but used a great deal in industry. It etches copper and zinc, forming a line of good definition with little lateral etch. Normally it is used with the plate face down in the bath to allow the residual material from the reaction to fall to the bottom. The reason it is not more widely used is that it is easily oxidized by the air, producing a dark heavy sludge which is ferric hydroxide. This can be removed by filtering, or repressed by the addition of a small quantity of hydrochloric acid ($Fe(OH)_3 + 3HCl = FeCl_3 + H_2O$, forming ferric chloride and water). It is normally sold in either yellowish-brown deliquescent lumps or as a solution registering 45° Baumé. Ferric chloride forms a viscous solution, and increase in concentration tends to retard the action since raising the viscosity restrains the movement of the components. The average concentration for use is approximately 40° Bé and by the addition of more water the strongest concentration of 35° Bé is reached. After this point the acid starts decreasing in strength. As with all chemical reactions, raising the temperature accelerates the rate of reaction. At temperatures under 60°F (15°C) ferric chloride has little effect as a mordant for copper and zinc.

Acid preparation

Acids are extremely dangerous substances and great care must be taken when making solutions for etching. Most important: *always add acid to water, never add water to acid*. Never mix the solution in a bottle: the heat generated by the reaction in a confined space could cause the bottle to explode. Dishes suitable for all conventional acids used in etching are plastic, ceramic or stainless steel.

Copper and zinc must be etched in separate baths. Newly-made acid solutions etch very harshly so it is common practice to add a proportion of the old bath to the new solution. If this is not possible, then odd pieces of zinc and copper should be added to their respective baths at least fifteen minutes before etching the plate. When etching a plate in a bath that has been used for several days add a small proportion of fresh acid to bring it up to the correct strength. Acid reacts proportionally faster as temperature increases. Besides raising the temperature of the bath by hot water or a thermostatically controlled photographic hot plate, many plates etching in the same bath or plates with large areas

Etch characteristics:
A nitric acid
B Dutch mordant of ferric chloride
C crevés are formed when the acid undercuts lines drawn very close together, causing the ground to lift and leaving open areas in the metal which then print grey.

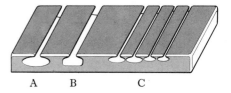

A B C

METAL	ACID	STRENGTH	SPEED	METHOD	REACTION	COMMENT
ZINC	Nitric (HNO_3)	1–10	Fast	Face up in bath. Keep bubbles away from surface of etch	Nitrogen tetroxide produced. A brown gas. Harmful to lungs	Good for open bite techniques. Severe lateral etch. Wax grounds liable to false bite
		1–16	Average	Constantly brush surface to get an even bite	Oxides of nitrogen released	Useful bite for most work
		1–20	Slow	Face up. No bubbles formed with dilutions under 5%	Zinc + ammonium nitrate only	Baths under 5% useful for de-scumming photo plates
	Hydrochloric (HCl)	1–4	Fast	Still bath, face up	Rapid release of hydrogen	Fume cupboard needed. Rough bite. Weaker dilutions not very useful
	Ferric Chloride ($FeCl_3$)	33 Bé	Fast	Face down. Still bath with agitation	No gas. Dark viscous deposit of ferric hydroxide	Easily oxidized by the air. Strengths above or below 33 Bé
		35 Bé	Fast	As above	Zinc is a strongly electro-positive metal and will displace many other metals from aqueous solutions of their salts	Useful strength for deep etch without fear of resists lifting. Repress formation of hydroxide by adding small amounts HCl. For all strengths. Very slow below temps of 60 °F (15 °C)
		45 Bé	Slow	As above		
	Dutch mordant	Not suitable gas evolved				
COPPER	Nitric (HNO_3)	1–4 / 1–2	Average / Fast	Face up	Bubbles form on surface of etch. Oxides of nitrogen evolved	Similar bite to that of zinc. Bite starts at boundaries of metal crystals – 4 times finer bite than zinc
	Dutch mordant					
	Buckland Wright's bath 20 parts hydrochloric acid (HCl) 4 parts potassium chlorate ($KClO_3$) 80 parts water (H_2O)	Average	Average	Face up or face down. Brush lightly to remove residue	Chlorine + chlorine dioxide evolved at start of reaction. No bubbles during etching	Accurate bite. Suitable for the finest aquatints. Lines darken during etching. If lines stay shiny and bright remove from bath and re-work with the needle
	Frank Short's bath 10 parts hydrochloric acid 2 parts potassium chlorate 88 parts water		Slow	Face up		Very slow but extremely accurate. Lines will take several hours to bite

METAL	ACID	STRENGTH	SPEED	METHOD	REACTION	COMMENT
COPPER	Hydrochloric acid + salt	1–20	Slow	Face up. Add sodium chloride (salt) to solution	Attacks oxide film to form copper acetate. Combines with salt to form copper chloride which attacks the metal	Suitable as a de-greasing agent for copper. Being a very hydrophobic metal it is difficult to de-grease with just ammonia + whiting solution
	Ferric chloride	35 Bé	Fast	No gas. Face down. Rock bath gently to disperse air bubbles	Oxidizes rapidly forming hydroxide. Filter or disperse by addition of small amounts of HCl	Concentrated solutions etch copper very smoothly. Beware of false biting as this does not show up during the etch. Rate of etching increases with agitation
		45 Bé	Slow	No gas. Face up. No agitation	Cuprous chloride forms on the etched areas, known as 'white etching'. Dissolves in the ferric chloride as it forms.	Temperature has great effect on speed of etching, below 60°F (15°C) rate of etch is very slow.
				General	If either of these solutions is too acid (reddish brown in colour – chocolate brown indicates a matured bath), add (a) copper turnings well before use (b) precipitated ferric hydroxide (mixture of ammonia, ferric chloride + water). Stir vigorously. Leave two hours, pour off liquid. Add precipitate sparingly	Problem of the plate being 'stained' after removal from the bath. Wash in 2% solution of HCl or acetic acid and salt
ALUMINIUM	Cupric chloride	1–3	Fast	Still bath. Face up.	Replacement reaction. Copper is readily displaced from solutions of its salts by metals higher in the electro-chemical scale	Sludge forms on lines. Remove by washing at end of bite
		1–8	Slow	Face up		
	Sodium hydroxide	Saturated solution	Fast	Face up	Hydrogen gas evolved	Lot of gas evolved – non-harmful. Liable to lift conventional grounds and varnish
	Hydrochloric acid	1–6			Cold acid reacts very slowly. Vigorous reaction with hot acid. Hydrogen gas evolved	
STEEL	Nitric	1–4 / 1–10	Fast / Slow	Face up in a fume cupboard or with adequate ventil-ation	Hydrogen gas evolved	Slow bites etch with a definite tooth in the metal. Baths easily exhausted. Throw away after use
	Hydrochloric Acid	1–2 / 1–6	Fast / Slow	Face up in bath	Hydrogen gas evolved	Use a fume cupboard

of metal being bitten will create an exothermic reaction thereby raising the temperature and increasing the rate of etch. Always place acid baths where there is adequate ventilation, either by an extractor fan or a window. Because most of the gases produced are heavier than air, low ventilation is essential as well. Avoid inhaling the gases and, in the case of spillage, drench with water and neutralize with an alkali. Acid reacts proportionally faster as the strength of the bath increases and this obviously affects the quality of etch. In general, the faster the bath the more harshly it will etch the plate, causing false biting in the non-image areas and creating considerable problems with lateral erosion. Acid) that produce gases when reacting with metals (nitric and hydrochloric produce a coarser bite with greater lateral erosion than non-gaseous acids like ferric chloride and Dutch mordant. The reaction takes place at the surface of the exposed metal, producing bubbles: the plate must therefore be etched face up in the bath to allow the bubbles to escape. The bubbles must be continuously wiped off the surface of the plate, otherwise they form a barrier against the etch. For brushing plates, use feathers or aetspinsel mops.

Non-gaseous ferric chloride and Dutch mordant produce a more accurate bite, with better definition at the sides of the etched image. Plates can be etched face down to allow the residue from the reaction to fall to the bottom of the bath, thereby minimizing lateral erosion of the image. Place two blocks of wood, grooved $\frac{1}{2}$ in. (13 mm.) from the bottom, in the bath to hold the ends of the plate and to prevent the image face touching the bottom of the bath. In all etching, where there are open areas to allow free access of the etching solution to remove the reaction products, then vertical and lateral etching proceed relatively quickly. With the fine lines and shadow dot detail in halftones the etch will be restricted and consequently be shallow and lighter in tone when printed. The longer a plate is left in the bath, the deeper the metal will be etched.

Etching the plate

Before etching, make sure that the sides and the back of the plate are stopped out with shellac varnish. Stop out areas of the ground that look weak and might break down during etching, causing false biting. Stop out the areas on aquatints that are to print white.

Plates should not be left unattended in the bath and the progress of the etch should be observed carefully throughout. Any areas of dark ground which have been completely scraped away when drawing the plate will etch flat and when printed will appear grey and not black as might be expected. These flat areas that have no tooth to hold the ink are called 'crevés'.

Subtle variations in tone can be achieved by 'progressive biting'. Stop-out varnish is used to protect the metal against the action of the acid. Those areas stopped out before the etching is started will remain white when printed. After the first bite the plate is washed and dried,

To etch plates face down, use two blocks of wood to prevent the face scraping against the bottom of the bath.

and those areas that need to be light grey are stopped out. The plate is then returned to the bath. The last areas to be etched will have been in the bath for the longest time and will therefore print the blackest. A lot of guesswork and mistakes can be avoided by using a visual guide showing the relationship between the duration of etch and the darkness of the resulting print.

Make two test strips of metal, approximately 12 × 3 in. (30·5 × 7·5 cm.). Lay a hard ground on one, and draw parallel lines along it. Lay a medium grain aquatint on the other. Make a new bath of the acid that is most used, or do one test for nitric and one for Dutch mordant. Stop out with shellac varnish all those areas that are to remain white. When dry, place the plate in the acid bath for the shortest time shown on the chart below. Remove the plate from the bath and wash off the acid under cold water. Carefully blot the plate dry and stop out 2 in. (5 cm.) next to the area already stopped out for the whites. When dry, place in the bath for the second bite, remove, wash with water and stop out the next step. Continue until the required number of steps has been etched. The times indicated below are the total times in the etch: after

The progressive biting of aquatints:
1 Ordinary aquatint etched lightly.
2 An increase in the depth of bite.
3 A further increase in the depth of bite: the aquatint has been undercut by the acid.
4 Further undercutting: the plate would print black.

stopping out the one minute step in the line plate, the next immersion will be for two minutes in order to give the total time for the next step of three minutes $(1 + 2 = 3)$.

Nitric acid strength 16–1 60°F *approx.*
Line 30 secs . . . 1 min . . . 3 mins . . . 6 mins . . . 30 mins . . . 1 hour
Aquatint 15 secs . . . 40 secs . . . 1.20 mins . . . 3.40 mins. . . .5.00 mins
Dutch mordant Buckland Wright's bath
Line 3 mins . . . 8 mins . . . 15 mins . . . 30 mins . . . 1 hr . . . 2 hrs
Aquatint 30 secs . . . 2 mins . . . 4 mins . . . 6 mins . . 10 mins . . 20 mins

After the plates have been etched, print carefully. Mark the times and strength of etch on the print for future reference.

BRUSH TINTING By using a small aetspinsel brush it is possible to work positively from black to white, and to make soft-edged changes in tonal value, or gestural marks in the aquatint.

Stop out those areas that are not affected by the tint or are to remain white. With cotton wool, sponge over the area to be etched with a mixture of water and gum arabic. This restrains the acid from spreading. Load the brush with acid (nitric 4–1) and start painting in the darkest areas first. Leave the acid for twenty seconds and then gently wipe with a piece of cotton wool soaked in water. Reapply acid to the same area and sponge off. In this way the acid is renewed all the time. During this time, gradually work the acid up the plate until the darkest areas have had about four to five minutes' etch and the lightest areas have had only ten seconds.

DEEP ETCH OR RELIEF ETCHING When areas of the plate have to be bitten deep for emboss, colour or relief printing, problems are created by the strength of the acid: the deeper the metal is bitten, the larger the shoulders of the image become, causing the acid to etch as fast sideways as vertically. There are two ways to overcome lateral etching.
1 *Dry-roll gillotage process:* with a spatula take a good quantity of black letterpress ink and mix it thoroughly with a third of its volume of boiled linseed oil. Using a hard glazed roller, roll out a thick layer of this ink on a glass slab. Etch the plate until the roller does not touch the intaglio in areas of fine detail. Roll the surface of the plate with printing ink applying no pressure to the roller. Where the inked-up roller touches large open areas of the intaglio, wipe off thoroughly with a clean cloth before applying the bitumen. When the plate has been covered with ink, apply a liberal coating of bitumen sprinkled through a stocking. As long as the intaglio is dry, when the plate is tapped from behind all the bitumen in the etched areas will fall off. Using a gas poker, heat the back of the plate to melt the bitumen. If there is enough ink on the plate it will run down the sides of the image with the bitumen and form an acid-resist barrier, protecting the edges from the acid.

2 *Four way powdering* ('*Dragon's Blooding*'): the resin used is obtained from the calamus draco tree from East Asia. (According to Pliny it was the blood of the elephant and the dragon mixed in their death struggle.) After the first etch, brush this resin on to the dried plate in one direction only. Keep brushing until all the red disappears from the depth of the plate. Burn in over a flame aimed at the back of the plate. The plate will appear very red but during the course of heating the colour will disappear, indicating that the resin is properly melted. Do this blooding on all four sides, fusing the resin after each side is brushed. The resin is trapped on all sides of the edge of the image and melts to form an acid-resist barrier. Continue etching until the shoulders appear to be undercutting again. Blood as many times as necessary.

ETCHING A HARD GROUND Even with this durable acid resist it is always advisable to stop out any areas that appear too light. When the plate is put in a nitric bath observe the formation of bubbles on the lines exposed to the acid: if certain lines do not show this reaction, then the hard ground has not been lifted properly. With copper in Dutch mordant the parts of the metal which are etching appear dark brown and those still protected by a thin layer of resist or grease look golden. As long as there is not too thick a layer of grease protecting the line the acid will eventually penetrate but will cause a very uneven jump in tone. To avoid this, take the plate from the bath and re-needle the unexposed lines. The acid does not etch a line drawing evenly all over. Lines drawn close together will increase the reaction of the acid and bite deeper. Broad lines will etch deeper than fine lines over the same length of time. To get areas of black by the use of line, allow a certain amount of hard ground to remain to create a tooth in the metal to hold the ink.

ETCHING A SOFT GROUND This type of ground is very liable to break down in the acid. The faster the mordant the quicker the ground will deteriorate. The non-image areas should be stopped out close to the image, taking care not to block the feathering quality of the line or texture. Use a medium bath of nitric 16–1: if too weak, the acid will not break through the film of ground remaining; and if too strong, the acid will destroy the quality of the image. Use a magnifying glass to check that the image is etched deep enough. It is sometimes impossible to tell whether a soft ground image is etching, yet when the ground is dissolved and the plate cleaned, the image shows up on the metal.

AQUATINT The greatest care has to be taken in etching aquatints, for a mistake, in most cases, means a ruined plate. If during the course of making the tint grease is left on the plate, then that area will not start etching immediately the plate is placed in the bath. Considering the short time taken to get differences in tone (see the test strip), it is clear that any delay in etching will ruin the tonal values of that piece of work.

Any mistakes made with the stop-out varnishes will mean cleaning the plate and re-laying the aquatint. Shellac and rosin are both soluble in methylated spirits.

Care must be taken to lay a grain large enough for the metal used and for the depth of etch. An extremely fine bitumen tint would be far better on a copper plate and etched in Dutch mordant. To get a very deep black use a medium tint on zinc, knowing that the grain is broad enough to withstand the lateral etching and still retain the tone. If aquatints are undercut by the acid, then the blacks and mid tones will print a cool grey, having nothing to hold the ink. Always etch to the finest dot, as this will be the first to be bitten away. An average nitric bath for most medium tints is 16–1, for fine work 20–1. Buckland Wright's bath for Dutch mordant is suitable for the finest aquatints on copper. For different tones, refer to the test strip. Always lay a coarse aquatint first, if several different tints and bites are being used. This will retain a brilliance in the tint with the white paper showing on the pin heads of the last fine tint that is laid and etched. Laying a fine tint first will make the tint muddy and also increase the possibility of the grain not adhering to the metal in subsequent tints.

ENGRAVING

Lines incised into metal plates by hand rather than by the action of acid are called engravings. This is an intaglio technique. It encompasses the craft of burin engraving and the direct drawing techniques of drypoint. Because of the tools used, engravings have a clarity of line which is very different from the uneven acid-bitten line. The plates are printed in the same way as etchings.

Burin engraving

The traditional method of carving metal is with a burin, a square-sectioned steel rod with a boxwood handle. This rod is set in the handle diagonally. The cutting face is ground to 45° to the vertical. The spine of the burin is the ridge where the two planes meet with the front face forming the cutting edge. Sharpen both these planes on a carborundum stone by holding the tool flat to the stone. Do not allow it to rotate, otherwise another plane will be made on the spine. When these edges are sharp, put the end face at 45° to the stone with the fingers close to the end. Rotate till the three facets meet in an absolute point. The multiple burin makes four to twelve parallel lines at the same time.

To exercise the most control over the burin, sit sideways to the bench, keeping the body weight behind, and allowing the forearm to rest on the bench. Push the burin through the metal, thereby cutting a V section in the surface. As this happens, a swarf of copper forms a spiral in front of the point: cut this off with a scraper at the end of the line. The pressure for this pushing is through the palm of the hand and shoulder,

with the thumb, index and middle fingers used to guide and control. The tool should glide through the metal with little hindrance. When cutting a straight line, catch the metal at about 40° to the horizontal and lower to the optimum angle where the tool moves freely without digging into the surface.

When producing wavy or circular lines, hold the burin hand still and move the plate with the free hand describing the arc or shape required. (The hand is not able to push the burin around 360° in one sweep.)

The characteristic marks of engravings are the way the burin enters and leaves the metal and the sharp quality of the printed line. A 'tail off' line is made by dropping the angle of the hand so that the burin leaves the metal. A 'double tail' is made by reversing the plate after making the first tail. A hard line is made by stopping the cut by just withdrawing the burin and cutting off the swarf with a scraper. A double-ended hard line is produced in the same way as the double tail

Burin engraving.

(*opposite*) Etched images can be erased by scraping the metal to reduce the level of the plate in that area to the same level as the intaglio so they do not hold ink when printed. The metal can then be polished with a burnisher.

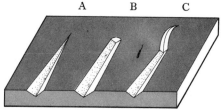

A B C

except the swarf is cut off at the end. Dots are made by jabbing the metal with the point of the burin: this makes a triangular mark. Take care not to do this too energetically or the point will break. Diamond shapes are made by cutting the triangular dot in the opposite direction. For round dots, hold the point in the metal and rotate the plate with the free hand through 360°. For small circles, allow the burin hand to be lower and rotate the plate smoothly; for larger circles, the point should be held in the direction of the arc and the plate rotated more slowly to allow the burin to travel the greater distance.

There are many modern appliances that rout metal by a rotary action or by vibration. These mechanical engraving tools offer a wide variety of cutting heads which allow a most imaginative approach to the sculptural working of the metal.

(*left*) As the burin is pushed through the metal, cutting a v section in the surface, a swarf of copper forms a spiral in front of the point.

(*above*) Burin lines:
A tail off
B hard end
C swarf of copper

Drypoint

In the drypoint process, the surface of the metal is not gouged out but displaced, setting up a rough edge to the side of the line which holds the ink. The 'burr' forms the characteristic element of drypoint engravings.

Any sharp instrument will scratch the surface of a soft metal such as copper, zinc or aluminium. The drypoint is traditionally a steel point which is used like a pencil. It makes marks from the very faintest scratch to a deep line, depending on the pressure applied. The diamond or ruby point (the jewel cut to a round point and set into steel sockets mounted on wood or steel) affords the artist greater freedom than the traditional steel point and it works the metal without catching. It should not be used, however, if a strong burr is required. Roulettes and punches can be used to make marks which produce the effect of pencil

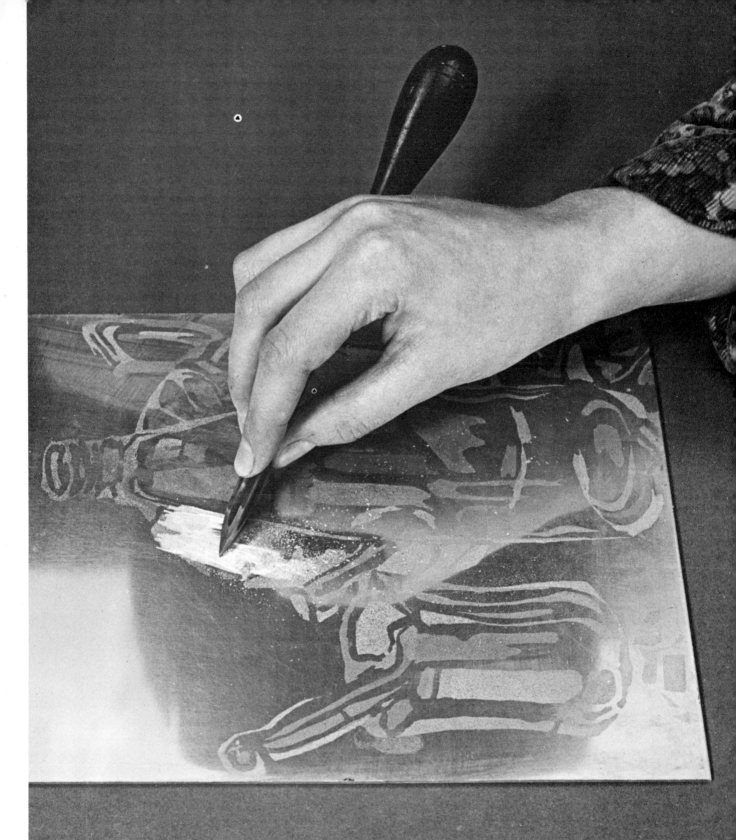

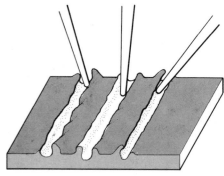

or crayon lines. Roulettes are serrated wheels with lines or dots engraved on the surface, used by applying pressure to the handle and rolling the surface of the metal. Punches, called mattoirs or mace heads, can be used in conjunction with the roulette to produce many varied and interesting configurations of dots.

The most durable, yet most malleable metal is copper and if the drypoint plate is planned for an edition run, copper must be used. (Zinc is much softer than copper but it is useful only for work where a limited number of prints is needed.) The plate should be reinforced before printing the edition. Steel facing of copper plates is done by the electro-deposition of a fine layer of steel over the whole surface.

The printing of drypoint plates must be done with care, using the hand or scrim to wipe the plate, making sure that the velvety textural tone on the edge of the line is not cleaned out.

Photo-engraving

The term photo-engraving can cause some confusion as it does not involve the direct manual working of the plate with engraving tools but

The drypoint displaces the metal to either side of the line forming a burr which holds the ink. The scratches on the surface of the plate are the natural grain of the metal.
(*right*) Drypoint lines: the metal is displaced to left or right according to the angle of the drypoint.

relies on acid biting the metal. The only fundamental difference between this process and conventional etching with grounds or aquatints is that the acid resist used is sensitive to light which makes it possible to transfer film images in either line or halftone on to the surface of the plate.

Photo-engraving is a term used in the commercial printing industry to define a letterpress (relief) technique of printing a photographic image from the surfac of a plate. When so used, the coated metal is exposed to ultra violet light (sunlight) through a negative film. By using a positive film instead, at the platemaking stage, this process is adapted as an intaglio technique of printing from the depth of the metal. If the light-sensitive resist is one of the durable types of coating, then when making a line image the artist is free to use all the techniques of drypoint and engraving through the resist in the highlight end of the plate and to apply wax grounds and aquatints in the shadow areas of the exposed metal without altering the initial photographic image or damaging the acid-resistant surface on the plate. If halftone is used, then control is exercised during the course of making the positive for printing down, and in the variables of etching the plate to extend the range of tonality and emphasis in the image. The artist can freely alter and manipulate the image at each stage of the process from making the film, platemaking, preparation for etching and etching the plate. The original intaglio photo-mechanical process, photogravure, is less predictable and more restricting than photo-engraving. For these reasons this section concentrates on the photo-engraving technique as applied to intaglio printing, using the copperplate etching press.

An image is first prepared, using the process camera as a positive line or halftone film, right reading and same size (see process photography chart, page 141). A light-sensitive coating is flowed on to the printing plate and exposed to ultra violet light through the positive film. The light hardens the exposed areas of the plate and makes them insoluble. Treatment with water or aqueous solutions removes the unexposed areas of the coating, leaving the hardened areas to form the basis of the acid-resistant negative image. Recently, synthetic water-soluble polymer resins called 'polyvinyl alcohols' have replaced natural colloids for photo-engraving. This light-sensitive resist forms an enameline surface on the plate when heated, its chemical and wear resistance is high, allowing the etcher to use all forms of progressive bite, aquatint, or wax ground techniques without fear of the acid-resist coating breaking down. The coating is left on the surface for proofing and printing; it forms a smoother base than the polished zinc as it eliminates the grain of the metal. Polyvinyl cinnamate is another light-sensitive resin which exploits the principle of photopolymerization, forming a three-dimensional molecular network similar to polyvinyl alcohol. Kodak photosensitive resists are made from polyvinyl cinnamate, and they are chemically resistant to the action of acids. The advantage of this form of coating lies in the ease of application, without specialist equipment. It is

(*top*) Photo-engraving: the highlight and the shadow dot.
(*below*) Photogravure: the structure of the cross-line screen image.

The hand whirler.

advisable to choose the resist with the best wear resistance to allow for a flexible approach in etching. There are two basic types of this photo-sensitive resist, negative and positive working. In the negative system the exposed areas of the resist remain on the surface after development to form the stencil, while with the positive working the unexposed areas remain. The positive working plate is made by making the coating sufficiently resinous and insoluble – on exposure to light the molecules change and become soluble.

PRINTING ON TO METAL WITH PVA LIGHT-SENSITIVE RESISTS
The resists are available in many proprietary brands. To get the best results follow the manufacturers' working instructions carefully. Most brands come in three solutions: the enamel, sensitizer and fixer. Measure out 40 fluid oz. (1000 cc.) of enamel and add the required amount of sensitizer (usually a ratio of 20 enamel to 1 sensitizer). Shake vigorously to disperse both solutions and then leave in a dark cupboard for at least twenty-four hours (until all bubbles disappear; strain if necessary through filters to extract dust, etc.).

Plate preparation Zinc should be scrubbed vigorously (but copper lightly) with pumice powder in a circular motion to obtain a strong 'key' on the plate surface and to de-grease the plate. Wash the plate thoroughly under cold running water, making sure that all the grains of pumice are removed. If necessary go over the plate with a clean rag. Keep the surface of the plate wet until it is flowed with the resist, either by flow coating or whirler coating. Flow coating is the most suitable technique for Kodak resists, as no heat is required during the course of flowing. Pour the liquid into the centre of the plate and gently tilt in all directions allowing the pool of resist to grow until it reaches the edges of the plate. Then tilt the plate sharply on to all four sides, allowing the excess liquid to drain off on all edges, making sure that the coating is even. Allow the plate to remain horizontal for five minutes and then hang in a photographic drying cabinet until it is completely dry and ready for exposure.

The flow coating is also used as a preliminary technique for polyvinyl alcohol to ensure an even, spot-free surface before whirling, when the heat necessary to this resist is applied. The hand whirler consists of a geared handle which rotates a shaft at the end of which a rubber suction bulb is attached to serve as a support for the plate. The illustration shows how a power whirler can be made. The whirling takes four minutes and the plate must come off feeling hot but easily held in the hand. The plate is now light-sensitive and ready for exposure through the positive.

Printing down frames The type of exposure frame is immaterial as long as it emits a good source of ultra violet light and can hold the film in close contact with the plate. Carbon arc, being a point light source, will give a shorter exposure and sharper definition than mercury vapour. Exposure should be determined by a step wedge test for the machine

The power whirler: plan (*right*) and elevation (*below*). Heating elements should be included in the design for use with the PVA photosensitive resists; if Kodak resists are used the elements can be omitted.

A Heating elements

B Electric motor

C Bevel gears

D Rotating arms

E Wing nuts

F Galvanized sheeting

G Rubber spacer

H Asbestos sheet

I Aluminium or steel hollow section

J Expanded metal grid

K Plate holder

L Bushed bearing

M 'V' pulley

N Variable rheostat

O Whirler speed control knob

P Handle for manual operation

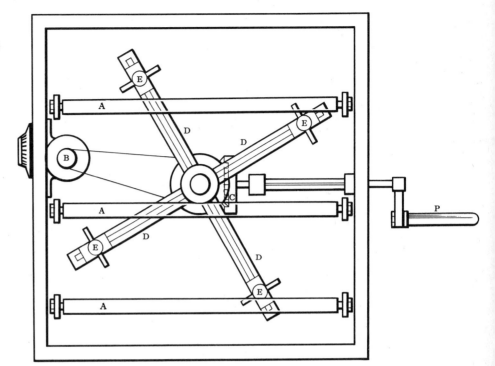

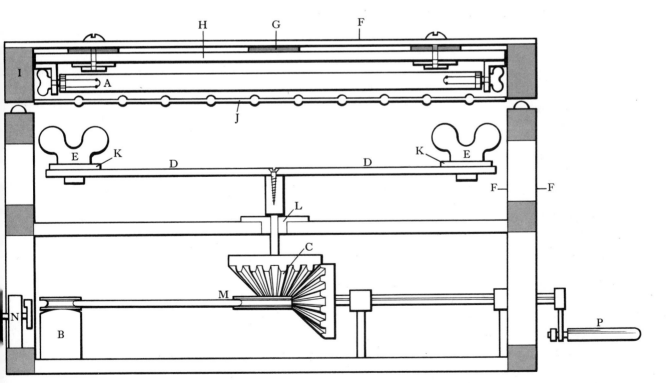

being used. For 30 amp carbon arc at 36 in. (914 cm.), the exposure time is approximately $4\frac{1}{2}$ to $5\frac{1}{2}$ minutes.

Development This is carried out under a spray of cold water and is usually completed in thirty seconds. Should there be any reluctance for the non-image areas to clear, then light wiping with cotton wool will not damage the enamel. In the event of the enamel lifting at this stage, the following might be the cause: (a) unsatisfactory preparation of the metal; (b) insufficient exposure; (c) plate not warm enough on removal from the whirler.

Hardening Drain all surplus water from the plate before immersing it in a bath of fixer solution for fifteen to thirty seconds. The colour of the enamel will change to a yellow straw colour. (Renew the fixer after about ten to fifteen plates, as there is no sign to show when it is exhausted.) Wash the plate in cold water to remove the surplus fixer, but do not over wash as this will affect the hardener. Do not leave any stain of the fix on the surface of the image areas of the plate, as this forms an acid-resist barrier which will affect the evenness of the etched image. Place the plate quickly on the whirler and pour a little isopropyl-alcohol over the surface to spirit off the water. When the plate is dry it becomes fairly resistant to abrasion but care should be taken until the plate has been burnt in.

Burning in The plate has to be heated to 392° to 446°F (200° to 230°C). The enamel turns a deep glossy black. An ordinary gas or electric oven can be used or, simpler still, a gas poker. Place the plate on an expanded metal platform and heat from the back of the plate taking care to move the flame continuously over the whole area until the enamel turns a deep glossy black. If the plate does not turn black on burning in, the following are likely to be the cause; (a) too much washing after hardening and before drying; (b) exhausted fixer; (c) too low burning-in temperature.

ETCHING PHOTO-ENGRAVING PLATES Before etching, the plate should be opened up or de-scummed by gently rubbing the surface with scouring powder and wet cotton wool or by immersing the plate in a bath containing either a weak solution of ferric chloride or a mixture of acetic acid (3 parts), nitric acid (1 part) and water (10 parts). This will change zinc to a dull silver colour; any areas remaining bright or with an amber film indicate (a) insufficient wash-out of fixer, or (b) over-exposure, or (c) bad contact of plate with positive causing veiling of fine detail in the halftone. This may be due to failure to place the emulsion of the film in contact with the emulsion on the plate. Copper sometimes causes trouble by an uncertain reaction that occurs between the copper and the sensitizing solution. This tends to form a thin film on the image areas which is more extensive and durable than the fringing of the dots on zinc. It is necessary to clear this before the plate is etched.

The plate is now ready for etching. Line plates and halftone plates require different techniques of etching. The line plate has large areas of

metal which are exposed to the action of the acid. To produce a black or series of greys in these areas the plate has to be aquatinted, but if the plate is aquatinted before the line image is etched the grain changes the structure of the original image. So, for both zinc and copper, the image is etched just below the surface using a 16–1 bath of nitric for zinc and Dutch mordant for copper. This establishes the photographic image on the plate. After this primary etch, wash the plate and de-grease it thoroughly. An aquatint can now be applied. Rosin tints do not adhere as well as bitumen to the etched metal and care must be taken to deposit a reasonable density of aquatint to avoid the possibility of crevés forming during the prolonged etching. Check through a magnifying glass that the tint is even; stop out all areas which contain fine detail transferred to the plate from the film image. If the grain of the photographic image is too lightly bitten in the primary etch, then this can be progressively etched with the aquatint. It is important to realize that the photographic line image on the plate must be established by etching before the ordinary wax-resist and aquatint techniques are used. The method used for biting the plate may be any one of the techniques described for etching (pages 114–17). Copper should have the primary etch in ferric chloride or Dutch mordant to establish the image accurately at the start, and then, if the plate is going to be deep bitten it should be transferred to a nitric bath, using the blooding or gillotage techniques to avoid excessive undercut.

With etching halftone plates the first consideration is the fineness of the image related to the type of metal used. Use copper for halftone images of 100 lines to the inch (40 lines per cm.) and above. Zinc will just hold a 100-screen image but no depth can be achieved without the shadow dot breaking down. With zinc, therefore, it is advisable to use a screen with a maximum of 80 lines to the inch. Prior to etching halftone plates, the metal must be properly de-scummed. Failure to do this results in some areas of the metal starting to etch later than the rest. These areas will be bitten less deeply and will be lighter in tone when printed. It is also essential that at the film making stage the dot in the shadow area is sufficiently large to prevent the possibility of being undercut, thereby causing a crevé. If there is no dot in the film, or if it is undercut during etching, an aquatint will have to be used to replace it but it is extremely difficult to apply aquatint to small shadow areas of halftone and expect to get a continuous gradation of tone from black, through the dark greys of the image first etched on the plate. Soft gradation halftones of subjects like skin or sky must be made with the right range of tonality at the film making stage to spare the etcher from having to try progressive bite techniques which would be more than likely to cause hard-edge changes in tone. A straight etched halftone plate will automatically extend its original halftone range by varying the depth of etch at either end of the scale. In the shadow areas the acid reaction is less restricted by the residual deposits which can be brushed or agitated away allowing etching to proceed vertically and laterally faster

than in the highlight dot. The highlight areas have confined boundaries with less surface area of metal exposed to the acid. The reaction deposits tend to reduce the rate of etch in these dots causing them to be less deeply bitten than the shadow dot. Let the halftone structure do the work in combination with the acid. To check the tonality in the soft tones of any halftone plate, rub magnesium powder into the intaglio after the plate has been dried. The quantity of powder that stays in the intaglio shows up the tone. If very little powder stays in the intaglio, continue etching for a few minutes longer. The powder shows up white against the red-black of the surface, making the plate look like a scraper-board image. Progressive bite techniques for halftone tone are done in the normal way with stop-out varnish. By following already established hard line divisions of tone in the original, the etcher can greatly extend the tonality of the original or select areas in the picture which require individual emphasis. Care must be taken to use short duration etches to achieve subtle variations in broad tonal areas. For all halftone work use weak solutions of acid to avoid harshness of etch or tonal change. For zinc use a nitric bath of 16–1 or 20–1 depending on the fineness of the screen image and for copper a Dutch mordant mix or ferric chloride at 40° Baumé.

After the line or halftone plate is etched it is advisable to leave the PVA enamel resist on the surface of the plate; indeed it is extremely difficult to remove unless the manufacturer's solvent is used. Metal has a natural surface grain which holds ink when printed but the PVA resist eliminates this texture. If rubbed with a metal polish before printing, the PVA surface will be smooth and easy to clean when wiping off the ink, and it will be possible to obtain a pure white similar to the surrounding area of paper. As the resist has a certain thickness, it can be polished down thinner in the midtone and highlight areas, thus slightly reducing the tonality in that part of the plate.

Preparation for printing

The paper should be selected and prepared before getting the hands dirty with printing ink. It is important to make the right decision about the weight and quality of paper to use. The three finishes available in hand-made and mould-made paper are: 'rough', suitable for all intaglio printing; 'not', meaning 'not glazed', the most commonly used surface for printing; and 'H.P.', meaning hot pressed or 'glazed', ideal for relief printing as it does not interfere with the surface of the ink on the plate. For proofing the plate to see how the image is progressing a heavy cartridge is cheap and ideal. For final printing the paper should be heavy enough to withstand the embossing. Papers with a weight of 72 lb. (155 gsm.), 90 lb. (200 gsm.) and 140 lb. (310 gsm.) are used in most forms of fine printmaking.*

During the course of printing the paper has to undergo a massive expansion over the plate surface, being forced into all the etched lines and areas, without distorting or creasing. To achieve this radical change

*Until recently, paper has been specified in terms of size in inches and ream weight. The equivalent metric terms would be size in millimetres and kilogram weight per 1,000 sheets. However, the weight of the same paper per square metre is always the same regardless of sheet size and, therefore, it is now customary to specify metric weight as grammes per square metre (gsm).

the paper has to be soaked in water in order to soften the fibres. It should be pliable enough to conform to the shape of the plate surface.

Cut the paper if necessary, using a ruler to tear the paper, to create the effect of the deckle edge characteristic of all hand-made and most mould-made paper. Place it in a large bath of cold water. Sized paper will take a few minutes to soak, because gelatine is insoluble in cold water. Waterleaf paper should be gently sponged with a little water on a flat surface. Take the paper from the bath and place between sheets of blotting paper. To avoid getting the paper dirty when handling it, use thin card, bent double, to form clips. The blotting is removed from the paper and racked to dry (a silkscreen rack is ideal for this). Place a clean dry piece of blotting on top of the paper and pass the forearm over the surface to absorb any moisture. Turn the paper over and do the same to the other side. Place the card clips at opposite ends of the long side. When the paper is picked up, glance along the surface to see if any shiny areas of moisture remain; if necessary, repeat the drying process.

When the paper is ready, prepare the ink. When buying ink for intaglio printing, specify 'Copperplate Printing Ink'. This ink has no artificial drying agents, such as are present in letterpress and offset lithographic inks. Some artists prefer to mix their own ink from powder pigment with copperplate oil. The grain size of the powder must be very fine to be able to hold in the light and fine etched areas. Frankfort Black powder has the same grain size as most commercial copperplate inks. French Black powder has in general a larger grain size, which would give a false tonal impression if it were not well ground before use when printing light aquatints. Thoroughly mix the powder with linseed oil until each particle of pigment is encased in the binding vehicle. Both tinned and powdered pigment can be thinned or thickened by the addition of oils with different viscosities: heavy, medium and light. (For ways of preparing powder ink refer to Gross's *Etching, Engraving and Intaglio Printing*, pages 119–24.) The ink needs to be as stiff as possible to remain in the intaglio without getting dragged out in the wiping, yet fluid enough to be able to clean the surface of the plate easily and quickly. In general, fine aquatints and shallow surface working of the plate require a stiff ink (the ink moves very slowly off the palette knife) or the ink will be cleaned out of the intaglio. Deeper etch plates can afford to have a more runny ink.

Before inking up the plate check the pressure on the blankets of the press. Make sure that the thin compressed felt blanket, the 'fronting', is next to the bed of the press. This will lie directly on top of the printing paper (if the fronting is uneven this will transfer a texture to the print). The top two blankets called the 'swanskins' are thick and resilient. They have to be thick and pliable enough to force the paper into the intaglio to draw out the ink. The pressure is applied by the large top roller of the etching press. This rotates when the wheel is turned, forcing the bed to move through the press supported by the free-wheeling bottom

129

roller. To alter the pressure, tighten the screws on top of the frame, forcing the top roller lower.

Set up the press by laying the blankets in order on the bed, rotate the wheel and push the bed to catch the blankets under the top roller. Then place a clean plate, about the same size as the one to be printed, on the press with a clean, dry sheet of blotting paper on top. Lay the blankets down carefully, smoothing out any unevenness. Turn the wheel until the bed travels through to the other side of the press. Lift the blankets and check the blotting paper, looking for any unevenness in the emboss image of the edge of the plate. If uneven, adjust the screws on top of the frame of the press. Correct pressure should show no difference in the amount of emboss on either side of the plate.

Printing procedure

The basic procedure for printing is the same for etching, engraving, drypoint and photo-engraving – all are printed from the intaglio using the etching press.

Prepare enough paper (cutting if necessary before soaking), as detailed above, before getting the hands dirty. Grounds and varnishes must be cleaned off the surface and back of the plate. The surface should be thoroughly polished with metal polish, taking particular care to get any residue out of the intaglio. Mix the ink, taking into account the type of plate to be printed. Heat the plate until it is warm and remove from the hot plate. Rub ink into the plate liberally, forcing it into the intaglio, using a dabber, a dolly (rolled felt), the leading edge of a piece of card or any material that will not scratch the surface or leave fluff and fibre in the ink. Remember that the image surface is normally very abrasive. After the plate is well inked, warm it slightly and remove again to the jigger box. Using a large piece of scrim or tarlatan which is black from previous use but not dry, remove the excess ink from the plate. Use progressively cleaner pieces of scrim until the image shows up clearly. Now take another clean piece of scrim and fold it into a tight ball with the face absolutely smooth, flat, hard and about the size of a saucer. Using a light circular polishing motion, continue wiping the plate till the face of the pad becomes dirty and then refold to get a clean face. As the wiping continues, turn the plate around so that no one area gets inadvertently over-wiped, or the ink becomes streaky looking.

Finish off the wiping of the plate using one of the following techniques:

1 *Scrim wipe* Continue wiping the plate with the scrim, changing the face often, using very light, fast strokes. As the plate is cold, the ink is more viscous and therefore harder to drag out of the intaglio so the surface can be cleaned very effectively. Stop wiping earlier on if you require a tone above that of the natural grain of the metal. If the plate is wiped hot, the ink is less viscous and, therefore, easier to drag out of the intaglio – this will produce a print which is tonally lighter and with less contrast. In proofing, over-wiping is often mistaken for under

bitten lines or faulty aquatints. Limited wiping in areas can be useful for retaining tone in certain parts of the plate.

2 *Hand wipe* Using the leading edge and ball of the hand, skim the surface of the plate. Turn the plate all the time to avoid streaking. If the hand is pressed too hard on to the plate, it will stick and pull out the ink. There should be no sound, bar that of a brushing noise. When the hand gets ink on it, dust with french chalk, brushing the excess off against the overall, not on the plate. Hand wiping is hard to control and often leads to a dry over-wiped or streaky print, but it is particularly useful for wiping mezzotint or drypoint plates which cause scrim to snag leaving pieces of material in the ink.

3 *Paper wipe* Thin tissue paper is suitable for certain types of plate. Do not use on drypoint, aquatint or plates with excessively fine surface etch work. If wiping the whole plate, cut the tissue into pieces about 6×4 in. (15×10 cm.) and using the ball of the hand, with the fingers straight, very lightly burnish the surface, constantly changing the piece of paper when it gets dirty. If the plate is worked cold, there is little chance of the oil in the ink being 'sucked dry' by absorption, unless the fingers are used; then the paper can be pushed down into the intaglio, causing a 'dry' light print. The fingers have to be used when highlighting small areas within the image.

For multi-colour prints, first wipe the lightest colour into an area, holding a piece of paper to mask off a straight edge if necessary. Using the scrim or paper, clean that area. Lay the second colour within $\frac{1}{8}$ in. (3 mm.) of the first and clean in the same way. In cleaning, the two colours will blend in with each other forming a soft colour change. For a more exact change of colour, use the masking paper first one side when cleaning, then the other.

When the plate is wiped, thoroughly clean the edges with a piece of cloth. Check that the bed of the press is clean; dust with french chalk; lay the plate on the bed and place the paper on top. The blankets can be lowered on to the plate flat and held taut, or they can be held over the top roller, thereby minimizing any movement in the paper before it is trapped under the roller. After going through the press, take the print off slowly, rack it and then clean the bed for the next print.

MULTI-PLATE COLOUR PRINTING Decide on the number of colours to be used and cut the plates to exactly the same size. Etch the images on all the plates. Follow the printing procedure described above. Ensure the accurate registration of each plate. Select a piece of cartridge paper the same size as the printing paper and place it on the bed of the press. Place all the plates in position on the paper, to make sure they fit. Remove and ink them. Place the first plate in the marked position and lay the printing paper exactly on top of the cartridge paper. Run through the press so that only the plate is free from the rollers. The edges of the cartridge and the printing paper are trapped by the rollers and cannot move out of alignment. Remove the first plate and place the

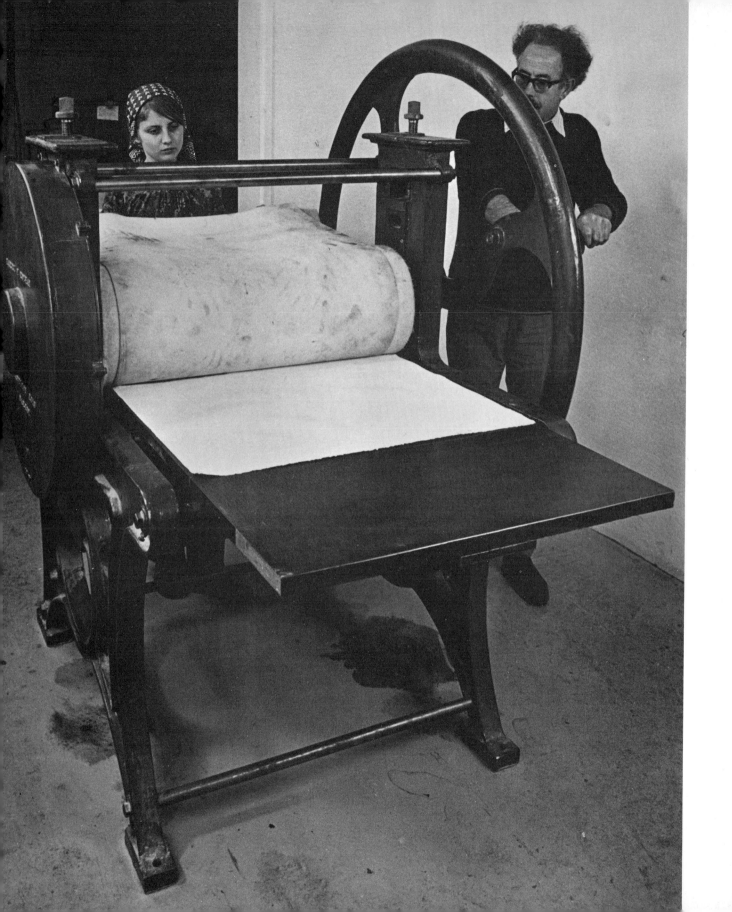

The blankets can be lowered on to the plate flat and held taut, or they can be held over the top roller as illustrated, thereby minimizing any movement in the paper before it is trapped under the roller.

second plate in the marked position on the cartridge paper. Lay the printing paper down or hold over the blankets and take through the press again. Continue this any number of times.

This method can also be used for plates of odd shape. Arrange the plates on a sheet of cartridge paper and draw a line round them. Mark the outlined shapes in the order of printing. As long as enough paper has been left on either side of the image so that it can be caught under the top roller, this method can continue indefinitely. If the cartridge paper with the key plan on it starts to cockle, then a new one must be drawn out.

Print drying

When the print comes off the plate, the paper is embossed around the edge of the plate and the image stands out in relief on the paper surface. The paper is still damp and pliable and must be dried with care – if large boards or weights are placed on top of the print, the paper will nearly revert to its original flat state. If taped to a board, the damp paper will contract as it dries and pull tight any unevenness, including the emboss image, making it as flat and as tight as a drum.

Prints should be dried on screen racks, ball racks or on a flat surface one on top of the other, interleaved with sheets of tissue paper and a sheet of card every four or five prints. Change the tissue paper frequently to prevent it sticking to the drying ink and leave to dry out thoroughly. When completely dry, after about seven to ten days, damp the back of the paper and place the prints in groups of three, interleaving with sheets of card. Place a rigid board on top, with a moderate weight to apply an even pressure. This will slowly even out the paper and will not destroy the emboss, as by this time the paper is 'set' and will not easily remould itself. Hand-made paper is not absolutely flat; there is always a slight wave in the surface.

Appendix: Process Photography
by Jack Shirreff

The enlarger:
A light source
B condenser
C negative holder
D lens
E copy board

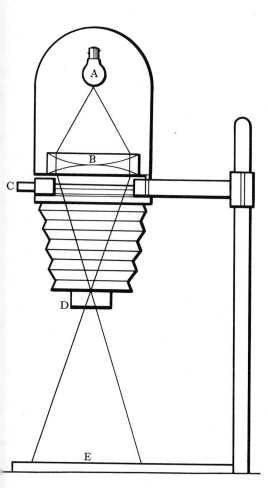

Photographic work has become an integral part of printmaking for the reproduction of art work, as a versatile element that can be manipulated and changed to suit the varying approach of the artist. Process photography requires no specialist skills other than close observation and a reasonably systematic practical approach. This chapter will point the way for printmakers who wish to use process photography for plate-making, with simple equipment.

Process photography is the vehicle with which the artist's original (whether a drawing, photograph or collage) is transformed into a positive or negative film which can be transferred to a printing surface for reproduction. Lithography, etching and silkscreen all use light-sensitive coatings to receive this image, which hardens when exposed to light. The unexposed areas are dissolved by a solvent. The main limitation of the process is that the original image has to be broken up into areas which are either black opaque or transparent, with no gradations of tone.

The two types of image are 'line', where the image is established as broad areas of black, the detail in the dark and light areas in the original being substantially lost; and 'halftone' which relies on the image being broken into tiny black dots, varying in size, which simulate the tones of the original.

The original image is transformed into a line or halftone film image either on the process camera or on a simple darkroom enlarger. In the process camera light is reflected off the original, through the lens and on to the light-sensitive emulsion of the film. The enlarger uses a continuous tone negative (35 mm., 120 or $2\frac{1}{4}$ in. square): light shines through the negative (transmitted light) on to the film. The film has a specially prepared slow working 'lith' emulsion, which is a fine grain, thin film silver-rich halide, capable of giving extraordinary contrast, when used with special alkali-hydroquinone developer. The normal lith films used are 'orthochromatic'. This means that they are only sensitive to blue-green light and can be handled in red safelight conditions. Some line films and document papers are 'non-colour sensitive', which means they are only sensitive to blue light and may be handled in yellow dark-room safelighting, or in the case of the slower working document papers, in low level artificial light. 'Panchromatic' films are sensitive to all colours and are used only in total darkness (for making direct, colour separation halftones from colour originals).

Films are graded according to the thickness of the base material. In

general, the stronger and thicker the base the greater the dimensional stability. (The opposite is true of the emulsion – the thinner the coating the more dimensional stability). The three main bases are paper, acetate and polyester. Document papers and translucent papers with lith-type emulsions are cheap but dimensionally unstable, and may not have sufficient opacity for some applications. They also tend to lose fine detail and veil on the edge of the black image, losing definition. Acetate is stable enough for most types of printing. Polyester is very stable and tough, making it possible to use thin bases which permit exposure through the back of the film when a laterally reversed image is needed. Base materials are measured in thousandths of an inch, ranging from 3/1000 in. (0·008 mm.) to 8/1000 in. (0·02 mm.). The average thickness of film suitable for most types of work is 5 or 6 thousandths. Thin base for laterally reversed film is 4/1000 in. (0·01 mm.) polyester base, 3/1000 in. (0·008 mm.) acetate base.

Films with special purpose emulsions are available from photographic suppliers: direct-positive and ready-screened. The direct-positive emulsion gives a direct positive of the original on exposure

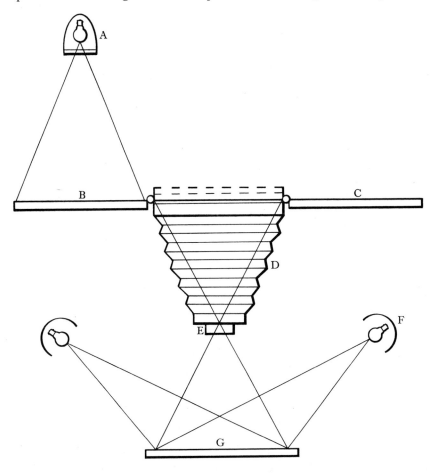

The process camera:
A beehive light for flash exposure or contacting
B vacuum film board
C viewing screen
D bellows
E lens
F light source
G copy board

without having to go through the negative stage. It has a very high contrast emulsion giving by contact printing a positive from a positive, or a negative from a negative for lateral reversal or composition work. It should be handled in room lighting.

The ready-screened emulsion contains a pre-exposed halftone screen, which means that continuous tone negatives or positives can be made direct by enlarger or contacted on to this film to produce a half-tone image without resorting to a halftone contact screen. This comes in only one screen ruling but can be altered by reduction or enlargement. It should be handled in red safelight conditions.

Line

The line image is used for black and white drawings, high contrast photographic material and for graphic work. For the printmaker, line film has a wide range of sensitivity and application. In the line negative the image is completely transparent and the background is solid black but the emulsion is able to record detail in a wide range around the mid-tone area of the continuous tone original. By using the variables of exposure, aperture and development, line film accepts this detail in the from of fine, high-contrast textural areas. In most cases this detail is quite adequate to represent the image and sometimes proves better than halftone, because of the arbitrary formation of the grain detail which appears more sympathetic than the hard photo-mechanical grid of the halftone structure.

Because of the wide variety of drawings and photographs, it is impossible to give standard working times and methods. The fundamental rule is to make test strips to find the right aperture-exposure ratio, and then develop by 'agitation' or 'still bath' until there is enough detail of the right density. Carefully observe the stages of development and choose the point when the film is to be transferred to the fix bath. Make the test strip on a piece of lith film using black paper to cover up the exposed steps. (Make a series of exposures of 5, 10, 20, 40 seconds, each step being double the previous one.) The exposure latitude for a good original is about 30 per cent above or below, compensating it in the development. Develop the strips in 'lith type' developer, according to the manufacturer's instructions. Select the step of the test strip with the most black and white detail for your requirements, noting the exposure time given to obtain it.

The most common method of developing is by agitating the bath, tipping it on to each of its sides in turn. This continuously washes the developer over the exposed emulsion making the image develop up evenly. The optimum development time is in the range of 2 to 3 minutes at 68°F (20°C) for lith films. Agitation should continue for 2 minutes and then the bath should be left still for the remainder of the time. It is essential to have adequate safelights to inspect the negative from the 2-minute stage in order to judge when the image reaches the correct density and development should stop. Using a transparent dish,

Line image.

the image may be observed with greater accuracy by a safelight set into the bench.

The still bath method of development allows the film to develop without agitation, but the inactive stale developer formed on the surface of the film tends to restrain the formation of silver. This inhibits development at the edges of the black areas, preventing bleeding and loss of fine detail. The developer should be agitated at the start of processing for 15 to 20 seconds to allow a thorough wetting of the film and then left still until completion is judged by inspection. The exposure time for still bath may be about 10 per cent more than normal. This method of development is useful for fine line work and the reproduction of existing halftone material ('dot-for-dot' technique).

Line positives can be made with the enlarger direct from camera negatives (35 ml. $2\frac{1}{4}$ in. sq. 5 × 4 in.). Place a negative in the enlarger (emulsion facing away from the light source for right reading, and towards the light source for wrong reading, mirror image, printing processes: see table page 141). Use a piece of lith film instead of photographic paper (correct safelighting must be observed) and make a test strip. The conventional continuous tone negative contains a transparent film base and the black image which is contained in the emulsion layer of the film. This image is composed of a random dispersement of black grains of such fineness as to be undetectable to the eye. When sufficiently enlarged, however, this grain structure becomes visible, and works as a random halftone image. It is possible to get more detail on line film from transmitted light exposures via enlarger than from reflected light images from the process camera. Select the exposure that gives the most detail in the mid- and light-tone areas, making sure that there is clear film between the individual grain structures. Develop either by the still bath or agitation method.

Halftone

A line image produces the structure of a picture, and detail in the mid-tone areas, but it cannot reproduce fine gradations of tone or detail in the dark and light areas of the continuous tone picture. Prints produced by the photo-mechanical printing processes have only two values: the black ink and the white paper. The image must, therefore, be broken up into a discontinuous series of dots or other shapes small enough to be unnoticed by the eye, and angled in such a way as not to affect the structure of the image. The contact screen which produces this broken image is an essential piece of equipment. It can be used with an enlarger (preferably with a vacuum base board) and on the small vertical process camera. It permits a wider latitude of tonal range and a greater control in the making of halftones than the ready-screened emulsions.

The easiest screen to handle is the grey screen which can be obtained in rulings from 60 to 150 lines per inch (24 to 60 lines per centimetre), 120 lines per inch (48 lines per centimetre) being suitable for most work.

Halftone image.

Screens can be bought with halftone structures other than the normal geometric structure of the cross line image: straight line, wavy line, and other irregular formations. Improvised screens can be made with open weave fabrics or wire meshes sandwiched between sheets of glass. These give an interesting irregular texture according to the material used, and retain the tones of the original.

To produce the conventional halftone structure the original image is broken up by exposing the film through the halftone contact screen, which consists of a series of uniformly sized, vignetted or soft edged dots, over the whole area of a flexible film base. Each dot has a centre of very high density which gradually reduces towards its edge, where the density is very low. When the film is exposed through the contact screen, the size and shape of the dots on the film depend on the amount of light passing through and the varying density of the screen. Contact screens reduce the tonal range of the original copy. Using a process camera, place the screen in contact with the film on the vacuum base (make sure the screen is larger than the film to get perfect contact). The emulsion side of the screen should be in contact with the emulsion of the film. When making a halftone negative from the original image, two exposures to the emulsion of the film are needed: (a) flash exposure to a light source with the screen in place, made with a low intensity light source approximately 4 ft. (1·2 m.) from the film to extend the duration of the exposure, affording greater control (a beehive safelight can be used for this exposure if it is fitted with a 'contact paper safelight' which is light yellow in colour), and (b) main exposure to the copy.

The first exposure establishes the latent image of the screen on the film, thereby starting the sensitivity curve of the emulsion. The second exposure establishes the actual image on the film. As light is reflecting from the copy and travelling through the lens to the film, insufficient light will reflect from the darker end of the picture to form a dot when the highlight end detail will be correctly exposed. The flash exposure is made to overcome the inertia of the film so that the shadow detail dot can be formed during the main exposure. The main exposure governs the size of the dot in the mid-tone and lighter end of the picture. The ratio of the two exposures determines the character of the halftone dot at either end of the scale, and also the over-all tonal contrast of the picture. Refer to the halftone scale to see the optimum highlight and shadow dot for the different printing media.

Develop the film in a strong solution of lith developer with close temperature and dilution control. Develop with the same method of agitation as for line, making the rate of agitation the same throughout the 2 to $2\frac{1}{4}$ minutes. Then still bath the film for 15 to 30 seconds, inspecting every few seconds with a strong magnifying glass. Stop development when the required size and density of the black dots of the shadow detail and the white dots of the highlight is reached. To produce standard and predictable results it is important to use fresh lith developer with each piece of film.

Continuous tone negatives can be enlarged to produce halftone positives. Place the negative in the enlarger as for line, with the lith film on the base board, emulsion up. Place the contact screen, emulsion side down, on the film; the screen must overlap the film so that the vacuum on the base board is able to hold it in close contact. If there is no vacuum then a thin sheet of glass should be used and weighted at the corners. Transmitted light exposures are usually shorter than reflected light but a flash exposure is still needed before the main exposure. Develop as for ordinary halftones.

When working with ready-screened halftone emulsions, the procedure is the same as outlined above, except that there is no need to use the halftone contact screen as this is incorporated in the emulsion of the film. A flash exposure is given in the same way as described. Develop as for halftone.

Flow diagram showing different ways of producing a positive or a negative film suitable for the various printing processes

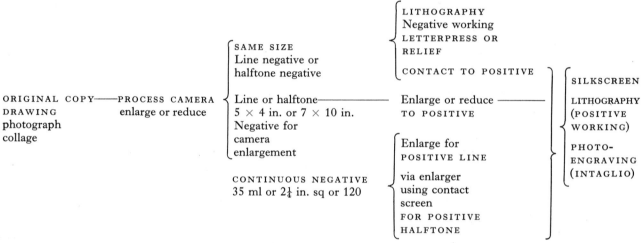

Making films for different printing media

When making films for platemaking it is important to recognize that each process has different requirements in order for the final image to appear as a positive image that reads the right way round. Each process, depending on the nature of the photo-sensitive resist or stencil being used, needs a negative or a positive transparent film image of the same size as the image to be printed.

The general photographic rule of emulsion to emulsion is sometimes disregarded as it is necessary for some printing processes to use a right reading negative or a wrong reading positive for platemaking so that the final printed image appears the right way round. In these cases the film is exposed through the base, as it is essential when platemaking that the emulsion of the film faces the emulsion of the plate or stencil, so that there is perfect contact between the two and the image is transferred to the plate or stencil without distortion.

The table shows which printing processes need negative film and which need positive film for platemaking; the right-hand column indicates which way round the image must appear when looking at the emulsion side of the film. This column also serves as a guide, when making the positive or negative, as to which way round the unexposed film should be placed on the copy board of the enlarger or when contacting from negative to positive, so that the image appears right or wrong reading when looking at the emulsion.

FILM	PROCESS	LOOKING AT EMULSION OF FILM
POSITIVE	Silkscreen	RIGHT READING[1]
	Photo-engraving Intaglio	RIGHT READING[1]
	Direct litho Pos. working	RIGHT READING[1]
	Offset litho Pos. working	WRONG READING[2]
NEGATIVE	Offset litho Neg. working	WRONG READING[1]
	Direct litho Neg. working	RIGHT READING[2]
	Photo-engraving Relief	RIGHT READING[2]

[1]Always keep emulsion to emulsion when making the film
[2]Laterally reversed (exposing the film through the base).

As a final check, the plate or stencil after it is made should appear:

Wrong reading { Photo-engraving Relief and Intaglio / Direct litho Neg. and pos. }

Right reading { Offset litho Neg. and pos. / Silkscreen }

To produce a back-to-front image (laterally reversed) the film should be placed in the process camera with the *base* facing the light source, and in the enlarger with the base towards the light. Definition is lost by the spreading of the light by the anti-halation layer. For fine work, laterally reversed films (thin base films with no anti-halation backing) are designed to be exposed through the base with no resulting loss of detail.

The halftone structure for the different media requires different sizes of dots at each end of the tonal scale. These are described in

percentage terms of the amount of black present in the dot formation. The way to remember this scale is to think of the positive image of the halftone scale and the amount of black present as a percentage figure. The highlight with only a little black present is called 5 per cent highlight and the dark end with nearly all black is called 95 per cent shadow. If a negative were being discussed then it would be 95 per cent highlight, as on a negative the highlight end is nearly all black and the shadow would only have a small black dot which would be 5 per cent shadow.

The table below shows the tonal quality of the negative or positive film which gives good tonal results when printed.

The halftone percentage scale.

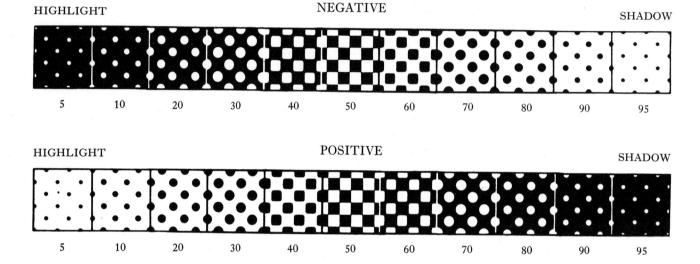

HIGHLIGHT NEGATIVE SHADOW

5 10 20 30 40 50 60 70 80 90 95

HIGHLIGHT POSITIVE SHADOW

5 10 20 30 40 50 60 70 80 90 95

Halftone percentages for maximum tonal scale

PROCESS	POSITIVE OR NEGATIVE	TONAL SCALE		COMMENT
		Highlight	*Shadow*	
SILKSCREEN	Positive	10 per cent	95 per cent	When contacting and platemaking, the highlight dot and the shadow dot are both reduced in size. With a very fine halftone screen the smallest dot might even drop through the apertures in the silkscreen mesh. The number of threads in the silkscreen mesh, therefore, must be at least twice the halftone screen ruling. (100 threads per inch will support no finer halftone dot than 50 lines to the inch.)
PHOTO-ENGRAVING Letterpress or relief	Negative	75 per cent	5 per cent	This halftone negative will appear dull with a very short tonal range. Because the highlight end of the photo-engraving plate is left in the acid for the longest time it has the deepest etch, reducing the dot to 90 to 95 per cent. If the highlight dot were too small at the start of etching it would be totally eaten away by the acid, giving a false tonal reading. The highlight dot in the negative must, therefore, be made larger so that the acid can do the work of reducing it to the right size.
PHOTO-ENGRAVING Intaglio	Positive	0–5 per cent	90 per cent	To get extra brilliance in the white when the plate is printed, the very lightest areas on the positive transparency can be devoid of dots so that when the image is transferred, the plate surface will be completely smooth without any pitting. It is essential that a regular shadow dot is kept throughout the darker end of the picture, otherwise the acid will etch the metal flat in those areas causing them to appear a light grey on the print. The shadow dot is the most important part to watch when making the negative, remembering that when contacted to the positive the shadow dot will get smaller and it is the shadow detail which has to be etched the deepest.
LITHOGRAPHY Direct Offset	Negative Positive Negative Positive	98 per cent 2 per cent 100–98 per cent 0–2 per cent	10 per cent 90 per cent 5 per cent 95 per cent	For both direct and offset litho plates, the extreme whites should be clear of dots and the blacks completely solid. The shadow end tends to fill in or scum up when printing because the little white dots are surrounded by greasy printing ink which gradually spreads by rolling up and pressure in printing. Direct litho needs a slightly larger dot than offset in the shadow end.

Bibliography

Screen Printing

AUVIL, KENNETH W. *Serigraphy: Silk Screen Techniques for the Artist* New Jersey: Prentice-Hall 1965

BAKER, F. A. *Silk Screen Practice* London: Blandford Press 1934

BIEGELEISEN, J. I. *The Complete Book of Silk Screen Printing Production* New York: Dover Publications 1963

BIEGELEISEN, J. I. and COHN M. A. *Silk Screen Techniques* New York: Dover Publications 1958

CARR, FRANCIS *A Guide to Screen Process Printing* London: Studio Vista 1961

HIETT, HARRY L., edited by H. K. Middleton *Silk Screen Process Production* London: Blandford Press 1950, 1960

KINSEY, ANTHONY *Introducing Screen Printing* London: Batsford 1967; New York: Watson-Guptill 1968

KOSLOFF, ALBERT *The Art and Craft of Screen Process Printing* New York: The Bruce Publishing Co. 1960

MIDDLETON, H. K. *Silk Screen Process: A Volume of Technical References* London: Blandford Press 1949

RUSS, STEPHEN *Practical Screen Printing* London: Studio Vista 1969; New York: Watson-Guptill 1969

SHOKLER, HARRY *Artists Manual for Silk Screen Print Making* New York: American Artists Group 1946

WITHERS, GERALD (editor) *Screen Printing Point of Sale and Industries Manual* London: Batiste Publications 1967

WOLFE, HERBERT J. *Printing and Litho Inks* New York: MacNair-Dorland Company 1957

Lithography

ANTREASIAN, GARO Z. and ADAMS, CLINTON *The Tamarind Book of Lithography: Art and Techniques* New York: Tamarind Lithography Workshop Inc. and Harry N. Abrams Inc. 1971

CLIFFE, H. *Lithography* London: Studio Vista 1965

HELLER, J. *Printmaking Today* New York: Holt, Rinehart & Winston 1972

JONES, STANLEY *Lithography for Artists* London: Oxford University Press 1967

KNIGIN, MICHAEL and ZIMILES, MURRAY *The Technique of Fine Art Lithography* New York: Van Nostrand Reinhold 1970

TRIVICK, H. *Autolithography* London: Faber and Faber 1960

Relief Printing

BRUNNER, FELIX *A Handbook of Graphic Reproduction Processes* London: Alec Tiranti 1962

DANIELS, HARVEY *Printmaking* London: Hamlyn 1971

PETERDI, GABOR *Printmaking* New York: Macmillan 1959

ROTHENSTEIN, MICHAEL *Linocuts and Woodcuts* London: Studio Vista 1962; New York: Watson-Guptill 1964

ROTHENSTEIN, MICHAEL *Relief Printing* London: Studio Vista 1970; New York: Watson-Guptill 1970

Etching, Engraving and Process Photography

AMMONDS, C. C. *Photoengraving: Principles and Practice* London: Pitman 1966

CARTWRIGHT, H. M. *Ilford Graphic Arts Manual* Vol. I London: Ilford 1961

CHAMBERLAIN, W. *Manual of Etching and Engraving* London: Thames and Hudson 1973; New York: Viking Press 1973

CHAMBERS, ERIC *Camera and Process Work* London: Ernest Benn 1964

GROSS, ANTHONY *Etching, Engraving and Intaglio Printing* London: Oxford University Press 1970

HAMERTON, P. H. *Etching and Etchers* New York: Macmillan 1876

LUMSDEN, E. S. *The Art of Etching* London: Constable 1963; New York: Dover 1963

PATEMAN, F. and YOUNG, L. C. *Printing Science* London: Pitman 1969

SALAMON, F. *Collector's Guide to Prints and Printmakers* London: Thames and Hudson 1972

TYRRELL, A. *Basics of Reprography* London: Focal Press, New York: Hastings 1972

Suppliers

EUROPEAN SUPPLIERS

ADANA (PRINTING MACHINES) LTD, 15–19 Church Street, Twickenham, Middlesex. London Showrooms, 8 Grays Inn Road, WC1 (Small printing machines and associated equipment)

AGFA-GEVAERT LTD, 20 Piccadilly, London W1 (Photographic equipment)

ALLIED INDUSTRIAL SERVICES, Lidget Green, Bradford, Yorkshire BD7 2QS (Cleaning cloths and dust control)

AULT & WIBORG LTD, 71 Standen Road, London SW18 (Printing ink and rollers)

BERRICK BROS LTD, 20–24 Kirby Street, London EC1N 8UA (Paper)

BLACKWELL & CO. LTD, Sugar House Lane, Stratford, London E15 2QN (Screen printing ink)

A. G. W. BRITTON & SONS LTD, 27 Willow Way, London SE26 (Screen printing ink)

BUCK & RYAN, 101 Tottenham Court Road, London W1P 0DY (Etching and engraving tools)

BURLEIGHFIELD PRINTING HOUSE, Loudwater, Buckinghamshire (Fine art editioning services and instruction in direct and offset lithography, intaglio, screen printing, and photo-mechanical work)

R. K. BURT & CO. LTD, 37 Union Street, London SE1 1SD (Hand-made and mould-made papers)

CARTIERE ENRICO MAGNANI S.P.A., Piazza Matteotti No. 11, 51017 Pescia (Pistoya), Italy (Paper)

F. CHARBONNEL, 13 Quai Montebello, Paris 5 (General etching supplies)

CITY GATE INKS, 63 White Lion Street, London N1 (Lithographic stones)

COATES BROS (INKS) LTD, Easton Street, Rosebery Avenue, London WC1 (Screen printing ink)

COATES BROS (LITHO PLATES) LTD, Easton Street, Rosebery Avenue, London WC1 (Lithographic plates)

CORNELISSEN & SONS, 22 Great Queen Street, London WC2 (General lithographic supplies)

CRODA POLYMERS LTD, INK DIVISION, 170 Glasgow Road, Edinburgh (Relief printing ink)

CURWEN PRINTS LTD, Midford Place, 114 Tottenham Court Road, London W1P 9HL (Editioning of artists' lithographs by offset and direct)

DANE & CO. LTD, Sugar House Lane, Stratford, London E15 2QN (Screen printing ink)

ESSEX PRINTERS SUPPLY CO., Elektron Works, Norlington Road, Leyton, London E10 (Presses)

FALKINER FINE PAPERS, 15 Yarrell Mansions, Queen's Club Gardens, London W14 9TB (Paper)

A. GALLENKAMP & CO. LTD, P.O. Box 290, Technico House, Christopher Street, London EC2P 2ER (Water jet filter pump)

A. R. GIBBON LTD, 22 Coleman Fields, London N1 7AE (Lithographic and letterpress ink)

A. GILBY & SON LTD, Reliance Works, Devonshire Road, Colliers Wood, London SW19 (Lithographic and letterpress ink)

GRAFIK, 28 Thornhill Road, London N1 1HW (Lithographic printing services)

GREEN'S FINE PAPERS DIVISION, W. & R. BALSTON LTD, Springfield Mill, Maidstone, Kent ME14 2LE (Hand-made and mould-made papers)

GEORGE HALL (SALES) LTD, Hardman Street, Shaw Heath, Stockport, Cheshire SK3 8DQ (Mesh materials and other screen printing supplies

FRANK HORSELL & CO. LTD, Howley Park Estate, Morley, Leeds LS27 0QT (Printing inks, offset plates, general lithographic supplies)

HUNTER PENROSE LITTLEJOHN LTD, 7 Spa Road, London SE16 3QS (Presses, rollers, sink units, graphic art and printing supplies, film chemicals, metal plates)

ILFORD LTD, 23 Roden Street, Ilford, Essex (Photographic equipment)

INVERESK PAPER CO. LTD, Clan House, 19 Tudor Street, London EC4Y 0BA (Hand-made and mould-made paper)

KAST + EHINGER GMBH, Printing Inks, 7 Stuttgart-Feuerback, Germany. Represented by NATIONAL PRINTING INK CO. LTD, Industrial Estate, Chichester, Sussex (Printing inks)

JOHN T. KEEP & SONS LTD, 15 Theobald's Road, London WC1 (Screen inks)

KODAK LTD, 246 High Holborn, London WC1 (Photographic equipment)

E. A. KUFFALL & CO. LTD, 157 Dukes Road, London W3 (Mesh materials)

LITTLEJOHN GRAPHIC SYSTEMS LTD, 16–24 Brewery Road, London N7 9NP (Dark room cameras and equipment, graphic art enlargers, contact printing frames, colour reproduction systems)

E. T. MARLER LTD, Deer Park Road, Wimbledon, London SW19 3UE (Printing inks, mesh materials, printing tables, mercury vapour lamps, copysacs)

MODBURY ENGINEERING, Belsize Mews, 27 Belsize Lane, London NW3 5AT (Supply of aquatint boxes, cast iron hot tables for etching, lithographic stones, levigators, rebuilt proof presses; maintenance and repair of etching, lithographic and relief proofing presses)

W. R. NICHOLSON LTD, 14 Wates Way, Mitcham, Surrey CR4 4HR (General lithographic supplies)

PAPERCHASE PRODUCTS LTD, 216 Tottenham Court Road, London W1A 3DM (Paper)

PAPIERFABRIK ZERKALL, RENKER & SÖHNE, D-5161 Zerkall über Düren, Federal Republic of Germany (Mould-made papers and boards)

PHILIPS ELECTRICAL LTD, City House, 420–430 London Road, Croydon CR9 3QR (Mercury vapour lamp)

A. J. POLAK, 439–443 North Circular Road, London NW10 0HR (Mesh materials)

PRONK, DAVIS & RUSBY LTD, 90–96 Brewery Road, London N7 9PD (Mesh materials, general screen printing equipment)

A J. PURDY & CO. LTD, 248 Lea Bridge Road, Leyton, London E10 (Mesh materials)

HARRY F. ROCHAT, 15a Moxon Street, Barnet, Hertfordshire (Relief, lithographic and etching presses, blankets, frontings, swanskin, hot plates)

SAMCO-STRONG LTD, P.O. Box 88, Clay Hill, Bristol BS99 7ER (Screen printing tables and other equipment)

SANSOM BROS LTD, 1a McDermott Road, London SE15 (Lithographic plates and regrainers)

CHARLES SCHMAUTZ, 219 Rue Raymond Losserand, 75 Paris 14 (General lithographic supplies)

THE S.D. SYNDICATE LTD, 121 Westminster Bridge Road, London SE1 7HR (Photo engraving copper and zinc sheets and associated chemicals)

SELACTASINE SILK SCREENS LTD, 22 Bulstrode Street, London W1M 5FR. Mail order, 65 Chislehurst Road, Chislehurst, Kent (Mesh materials and printing tables)

SERICOL GROUP LTD, 24 Parsons Green Lane, London SW6 4HS (Screen printing inks, mesh materials, mercury vapour lamps, copysacs, autotype materials)

SPICER-COWAN LTD, New Hythe House, Aylesford, Maidstone, Kent ME20 7PD (Paper)

ALEC TIRANTI LTD, 72 Charlotte Street, London W1 (Engraving tools)

USHER-WALKER LTD, Chancery House, Chancery Lane, London WC2 (Copperplate inks.

WINSTONES LTD, Park Works, Park Lane, Harefield (Printing inks and rollers)

WIGGINS TEAPE LTD, Belgrave House, Basing View, Basingstoke RG21 2EE (Printing papers)

AMERICAN SUPPLIERS

AMERICAN SCREEN PROCESS EQUIPMENT COMPANY, 1439 West Hubbard Street, Chicago 22, Ill. (Presses and general screen printing supplies)

ANDREWS, NELSON, WHITEHEAD, Boise Cascade Corporation, 7 Laight Street, New York, NY 10013 (Paper)

APEX ROLLER COMPANY, 1541 North 16th Street, St Louis, Missouri 63106 (Rollers)

BECKER SIGN SUPPLY COMPANY, 319–321 North Paca Street, Baltimore 1, Md. (General screen printing supplies)

CHARLES BRAND MACHINERY INC., 84 East 10th Street, New York, NY 10003 (Etching and lithographic presses, rollers, hot plates, general supplies)

CHALLENGE MACHINERY COMPANY, Grand Haven, Michigan 49417 (General equipment)

CINCINNATI SCREEN PROCESS SUPPLIES, INC., 1111 Meta Drive Cincinnati 37, Ohio (Drying ovens and related supplies)

CRAFTOOL INC., 1 Industrial Avenue, Woodridge, New Jersey 07075 (Woodcarving and cutting tools)

THE CRAFTOOL COMPANY, 1421 West 240th Street, Harbor City, California 90710 (Woodcarving and cutting tools)

B. DRAKENFELD & COMPANY, 45–47 Park Place, New York 7, NY (Screen fabrics, ceramic colors, decal papers)

E. I. DU PONT DE NEMOURS & COMPANY, INC., 2410–17 Nemours Building, Washington 98, Del. (Photographic equipment)

EASTMAN KODAK COMPANY, Rochester 4, NY (Photographic equipment)

GRAPHIC CHEMICAL & INK COMPANY, 728 North Yale Avenue, Villa Park, Ill. 60181 (Ink and presses)

GRAPHIC EQUIPMENT OF BOSTON, INC., 22 Simmons Street, Boston 20, Mass. (Presses and related equipment)

IDEAL AND GRAPHIC ROLLERS COMPANY, 30 31st Street, Long Island City, NY 11102 (Rollers)

INTERCHEMICAL PRINTING INK CORPORATION, 67 West 44 Street, New York, NY (Printing inks)

JAPAN PAPER COMPANY, 7 Laight Street, New York, NY 10013 (Paper)

W. M. KORN, INC., 260 West Street, New York, NY 10013 (Lithographic and silk screen crayons, general lithographic supplies)

LAWSON PRINTING MACHINE COMPANY, 4453 Olive Street, St Louis 8, Missouri (Printing equipment)

MCLOGAN'S SCREEN PROCESS SUPPLY HOUSE, 1324 South Hope Street, Los Angeles 15, Calif.

M. & M. RESEARCH ENGINEERING COMPANY, 13360 West Silver Spring Road, Butler, Wisconsin (Presses and related equipment)

EDWARD C. MULLER, 3646 White Plains Road, Bronx. New York, 10467 (Woodcarving and cutting tools)

NU-ARC COMPANY, INC., 4110 West Grand Avenue, Chicago 51, Ill. (Photographic equipment)

PRINTING AIDS CORPORATION, 9333 King Street, Franklin Park, Chicago, Ill. (Printing consultants and equipment)

ROBERTS & PORTER INC., 4140 West Victoria Avenue, Chicago, Ill. 60646 (Ink, rollers, blankets, general supplies)

TAMERIND INSTITUTE, 108 Cornell Avenue, SE, Albuquerque, New Mexico 87106 (Lithographic printing services)

ZELLERBACK PAPER COMPANY, 245 South Spruce Avenue, San Francisco, Calif. 94118

Index

760.28
RUS J

748.3